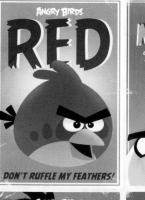
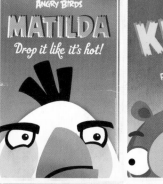

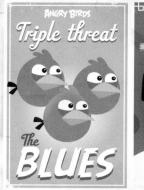
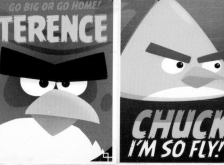

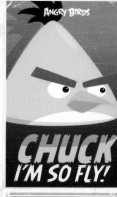

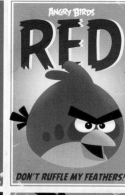

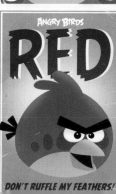

# ANGRY BIRDS
# HATCHING A UNIVERSE

*Behind the Scenes of a Phenomenon*

**DANNY GRAYDON**

*Foreword by*
**MIKAEL HED**

TITAN BOOKS

*London*

TITAN
BOOKS

A division of
Titan Publishing Group Ltd

144 Southwark Street
London SE1 0UP
www.titanbooks.com

f Find us on Facebook: www.facebook.com/titanbooks
t Follow us on Twitter: @TitanBooks

Published by arrangement with Insight Editions, 10 Paul Drive,
San Rafael, California 94903, USA.  www.insighteditions.com

ISBN: 9781781168165

A CIP catalogue record for this title is available from
the British Library.

REPLANTED PAPER    ROOTS of PEACE

Insight Editions, in association with Roots of Peace, will plant two trees for each tree
used in the manufacturing of this book. Roots of Peace is an internationally renowned
humanitarian organization dedicated to eradicating land mines worldwide and
converting war-torn lands into productive farms and wildlife habitats. Roots of Peace
will plant two million fruit and nut trees in Afghanistan and provide farmers there
with the skills and support necessary for sustainable land use.

Manufactured in Hong Kong by Insight Editions

10 9 8 7 6 5 4 3 2 1

**THESE PAGES** Piggy Island concept art • Miguel Moreno
**FOLLOWING PAGES** Fazer Angry Birds television advertisement
concept art • Sami Timonen

# CONTENTS

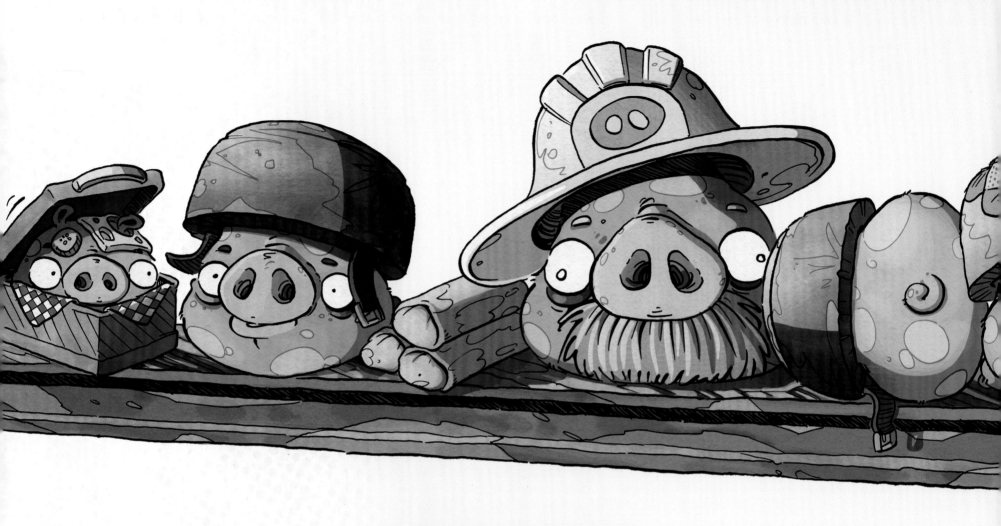

# FOREWORD
## BY MIKAEL HED

**ROVIO ENTERTAINMENT HAS SUCCEEDED** in growing from a small Finnish mobile games startup to a globally recognized media entertainment company in just a few years—faster than any entertainment company before us. These formative years have been record-breaking for Rovio as well as for the Finnish entertainment industry.

At Rovio we see entertainment as a chance to discover new experiences and enjoy quality time with friends and family. Again and again, our fans are delighted by our products, whether it be games, animations, books, toys, or other merchandise. This synergy with our audience is possible only because we love what we do, keep our minds open, and care about our fans.

Having our roots in Finland has influenced our understanding of simple but vital elements in business; like having a sense for high quality and fine design, and appreciating skilled and creative personnel. For Finns, being humble is almost a built-in thing, yet that doesn't mean that we can't have ambitious visions. At Rovio, we apply an inspired mindset to what we do. We believe that whatever

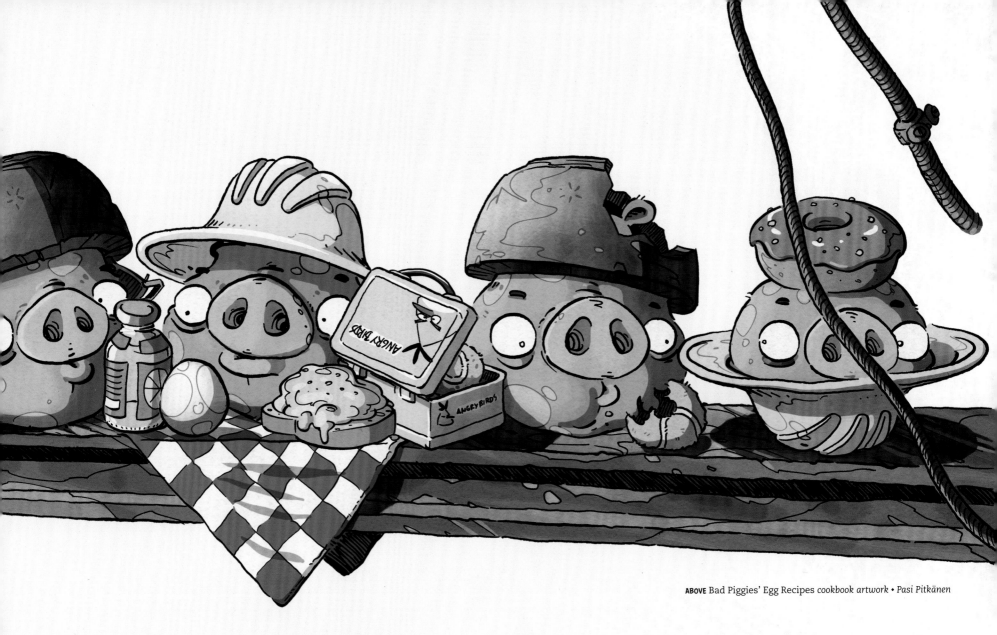

task you are undertaking, you should do it properly, and with all your heart. That philosophy has taken us far.

We see Rovio as a curious young bird leaving its nest and flying off into the world, telling everyone stories of what it has seen and experienced on the journey. In the same way, we want to tell fun and delightful stories, and introduce foreign countries and cultures to the rest of the world. For that, we use our content, along with social media, which gives fans around the world the opportunity to share their enthusiasm for *Angry Birds* with us, and each other.

In this unique book we introduce a wealth of memorable artwork created during our first few years. Arranged into a series of themed chapters, these specially selected pieces shine a light on the incredible hard work and innovation that goes into creating new *Angry Birds* characters, stories, and worlds.

While the *Angry Birds* universe may seem straightforward, there is a fine art to creating such endearing simplicity, and it is this art that makes *Angry Birds* a constant source of surprise and delight for all our fans.

# INTRODUCTION

**THROUGHOUT THE HISTORY OF** video games, there are few titles that have managed to expand beyond the gaming arena to become pop culture sensations in their own right. Fewer still are the games that have achieved this recognition to such a degree that they embed themselves in the popular imagination and come to help define the zeitgeist.

*Angry Birds* is very much one of these games, and yet, it's even more than that. It's a genuine phenomenon. Released in December 2009, it reached the number one spot in the United States within six months. It seemed as if everyone was playing it, gripped by an addiction to get just the right trajectory, to sling those birds from the slingshot and destroy those darned pigs, who snorted mischievously at the end of every failed attempt. Social media sites like Facebook and Twitter hummed with excitement—and enthused frustration—generated by a true gaming sensation. *Angry Birds* has since resulted in excess of a billion downloads across various platforms and boasts a multitude of fans.

It's easy to see why: *Angry Birds* is defined by a beautiful simplicity. The games are driven by potent core attributes: They're addictive and amusingly surreal, and they cater to an innately cathartic desire to be destructive. Plus, in terms of gameplay, being successful at *Angry Birds* hinges on a basic understanding of physics.

Such simplicity, albeit bolstered by an underlying sophistication, has allowed *Angry Birds* to achieve instant international appeal and also to easily fit into our busy, mobile, social media–dominated lives. It's a game that can occupy a five-minute bus ride to work or a lazy couple of hours on the sofa at home, and as the multiple sequels have proven, it always keeps you coming back for more.

**LEFT** Bad Piggies' Egg Recipes
*cookbook artwork • Pasi Pitkänen*
**OPPOSITE** *Poster art • Pasi Pitkänen*

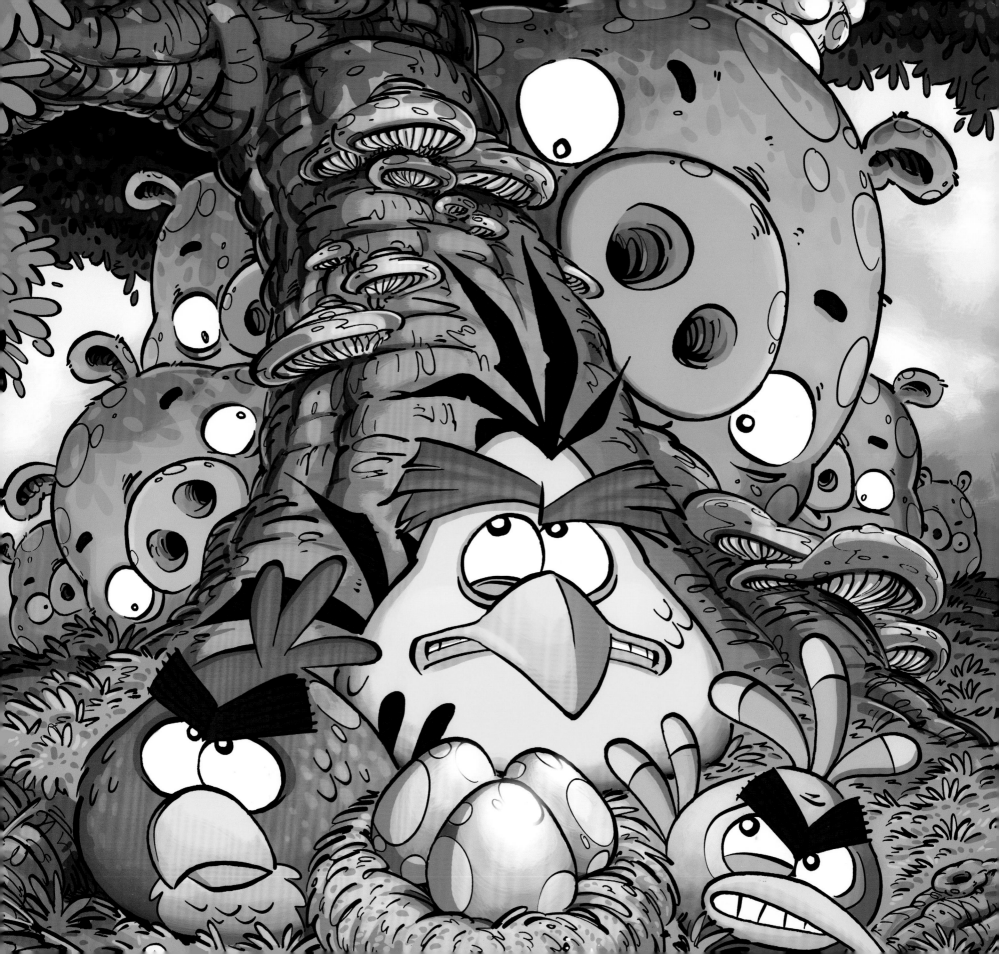

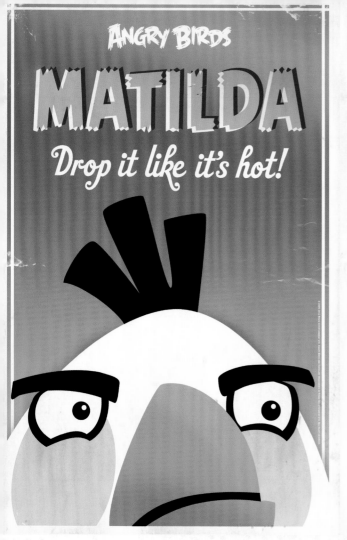

For Rovio Entertainment, the Finnish game developer behind *Angry Birds*, the game's creation was a mixture of experience, perfect timing, and a forward-thinking desire to capitalize on the emerging mobile platforms market—as well as a dedicated drive to delight audiences. Rovio was first established in 2003 under the name Relude and is based in Espoo, Finland's second-largest city, situated immediately west of its capital, Helsinki. The company itself was formed by three university friends, Niklas Hed, Jarno Väkeväinen, and Kim Dikert, following their victory in a mobile game development competition. Sponsored by Nokia and HP, the contest saw the trio create a well-received real-time multiplayer game called *King of the Cabbage World,* and greatness beckoned.

The company was renamed Rovio in January 2005 following a significant investment from Niklas Hed's uncle Kaj Hed, who is now Rovio's Chairman of the Board. "The convention early on was: You launch a game, and then a new game, and then the next," recalls Niklas Hed of Rovio's beginnings. "Back then to update a game would've been too expensive. Basically it was a product-driven, not service-driven business. Reaching the customers in a cost-effective way was very difficult. Our hit games were selling on average about five hundred thousand to one million—but we had lots of games that were not selling. The whole strategy was to create niche games for core gamers on mobile platforms, which didn't work long-term."

Before the arrival of *Angry Birds*, Rovio had released over fifty mobile game titles. "If you look

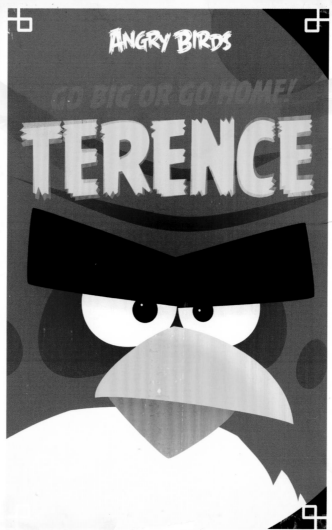

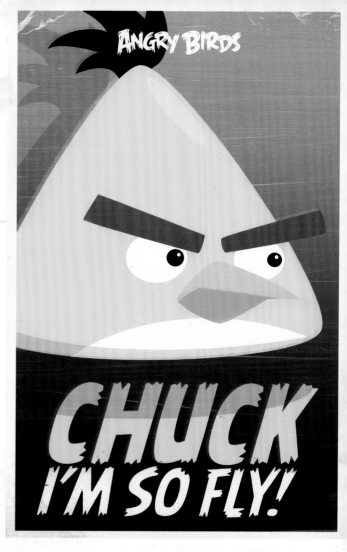

at those games," notes Niklas Hed, "the average critical rating was around 80 percent. There were very few other developers who had that rate of quality. It has always been in Rovio's DNA that, if we develop something, it better be good!"

Niklas Hed's cousin Mikael, who rejoined Rovio as CEO in 2009, agrees, noting the limitations of the platform the company worked with at the time. "Our early games were very good examples of just how far you could push the capabilities of those devices," he says. "They all had great mechanics and were highly polished, but the reason why they were not as successful was that the Java platform was too fragmented and too small on a global scale to be of any significance for the games industry."

A defining development for Rovio came with the release of Apple's revolutionary iPhone in

2007. "We speculated on what the next big development would be, and even then we were unsure about it. That was the key moment for Rovio," Niklas recalls. "We had twelve people and felt that we could do something that could change the world if we were clever enough."

The genesis of *Angry Birds* can be traced to early 2009 when Rovio was reviewing proposals for new games. Jaakko Iisalo, then a Senior Game Designer at Rovio, presented a single screenshot of a group of angry-looking birds with no wings or legs. Despite there being no indication of what the game would be about or what the birds would be doing, the enthusiastic response from Iisalo's colleagues prompted the decision to develop a game from the picture alone. "In that original concept image," recalls

**RIGHT** *Concept art* • Miguel Moreno

**FOLLOWING PAGES** Bad Piggies *animation production art* •
*César Chevalier—line art; Meryl Franck—coloring*

Niklas Hed, "we saw the spark, the mood, the attitude that we needed. It was not just pink and fluffy."

"Initially, Rovio's management wasn't entirely sure about the notion of a game with the birds," says Iisalo, now Rovio's Creative Director, "so we researched web gaming and discerned what was really popular at that time. We realized that 2D, physics-based games, and artillery-based games were very popular. So, we decided that these would be the areas we would focus on, utilizing the bird characters."

There would be a crucial difference to the development of this particular game, however, according to Iisalo: "We made a list of parameters to adhere to in creating *Angry Birds*, and from the very beginning, the idea was to make a big IP [intellectual property]. Not just a game, but something much bigger: a brand—something that can be built on." Yet, simplicity and accessibility were the driving forces: "That was the core idea: to make something simple that everyone can enjoy. That's what we have always focused on—but maintaining a simple concept is not a simple task!"

Circumstantially, the development of *Angry Birds* came at a critical time for Rovio, Mikael Hed recalls. "By mid-2009 our games catalog was generating virtually zero revenue," he says. "By the time we released *Angry Birds* in late 2009, we were in a very desperate situation." A situation so desperate that Mikael's father, Kaj, offered to remortgage his parents' home in a last-ditch effort to aid Rovio, a prospect that justifiably worried Mikael intensely. "At the very least this game would have to make enough money to ensure my grandparents weren't out on the street!" he says. "I simply wasn't ready to take that bet and pleaded with my father to not do it. He went ahead and did it anyway—one of the few times that I was grateful for an irrational decision. Thanks to that money, we were able to keep going and get *Angry Birds* off to a good start—and here we are today!"

Released to widespread critical acclaim and tremendous sales, *Angry Birds* has since achieved some genuinely startling statistics: *Angry Birds* is the most downloaded app of all time in Apple's App Store, and as of May 2012, there have been a combined billion downloads of *Angry Birds* games on various platforms. "At the center, you have to have the best possible

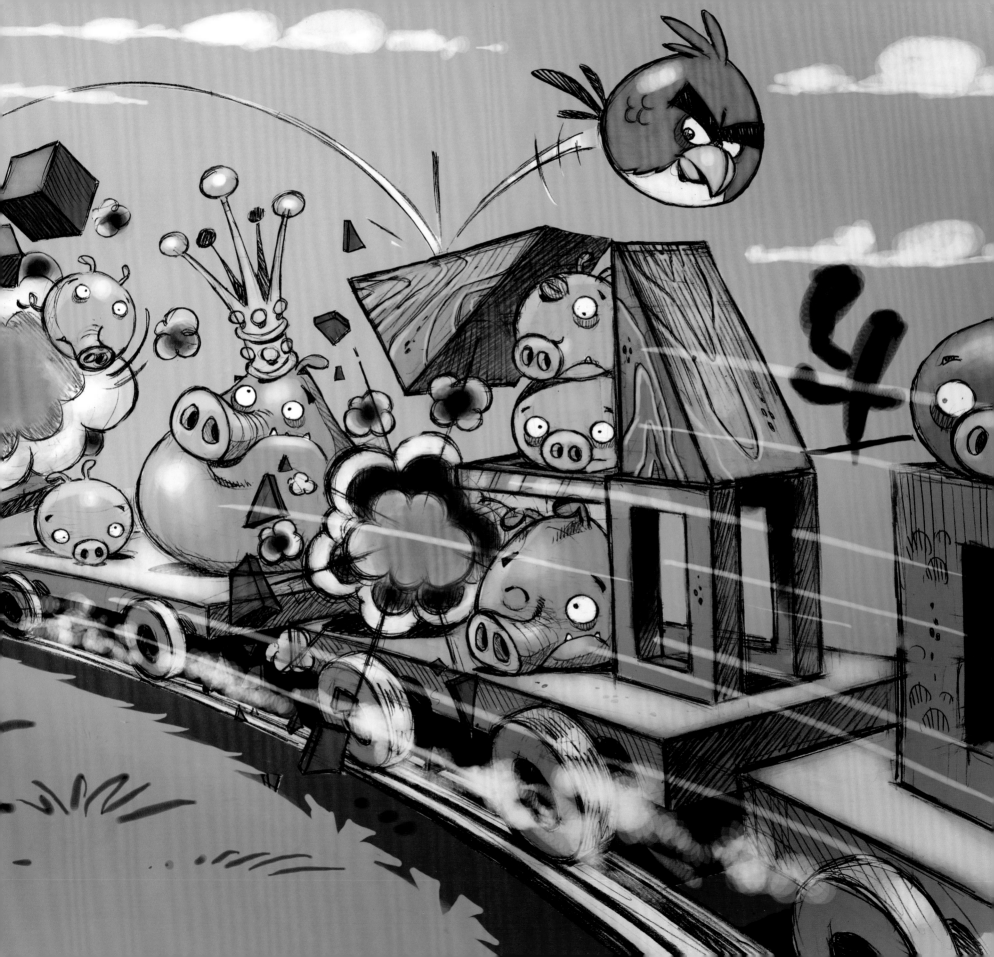

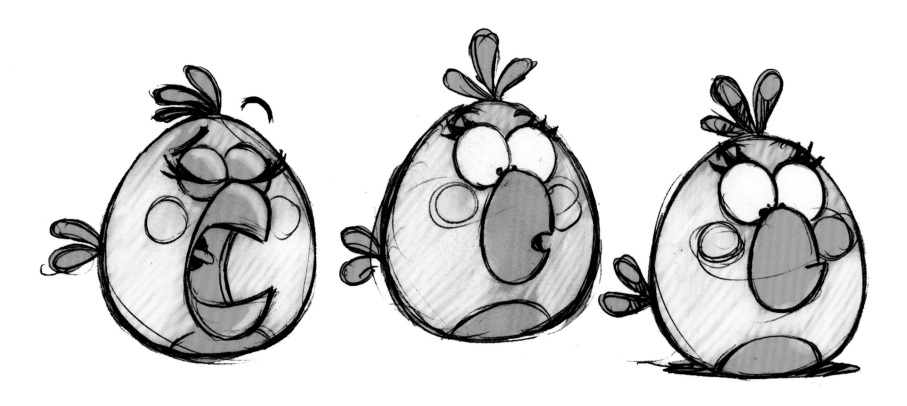

concept—and if you have the marketing right, then you can reach the necessary critical mass," says Niklas Hed. "The next step is: How do you sustain that, and make it into a service rather than a single product?" Impressively, since its initial release *Angry Birds* has spectacularly achieved its goal of becoming a brand—one that has ascended with the dizzying trajectory of a bird fired from a slingshot. In the space of just three years, the original game has generated no less than four direct sequels, two spin-offs based on hot Hollywood properties, an animated series, and an array of books. Not to mention high-profile collaborations with internationally renowned brands, a vast merchandising line that encompasses tens of thousands of products, and an animated feature film in the works.

"The most important consideration when it came to expanding *Angry Birds* was that we didn't simply want to monetize it," Niklas Hed asserts. "We were already profitable, so there was no pressure to force it. There was no hurry, and this has given us the freedom to focus on the user experience. We have actually been criticized for *not* pursuing profit! We want to have a long-lasting brand."

This is something enthusiastically reiterated by the man known as "Mighty Eagle," Rovio's Chief Marketing Officer, Peter Vesterbacka. "We have a very solid foundation on which the brand is built," he says. "The premise begs the question: Why are the birds angry? That's the hook. I see that happen everywhere. There are only two things we care about: the *Angry Birds* universe and our fans. They are very tightly coupled, and whatever we do, we aim to ensure that we *surprise* and *delight*."

For Vesterbacka, there are no limits to what Rovio can accomplish, and as he puts it: "*Angry Birds* is aiming to be bigger than some of the classic entertainment brands today." The astounding success of *Angry Birds* has shown that it's a claim that deserves to be taken seriously; but for Rovio and their beloved property, this is only just the beginning.

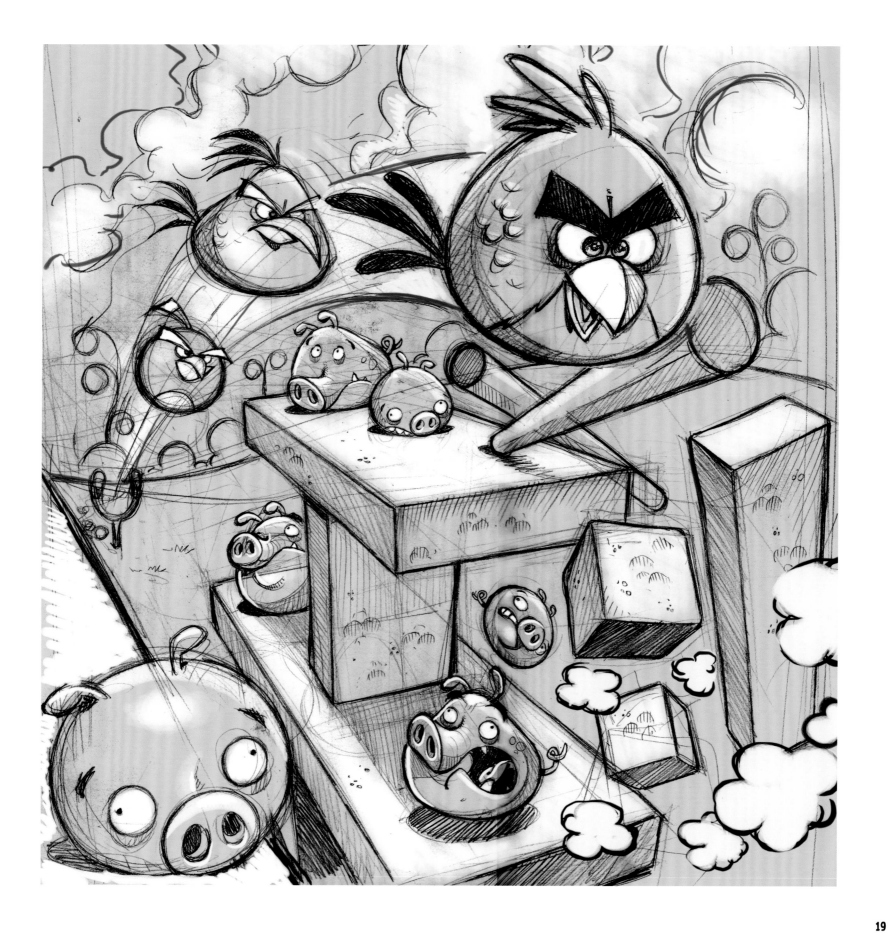

# THE EVOLUTION OF RED

"The two people who had the most impact on the design of Red," Mikael Hed explains, "were Jaakko Iisalo, who came up with the original design, and Tuomas Erikoinen, the Graphic Artist who made Red and all the other birds look the way they do today." In what is now standard design practice at Rovio, Red underwent various iterations as part of an organic process of refinement that would adapt his iconic look for a range of different *Angry Birds* adventures.

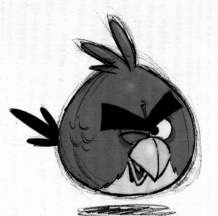

CHARACTER STUDIES
MIGUEL MORENO
SUMMER 2010

RED AS SEEN IN THE FIRST ANIMATION:
THE "CINEMATIC TRAILER"
LAURI KONTTORI
FALL 2009

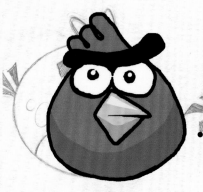

"GEORGE",
THE VERY FIRST RED BIRD
JAAKKO IISALO
SPRING 2009

VERSION FROM
MIGHTY EAGLE
ANIMATION
MIGUEL MORENO
FALL 2010

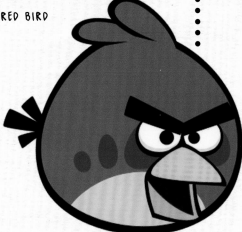

THE "CLASSIC" RED BIRD
TUOMAS ERIKOINEN
SUMMER 2009

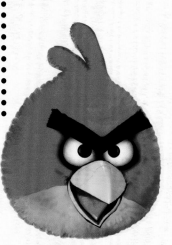

THE ORIGINAL
TITLE SCREEN IMAGE
KIMMO LEMETTI
FALL 2009

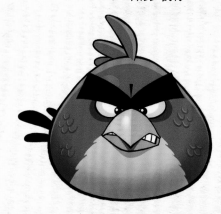

**LEFT** *Character personalities concept art • Tuomas Gustafsson*
**OPPOSITE** *Angry Birds trademark artwork • Markus Tuppurainen*
**INSIDE FLAP** *An assortment of the hundreds of licensed Angry Birds Red products produced yearly by Rovio*

— CHAPTER 1 —

# RED ALERT!

JAAKKO IISALO'S ORIGINAL 2009 CONCEPT IMAGE for what would evolve into *Angry Birds* boasted one aspect that would ultimately come to define the entire brand: the yellow-beaked, heavy-browed red bird. Red is the central protagonist in the games and essentially the face of the *Angry Birds* brand. "That image provided the basis for the bird," says Iisalo. "In the beginning, the emotion was the important thing. I had this bunch of angry birds, and they had this real energy."

"Red was the icon from the start," recalls Mikael Hed, who played a key role in developing all the *Angry Birds* characters. "He was the first character you see when you play the game, but, ironically, he doesn't have any powers like the other birds. As we started character development, we considered what makes him so special, and the answer is that he's the natural leader. Red has the smarts to make sure that the team gets through every situation."

In the *Angry Birds* universe, Red—loosely based on the desert cardinal—is the de facto leader of the flock, and more important, he's the angriest bird of all! Having found the three eggs on Piggy Island, Red is vastly overprotective of them and typically overreacts to the slightest

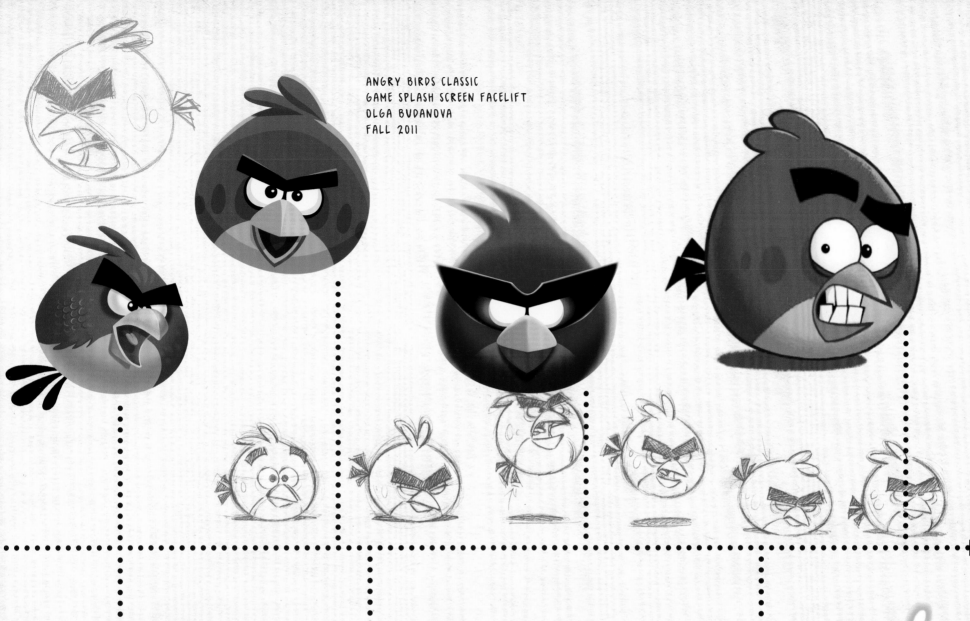

ANGRY BIRDS CLASSIC
GAME SPLASH SCREEN FACELIFT
OLGA BUDANOVA
FALL 2011

SKETCH FOR AN EXPRESSION STUDY
MIGUEL MORENO
SUMMER 2011

"THE ANIMATION STYLE" (MK 1)
JUSSI KEMPPAINEN
FALL 2011

RED SKYWALKER,
ANGRY BIRDS STAR WARS
JARROD GECEK, TONI KYSENIUS
FALL 2012

25

LEFT *Red character development art* • Miguel Moreno
RIGHT Angry Birds Toons *pre-production art* • Carine Becker—layout; Copenhagen Bombay—coloring; Jussi Kemppainen—rigging

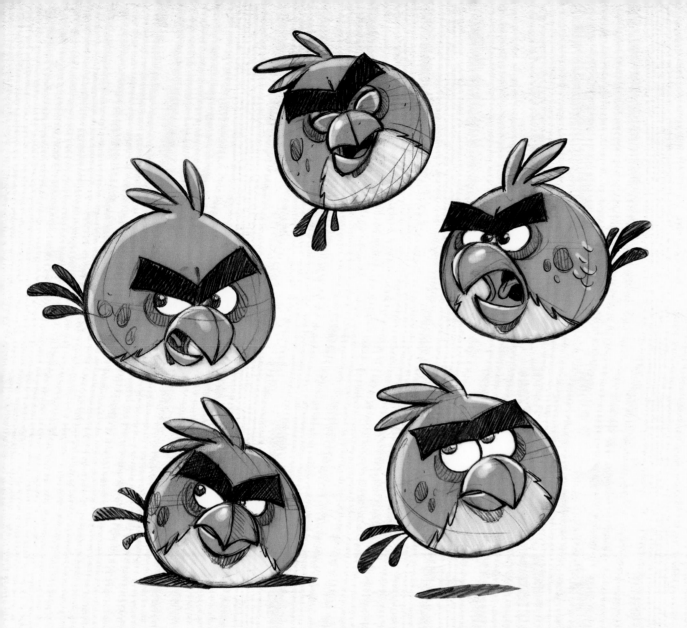

threat to their safety, flying into a berserk rage. Despite his youth, Red is something of a father figure to the other Angry Birds. Red knows that no one else will take responsibility, so he is forced to do so. When the eggs have hatched, Red will have done his duty and will be able to forget the burden of leadership and finally embrace his own carefree nature.

"Red has the attitude," Mikael Hed explains, "telling the world that he's someone to be reckoned with, while also being charming and funny. There is also the anger, of course—you don't mess around with Red!"

Red's signature color was not only an important visual aspect—red being the color typically associated with anger—but also had vital implications with regard to the marketing of the *Angry Birds* universe. "Making the main bird red was a key decision," notes Peter Vesterbacka, "because it really stands out in a very crowded marketplace. The big question is: How do you stand out against the millions of other products?"

While there have been various iterations of Red, Mikael Hed has particular affection for the version from the earliest incarnation of the *Angry Birds* game. "For nostalgic reasons, I always come

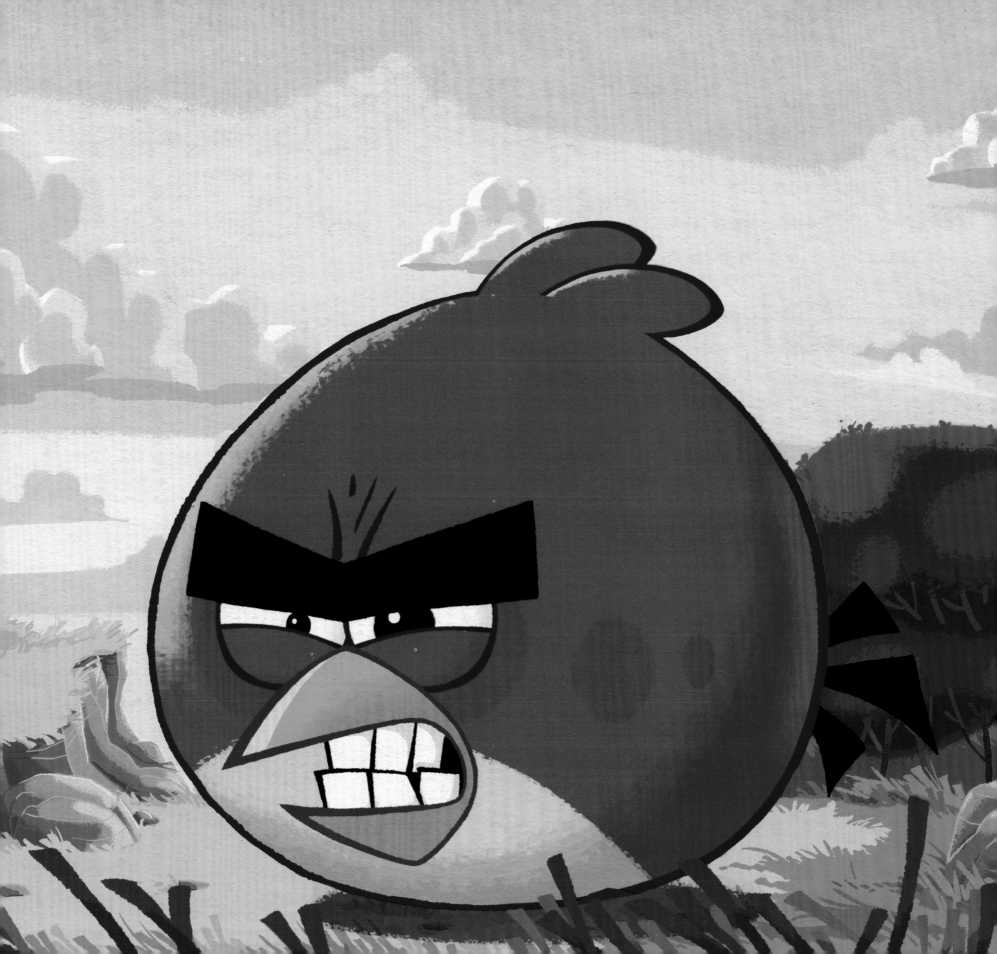

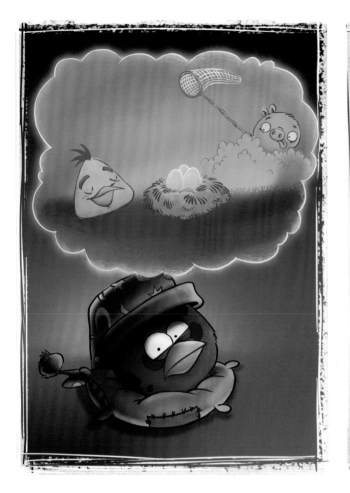

back to a version of Red that might not be the most technically sophisticated, but which has a great deal of meaning to me: the original title screen image of him," he says. "It was a version painted by an outside artist whose comic book I had published. He made this slightly more photorealistic version, which was later touched up by our artists before it was released to the public. In that image, Red is lunging toward you and looking suitably angry, and his beak is a little cracked because he's been in quite a few fights! That one is my favorite."

Within the Rovio offices, many employees can be found wearing Red hooded sweatshirts with the icon's fierce eyes emblazoned on the chest. They're far from the only ones: Red has become the focal point of *Angry Birds* merchan-

dising, providing a potent and highly recognizable face for a worldwide brand. "Red is so recognizable that it undoubtedly helps us," Mikael Hed agrees. "People all over the world catch one glimpse of this character, and they instantly know who he is. As an icon, Red works fantastically well! I don't know of many other characters who would work better."

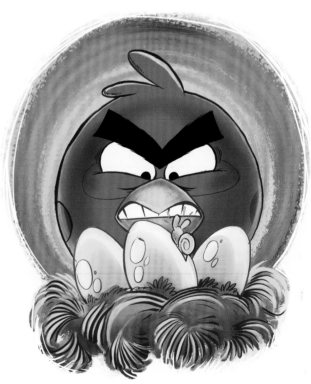

**TOP AND RIGHT** *Character personalities concept art* • *Tuomas Gustafsson—line art; JP Räsänen and Iida Koivisto—coloring* **OPPOSITE** Angry Birds Space *poster art* • *Toni Kysenius and Olga Budanova*

BLANK

TENDER

LAUGHING

LAUGHING x 2

SURPRISED

SHOCKED

ECSTATIC

EXCITED

UPSET

CRYING

SLEEPY

PAIN/HURT

SKEPTICAL

GRUMPY

ARROGANT

PROUD

**THIS PAGE** *Red preliminary model sheet • Tuomas Gustafsson*

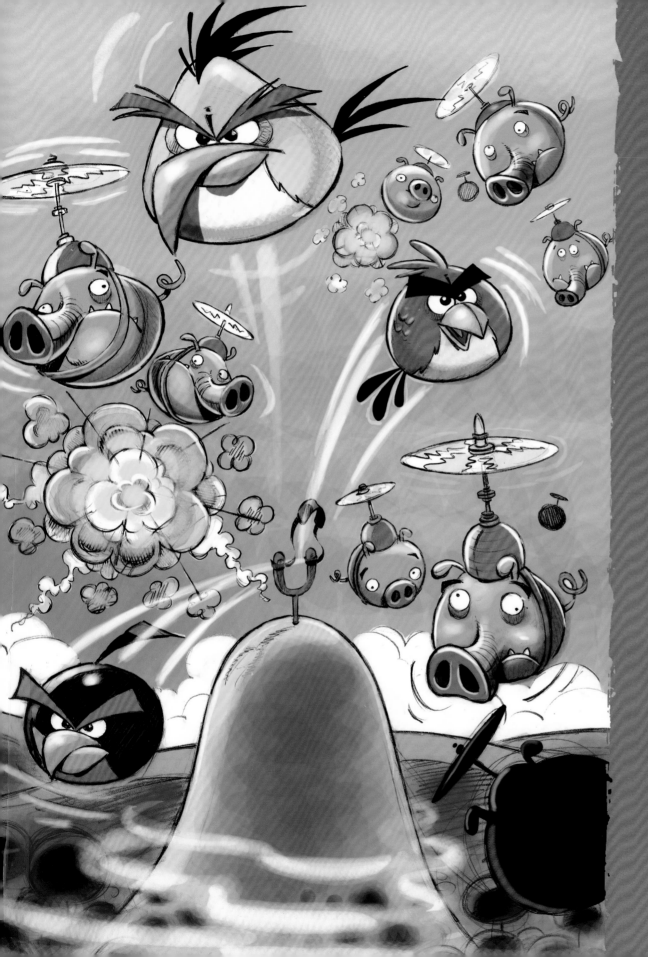

# MEET THE *Flock*

## JAAKKO IISALO

**FOR THE MAN WHO CAME UP** with the original *Angry Birds* concept, the game's success remains something of a shock. "The evolution of *Angry Birds* is hard to grasp," Jaakko Iisalo says. "I don't really know what to think about it all! I understand that I created it, but when you think about a billion downloads—it's crazy!"

A self-confessed "hard-core gamer," Iisalo worked as a Graphic Designer prior to joining Rovio and making the transition to Game Designer. He recalls that his initial idea for *Angry Birds* came at a tumultuous time for Rovio: "We had a really small team and simply set out to make the best game we could. We had the opportunity to make one more game—it really was a make-or-break situation."

In the wake of *Angry Birds'* worldwide success, Iisalo now occupies the position of Creative Director of the Games Department at Rovio: "For me, the games are the most important part, but I don't think it should be like that for everybody. The company has taken *Angry Birds* in so many different directions."

With a view to the future, Iisalo is well aware of what fuels a good project. "We need to be excited," he says. "If I'm making a game, I'm making it for myself. I don't just want to repeat myself; I want to see something new. If it's exciting to me, then I think it will be exciting for others as well. We just need to maintain that state of mind when creating new things."

**LEFT** *Concept art • Miguel Moreno*

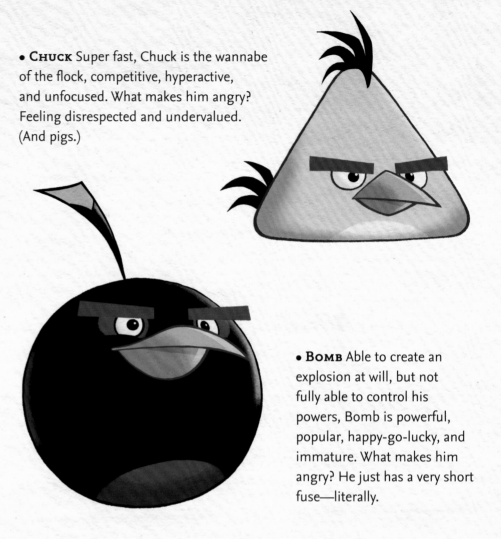

• **CHUCK** Super fast, Chuck is the wannabe of the flock, competitive, hyperactive, and unfocused. What makes him angry? Feeling disrespected and undervalued. (And pigs.)

• **BOMB** Able to create an explosion at will, but not fully able to control his powers, Bomb is powerful, popular, happy-go-lucky, and immature. What makes him angry? He just has a very short fuse—literally.

# BIRDS OF A FEATHER

Red may be the star of the Angry Birds, but he's supported in his battle with the Bad Piggies by a multicolored flock of vivid characters.

**THESE PAGES** Angry Birds Toons *character concept art* • *Miguel Moreno—character design; Jussi Kemppainen—character rigs; Antti Kemppainen, Jussi Kemppainen, Marija Dergaeva, and Jaakko Tyhtilä—inking and coloring*

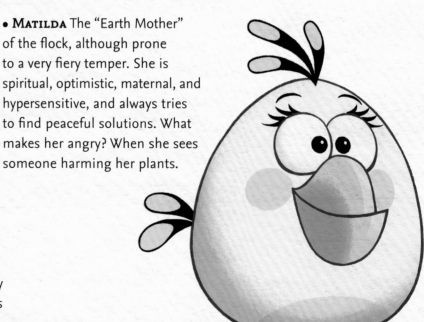

• **MATILDA** The "Earth Mother" of the flock, although prone to a very fiery temper. She is spiritual, optimistic, maternal, and hypersensitive, and always tries to find peaceful solutions. What makes her angry? When she sees someone harming her plants.

• **JIM, JAKE, AND JAY** Always sticking together in a trio, Jim, Jake, and Jay are the kids of the flock. Hyperactive, carefree, clever, and vulnerable, they are well known for being pranksters. What makes them angry? Being blamed for losing the eggs!

• **STELLA** Stubborn and unruly, Stella is a mystery to the other birds—and visits them whenever she feels like it. What makes her angry? Like a teenager, she hates being told what to do.

• **BUBBLES** The candy-loving Bubbles is the quietest of the flock. Small and cute, he expands to a vast size to get what he wants. What makes him angry? When he doesn't get what he wants!

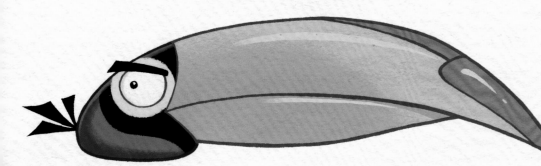

• **HAL** A drifter, the large-beaked Hal is easygoing, friendly, and open-minded. He would rather be camping and telling stories than fighting pigs. What makes him angry? When someone tries to set boundaries.

• **TERENCE** Also known as Big Red Bird, Terence is the enigma of the flock, silent, sinister, and inscrutable. Of all the birds, the pigs are frightened of him the most. What makes him angry? Pigs, of course! Even if he only thinks he sees one, he causes mass destruction!

• **MIGHTY EAGLE** The biggest of the Angry Birds by far, Mighty Eagle is too huge to appear on this page! Find out more about him in chapter 6.

# DISCOVERING
# THE ISLAND

**JUST INSIDE THE ENTRANCE** to Rovio's Animation Department is an impressive, handcrafted model of Piggy Island encased in glass. Highly detailed and beautifully rendered, it's a tangible sign of the considerable effort that goes into creating a detailed world in which the *Angry Birds* characters can thrive as the property expands beyond the games and into multimedia arenas.

With its striking central mountain shaped like the head of one of those greedy green oinkers, Piggy Island is separated into distinct environments, and it's in this myriad of locations that the *Angry Birds* adventures take place. The exact location of Piggy Island is something of a mystery, but it has been designed to reflect elements of just about every location in the real world. As such, it features a natural landscape that bears all kinds of climates, from desert to glacial.

According to Lauri Konttori, Creative Director at Rovio Entertainment, the creation of a wider universe was a vital step in the expansion of the brand: "The games gave the first glimpse of the world and the characters, but we wanted a mythology with characters who had distinct personalities."

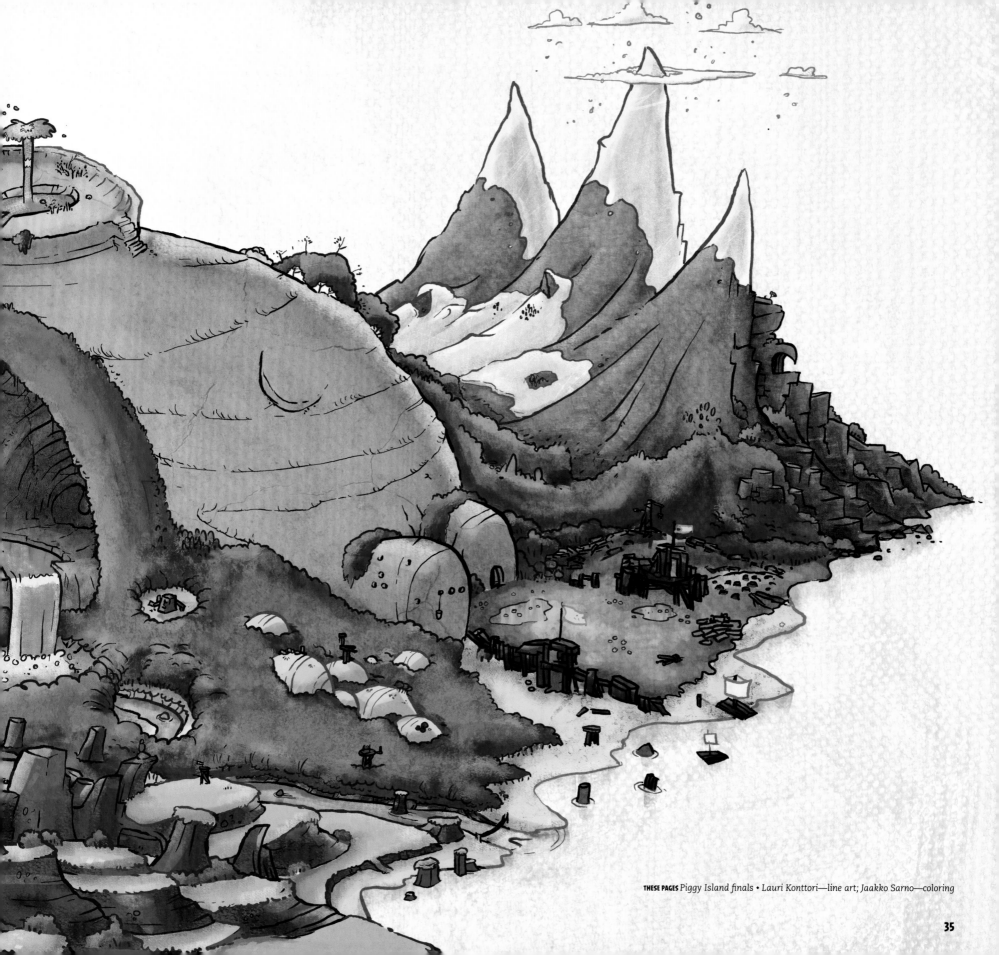

**THESE PAGES** *Piggy Island finals • Lauri Konttori—line art; Jaakko Sarno—coloring*

# MEET THE *Flock*

## MIGUEL MORENO

**PIGGY ISLAND IS FILLED WITH** colorful characters, and the man charged with giving them a distinctive and fun look is Miguel Moreno. "My position at Rovio is Lead Character Designer, for both *Angry Birds* and any new projects," he says. "I work for different departments like Animation, where I design all the model sheets; Marketing, where I create character designs for new projects; and Games, where, for example, I created many of the characters for *Angry Birds Star Wars*."

Moving to Finland from Barcelona, Spain, in 2008, Moreno freelanced for Rovio prior to the development of *Angry Birds*, returning in 2010 following the game's release and phenomenal success. "It's quite amazing to be part of a big brand like *Angry Birds*," he says. "I've had a lot of fun sitting at my desk drawing those little birds, and giving them personality, expressions, and life. It was, and still is, a big challenge."

For Moreno, that challenge is made significantly easier by the diversity of his task: "I never get bored of *Angry Birds* because I have the chance to work in different medias. That's really exciting for an artist. Because of the variety you remain fresh and excited about the projects."

Helping to create the iconic look of the characters has made Moreno an essential part of *Angry Birds'* success, and he has no doubt that Rovio's birds and pigs are now unstoppable. "At this point I think that everything is possible!" he says. "We always have lots of fun, and that's the trick: having fun making other people have fun!"

**RIGHT** *Pig City background development • Jean-Michel Boesch—line art; Meryl Franck—coloring*

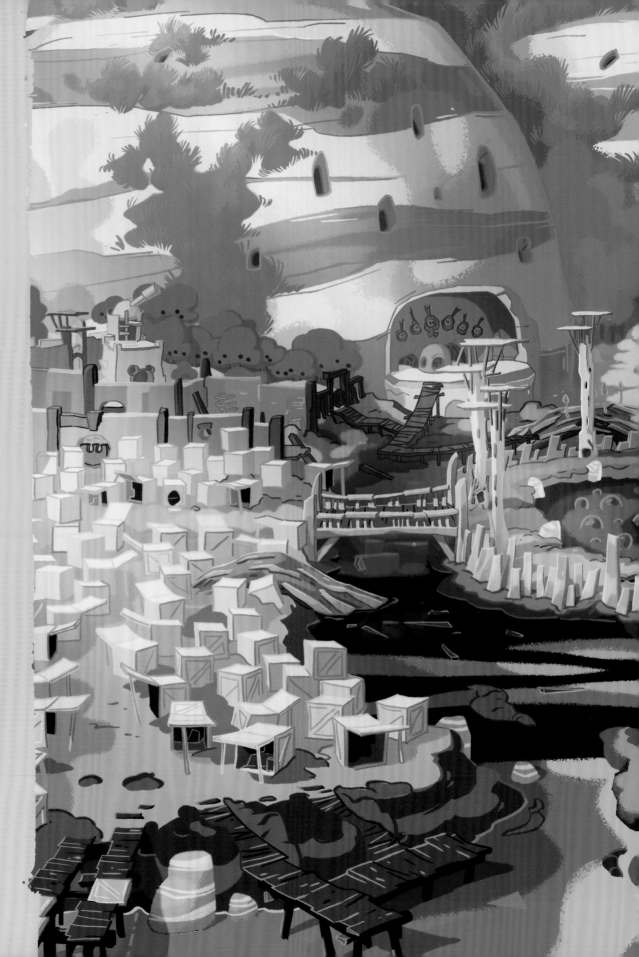

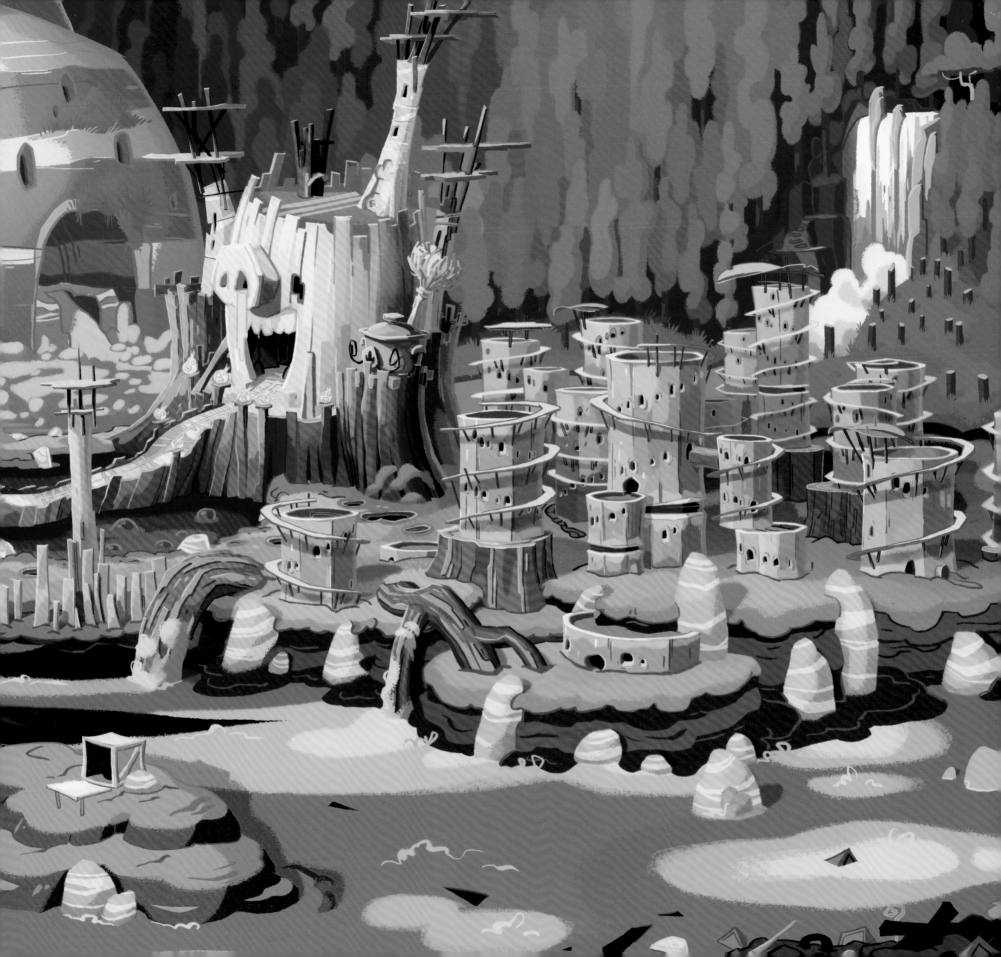

Mikko Pöllä, Rovio's Creative Director in Entertainment, was explicitly charged with this task. "I am responsible for what stories we tell about this universe," he says, "who these characters are, and how their personalities are expressed in different products." Pöllä first worked with Rovio as an external creator and writer on the animation series *Angry Birds Toons*, where he was asked to create a "Series Bible," which would document all aspects of the *Angry Birds* universe. This eventually led to him joining the team at Rovio full time.

The fifty-two-episode *Angry Birds Toons* is one of the primary arenas for fans to learn of the wider world of *Angry Birds*. "In the beginning of the story process," says Pöllä, "we were designing story arcs with elaboration about the birds' history, but after writing a couple of scripts, we came to the conclusion that it was better to stay in the present and focus on the fixed conflict between the birds and the pigs. To us, this is the right way to introduce their characters and personalities."

"We have developed the history of the *Angry Birds*, but we won't show it to the fans yet, because the priority is to build the characters first," Konttori says. "Eventually, we can bring in the island, the new locations, and the

**BELOW** *Wreck the Halls animation art •*
*Jean-Michel Boesch—layout and color*
*script; Antti Lukinmaa—background*
**OPPOSITE** *Concept art •Tuomas Gustafsson—*
*line art; JP Räsänen—coloring*

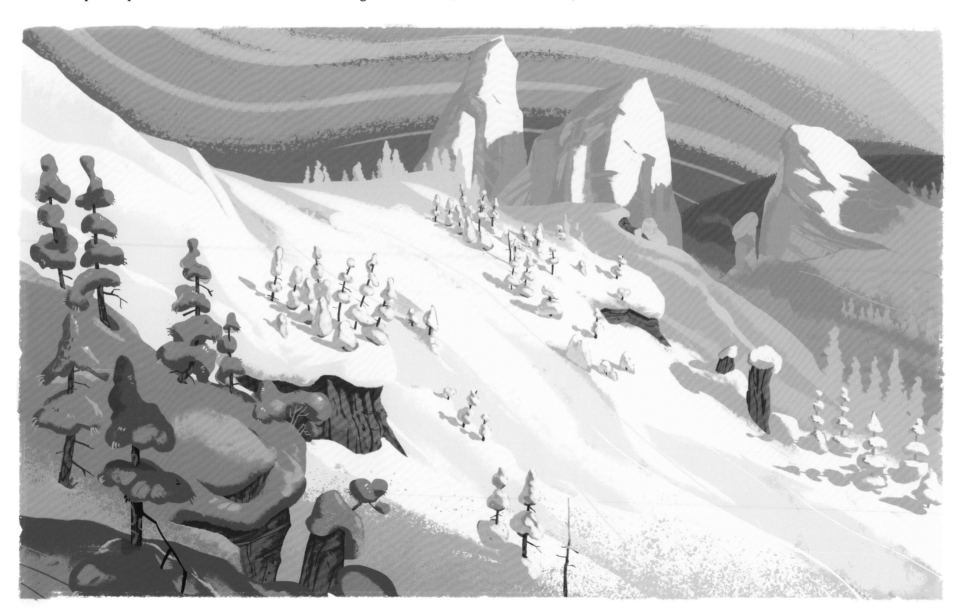

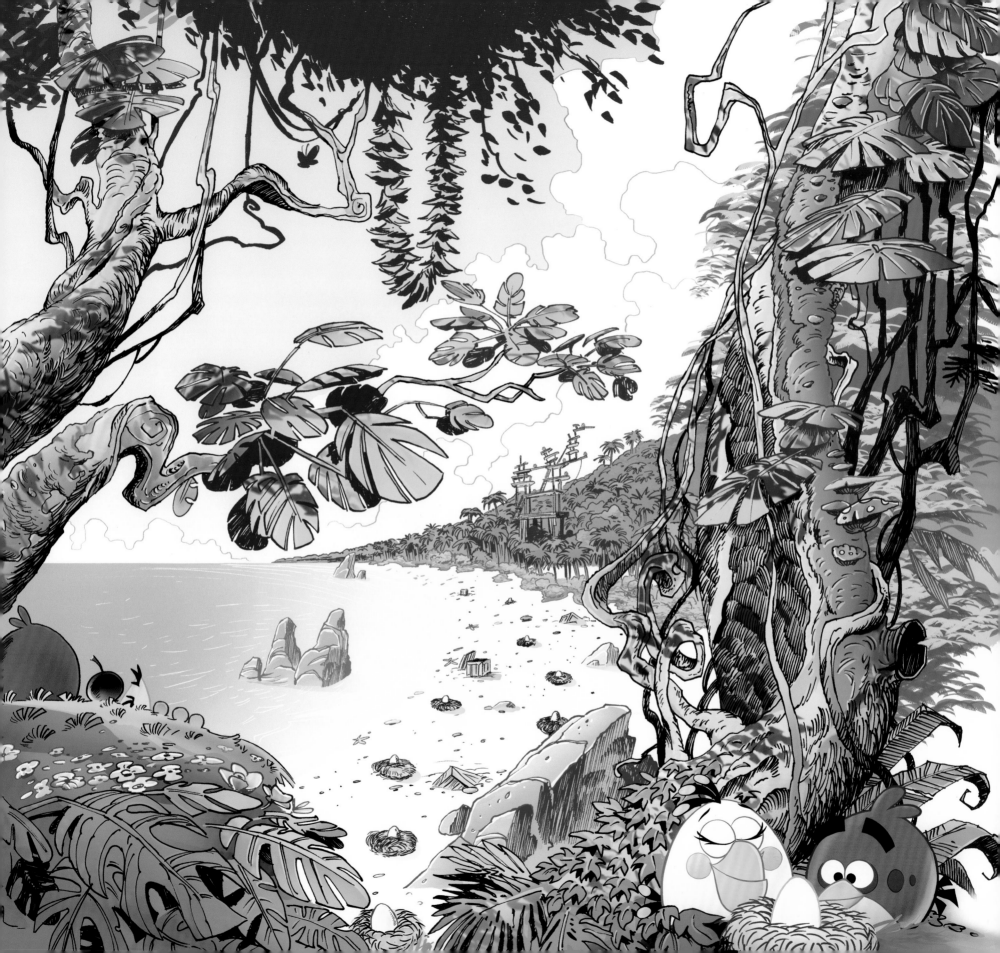

history, bit by bit. The fans want to see some 'meat around the bones' of the game, and the character personalities will be the first thing shown in *Angry Birds Toons*."

This will eventually lead, Pöllä says, to considerable exploration of the history of Piggy Island and its flora and fauna: "We are figuring out how the island functions, what animals are present beyond the birds and the pigs, and how they react to the chaos going on around them." However, despite this concerted drive to provide depth and detail to the *Angry Birds* world, Pöllä doesn't feel that the lovable simplicity of the brand will be diminished in any way. "With the *Toons*, for example, each and every episode has

to be understandable, funny, and entertaining, even if you have not played the games," he says. "Likewise, each and every book or other entertainment product we publish has to work on its own. We want to create great products for different mediums and, in time, this builds up the universe. Also, we'll learn what the best mediums are to tell *Angry Birds* stories."

Above all, Pöllä and his colleagues are keenly aware that they have a fanbase they have to delight and surprise: "Our fans know what the characters are like. We have a great basic dynamic—a fun conflict with characters with real personalities— but it's important that we know how they will fit into new stories."

OPPOSITE PAGE *Piggy Island locations • Tuomas Gustafsson*
THIS PAGE *Piggy Island locations • Joel Sammallahti—line art; Elina Penninkangas—coloring*

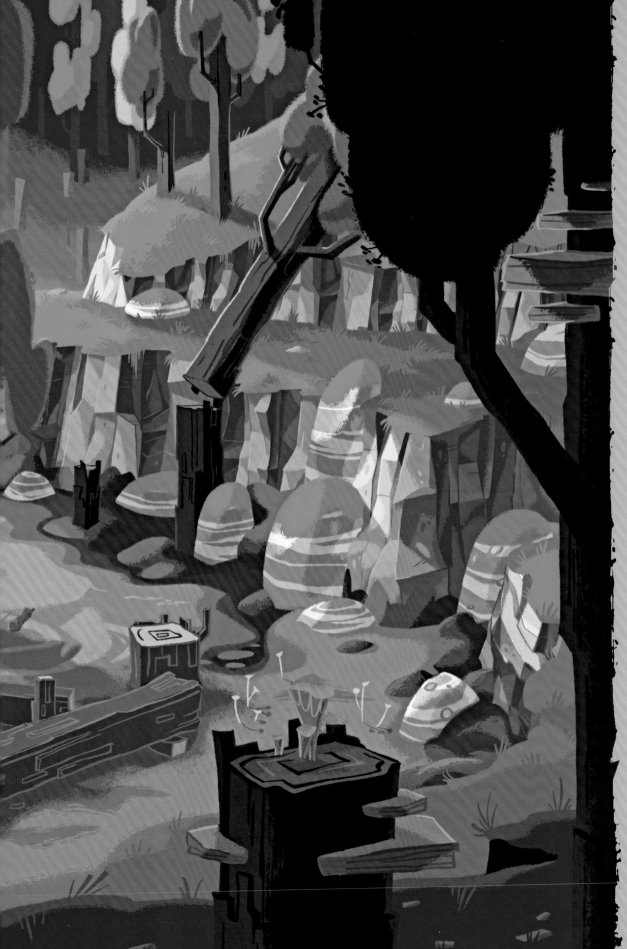

# MEET THE *Flock*
## LAURI KONTTORI

**THE ANGRY BIRDS AND THE BAD PIGGIES** are known for their attitude, and creating these well-defined, if volatile, personalities, is the job of Lauri Konttori, Rovio's Creative Director. With Mikael Hed, Niklas Hed, Mikko Pöllä, and Creative Assistant Jaakko Sarno, Konttori has been tasked with giving all the *Angry Birds* characters distinct personalities that allow them to thrive beyond the core arena of the games.

"The game's success was the path by which we could take the birds and the pigs into books and comics," says Konttori. "The fans were already familiar with the look of the characters and the feel of the world, so we picked up the key elements and developed a precise mythology from there. When we started developing the character of Red, for example, we focused on the notion of his dreams, his intentions, his weaknesses and strengths. Once you have all that, it's much easier to build a story around them."

Konttori is confident that the resolute efforts Rovio is making to build a cohesive universe for *Angry Birds* will be appreciated by the fans who have made the games such a massive hit: "It's super important that when we release material about Piggy Island, the fans who have played every level of the games will see the connections between those levels and the island and feel very content that everything links together."

**LEFT** *Pig City background development • Jean-Michel Boesch—line art; Meryl Franck—coloring*

# WHY PIGS?

"Why are the birds angry?" is not the only question that *Angry Birds* prompts from fans. Many are also curious to know why the birds are locked in an eternal battle with the pigs. The decision to make the antagonists in *Angry Birds* rather porky in appearance emerged from designer Jaakko Iisalo's working methods: "I've always drawn a lot of animal characters and it was just something natural that came out in my initial sketches."

Yet, although the aim of the game is to destroy the pigs, Iisalo never saw them as malicious. "The birds are the aggressive side, the pigs are just mischievous," he says. "In the beginning, I felt the pigs were the gentle side of the game. They just can't help themselves!"

However, it's long been rumored that there was a circumstantial aspect that may have influenced the choice of the *Angry Birds* nemeses: an outbreak of swine flu. Iisalo is quick to play this down: "It was certainly something that was happening that you couldn't fail to notice, but I wouldn't say that it was a direct influence!"

**TOP AND RIGHT** *Pigs' habitation concept art • Jean-Michel Boesch*

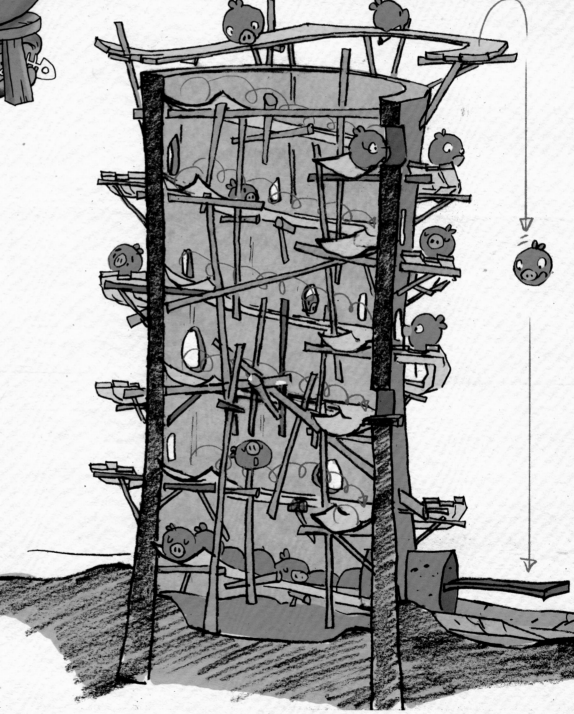

44

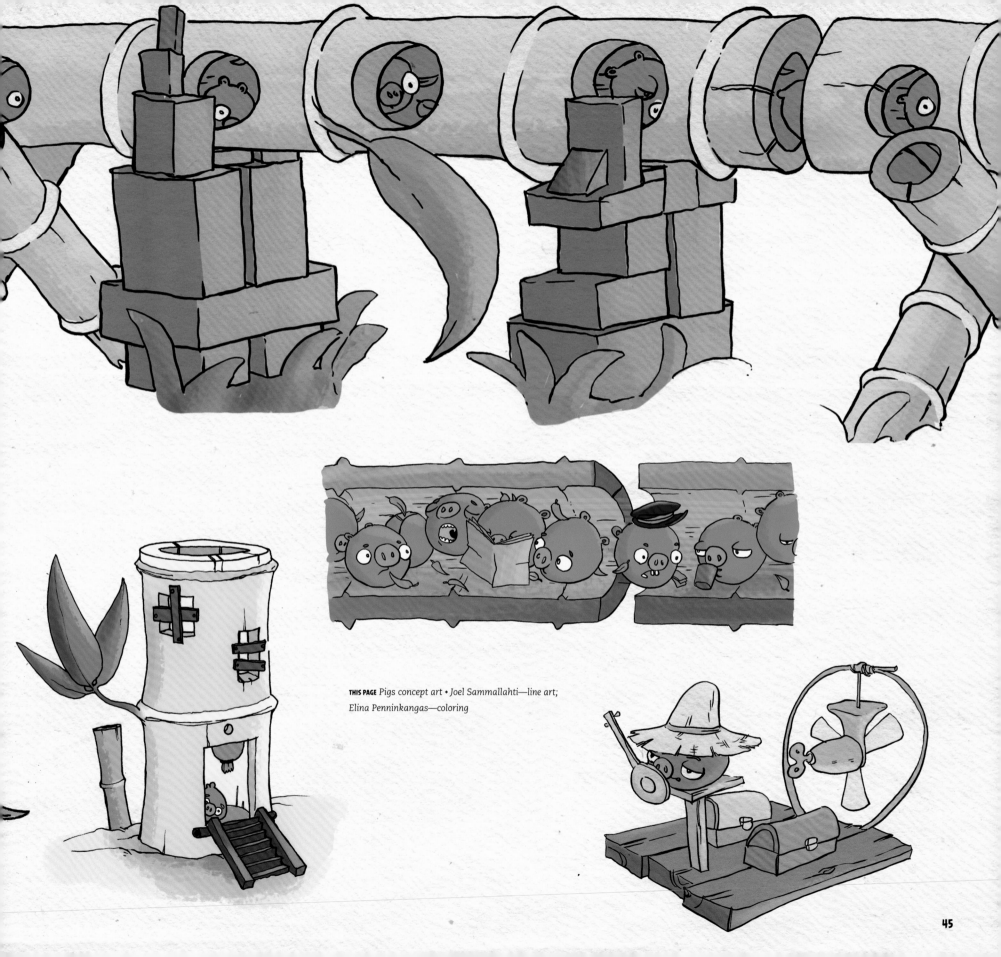

**THIS PAGE** Pigs concept art • Joel Sammallahti—line art; Elina Penninkangas—coloring

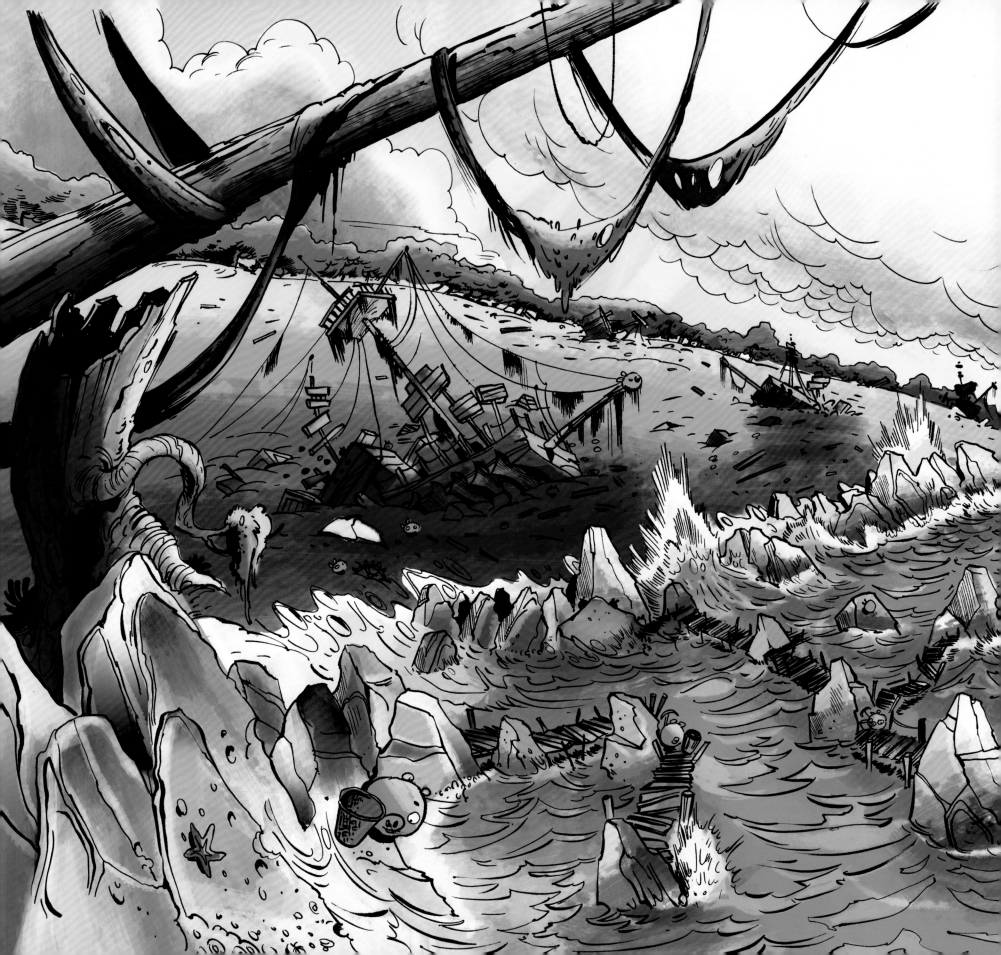

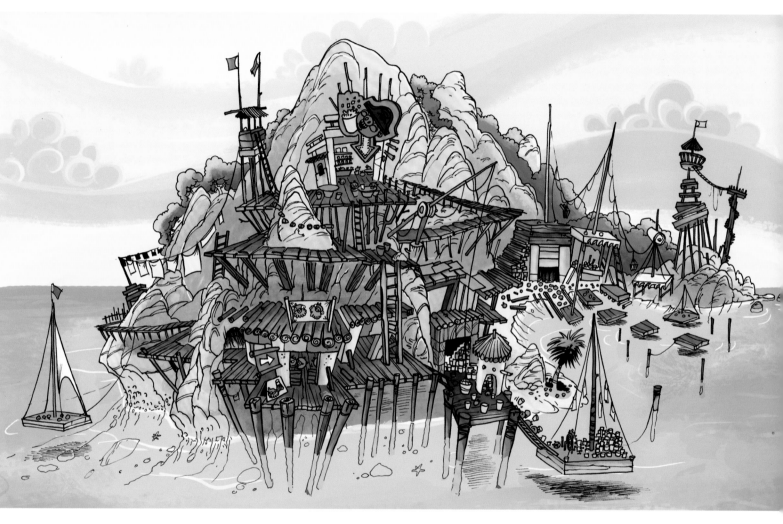

THESE PAGES *Piggy Island concept art •*
*Tuomas Gustafsson—line art;*
*Elina Penninkangas—coloring*

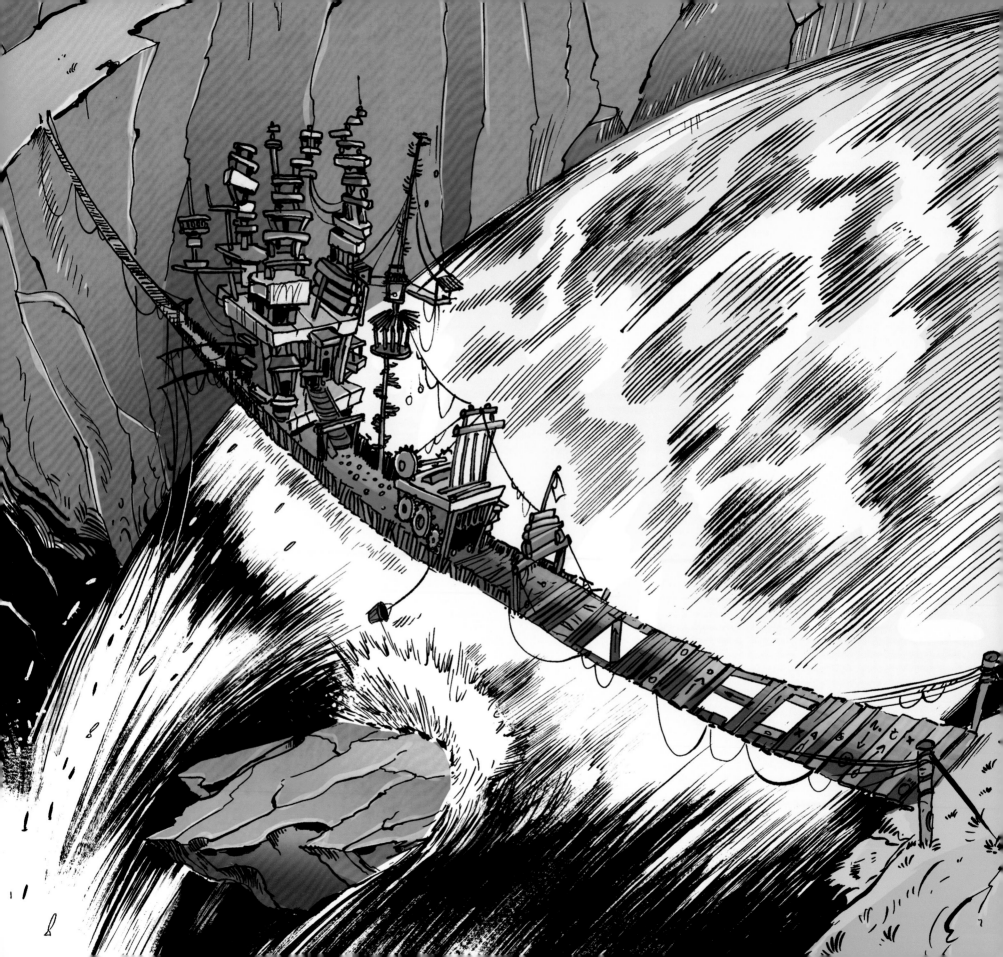

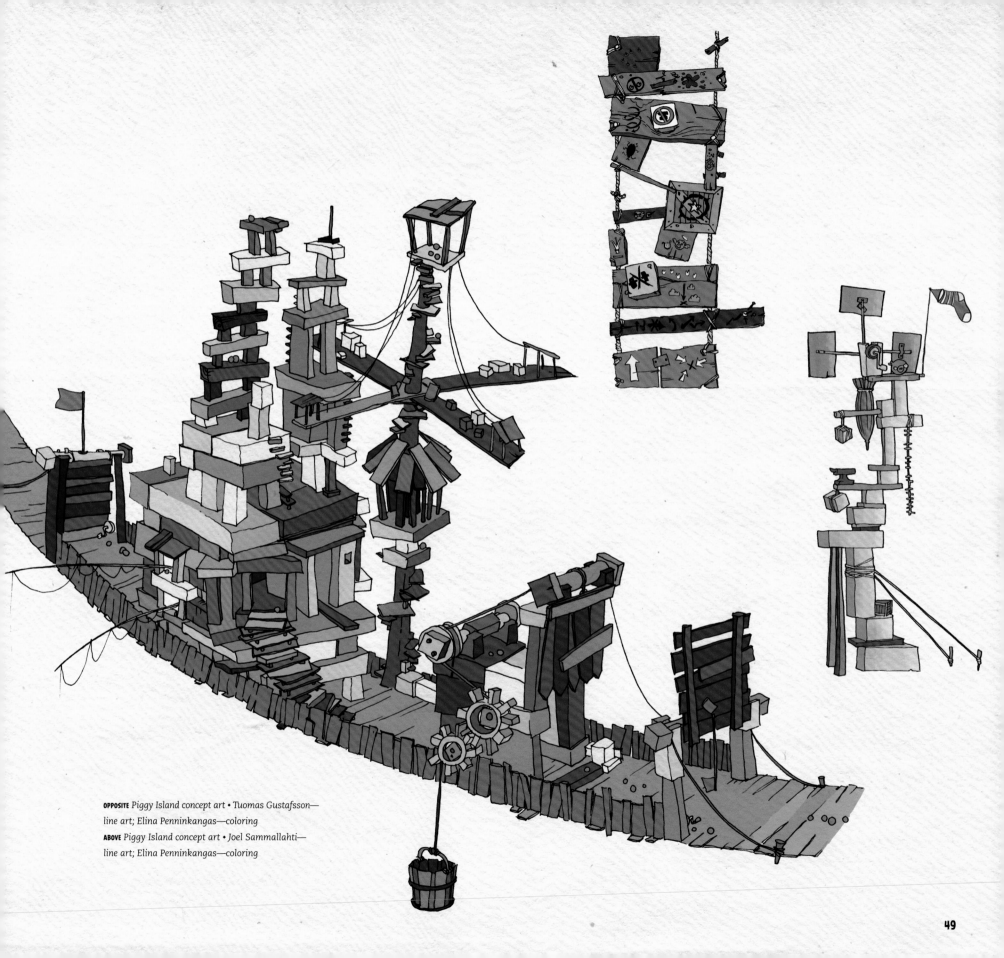

OPPOSITE *Piggy Island concept art • Tuomas Gustafsson—line art; Elina Penninkangas—coloring*
ABOVE *Piggy Island concept art • Joel Sammallahti—line art; Elina Penninkangas—coloring*

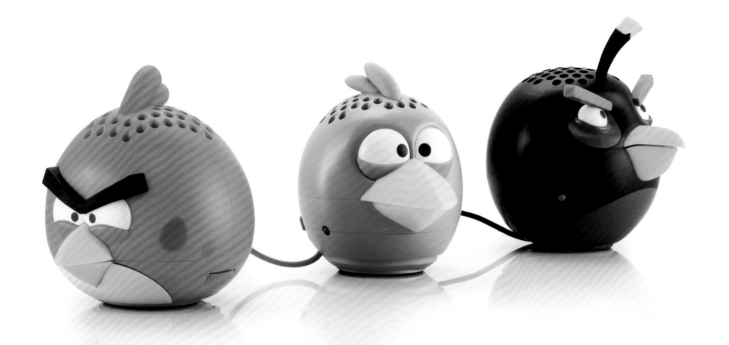

# MUSIC TO THROW BIRDS TO

"I aim to make music that I find interesting and to take a new approach to composing," says Salla Hakkola, the composer who is responsible for giving *Angry Birds* its distinct soundscape. An acclaimed harpist and folk singer in her native Finland, Hakkola—along with her brother Ilmari—are key figures in Rovio's Audio Department, providing title themes and incidental music for the various games and animations.

"When I started, the characters were still being developed," she recalls, "so there wasn't yet the opportunity to create themes for them. There wasn't an established Audio Department, so we produced everything from scratch." Hakkola did not have to work from a completely blank slate, however: "Ari Pulkkinen had composed the original theme for the first game, and my brother Ilmari and I took elements of that to develop the music for the wider universe. At that point, it also meant creating themes for the characters."

Full of energy and appealingly ramshackle, the iconic main theme for *Angry Birds* has a distinct lineage: "We were very influenced by Balkan folk music— very anarchistic, but with strong rhythm; a mass of sound—and we wanted to develop the music in that direction, but not make it sound directly like it—it had to be original *Angry Birds*."

Hakkola's work has provided the *Angry Birds* universe with an effective musical signature, despite the obvious restrictions. "With the animations, even though you don't get to create big themes because it's such a small timespan, you can still create a distinct feel," she says. "The aim is always to create fun and interesting music for all our products."

**THESE PAGES** *Official Angry Birds Gear4 stereo speakers (images courtesy of Rovio partner Disruptive Limited)*

— CHAPTER 3 —

# CELEBRATING

# Ham'o'Ween

**In October 2010,** Rovio released *Angry Birds Halloween*, the first sequel to their smash hit original. A special edition just for iPhones, the game was followed in December by *Angry Birds Seasons*, which launched on multiple platforms with 25 Christmas-themed levels, released one per day, in the style of an Advent calendar.

Over the next year, various seasonally themed updates were released, including Easter Eggs, Summer Pignic, and the cross-cultural Mooncake Festival, released in conjunction with the traditional Chinese mid-Autumn celebration. The following October, a second Halloween-themed update, titled Ham'o'Ween, made its debut, accompanied by the first appearance of a new character, Bubbles.

Significantly, Ham'o'Ween was trailed by a specially made five-minute animation, which would have a considerable impact on the evolving look of *Angry Birds*. Featuring a fresh new rendering of the familiar *Angry Birds* world that further expanded the scope of the characters' universe, it has since served as the design blueprint for the entire franchise.

According to Art Director Jean-Michel Boesch, who oversaw Ham'o'Ween as a Production Designer, the piece was initially designed to

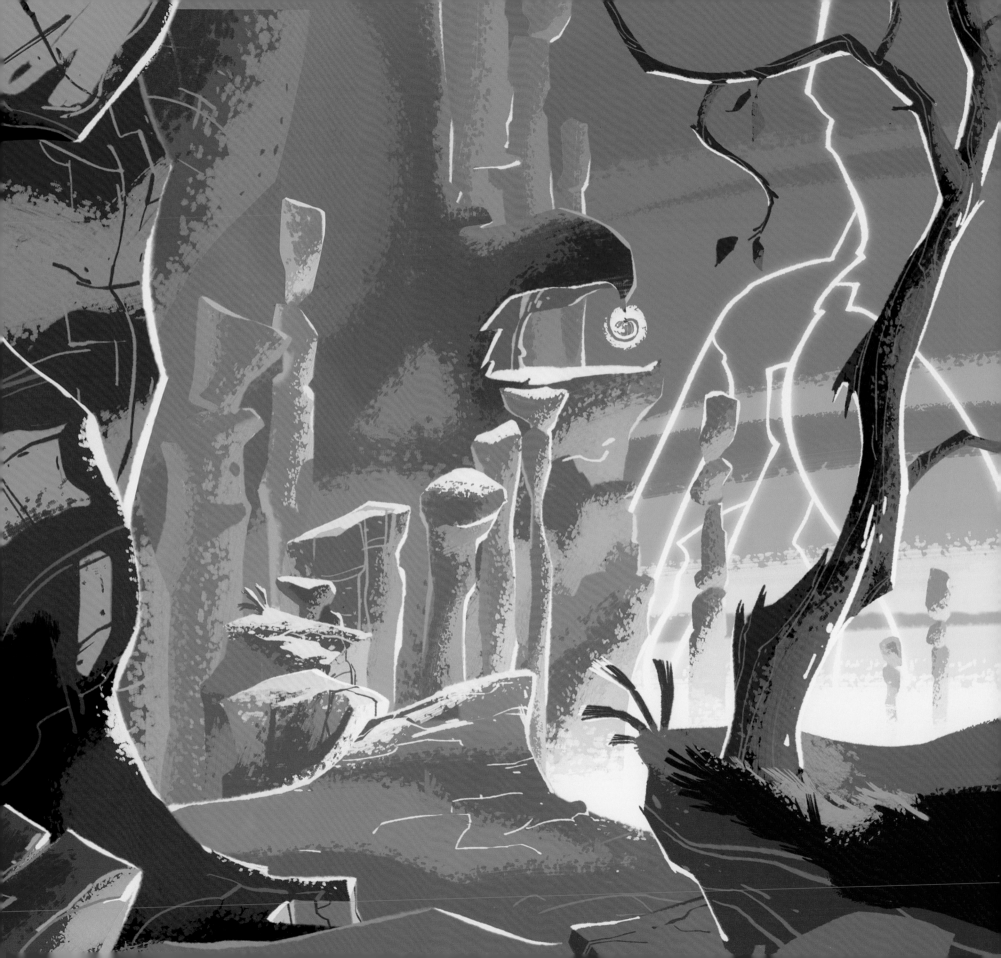

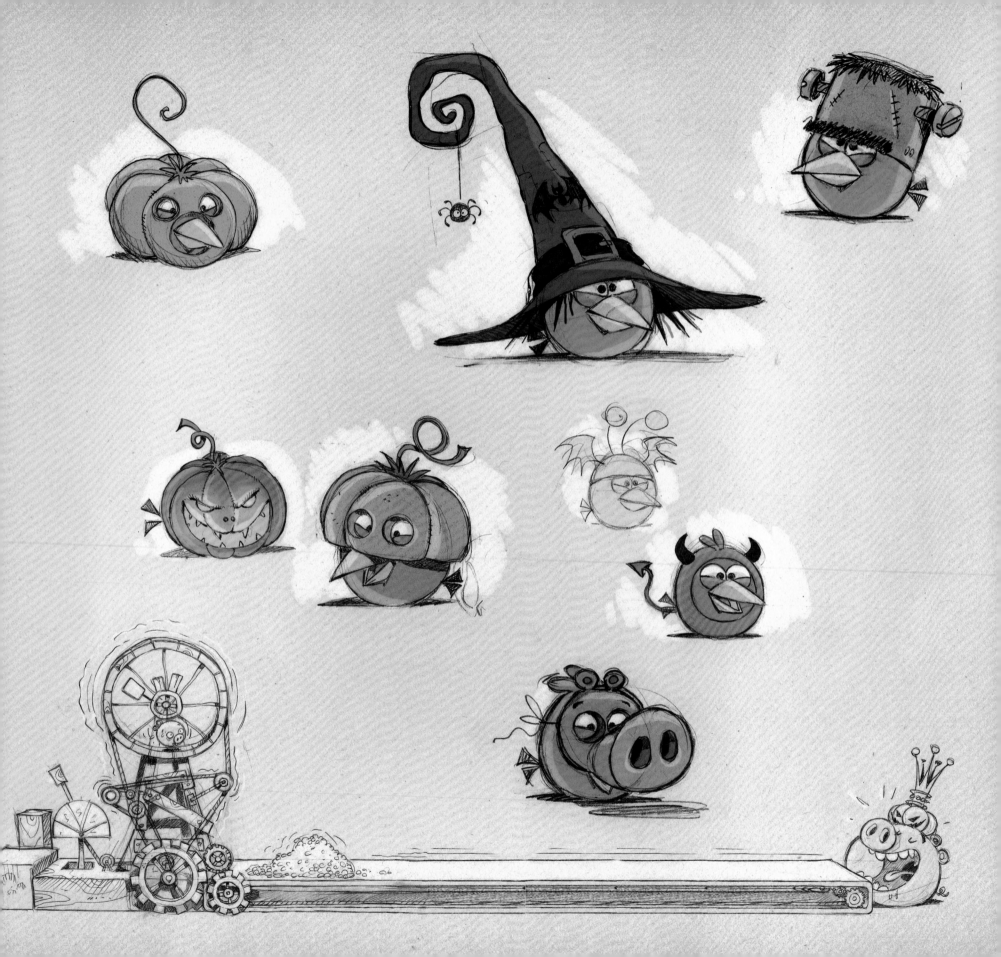

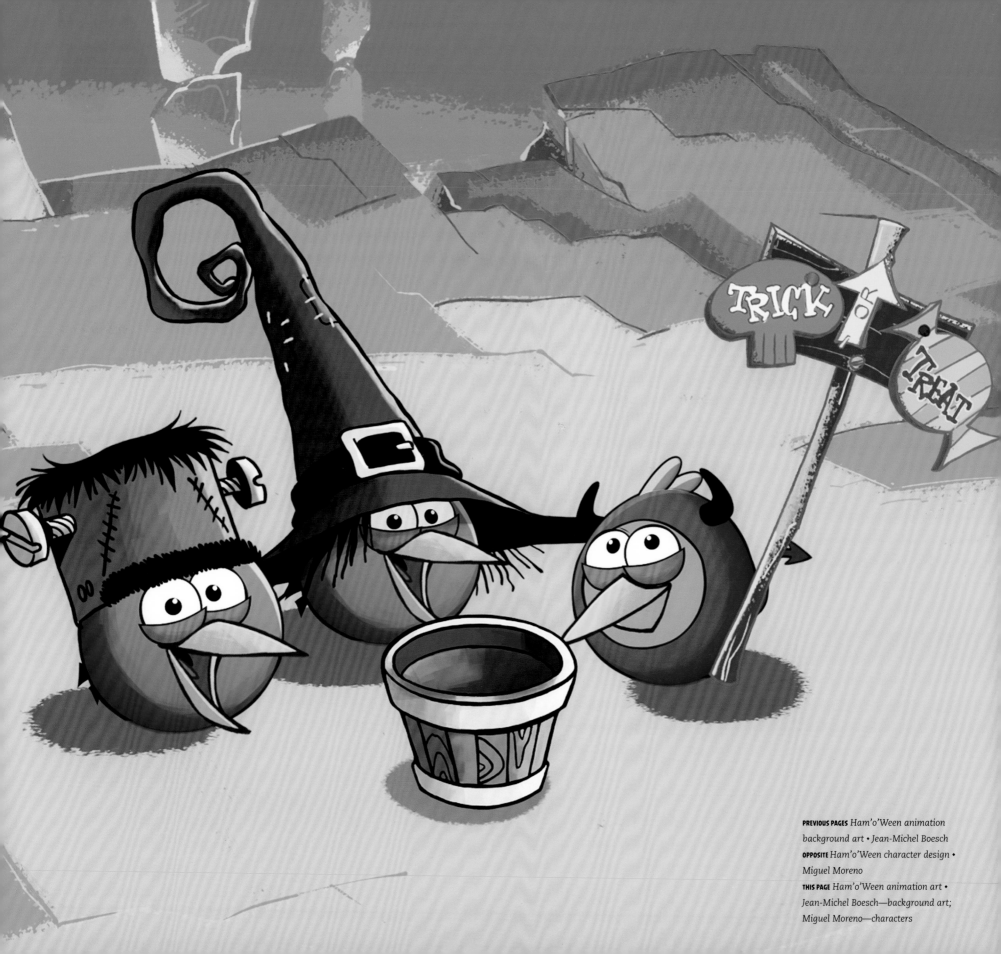

**PREVIOUS PAGES** *Ham'o'Ween animation background art* • Jean-Michel Boesch
**OPPOSITE** *Ham'o'Ween character design* • Miguel Moreno
**THIS PAGE** *Ham'o'Ween animation art* • Jean-Michel Boesch—background art; Miguel Moreno—characters

solely support future animation projects. "Ham'o'Ween was the first project I worked on and we needed to finish it within three weeks," he says. "So I had to rush to develop a base style, which was unlike that seen in the games. Later, though, it really influenced the games and the books. It was greatly liked within Rovio, so we pushed it further, and now it's being utilized for *Angry Birds Toons*. Before Ham'o'Ween, the animation studio Kombo [which Rovio has since acquired] had created a number of shorts for *Angry Birds*, but it was in a different style. This was the first time that we defined a specific style for the animations."

Boesch and his team were focused on accenting the established atmosphere of *Angry Birds*. "Our base design is primarily related to backgrounds and influencing the mood of any given story," he says. "We also try to avoid things being too round as, obviously, that's already expressed by the characters! We wanted to break with that and also create a contrast with the lighting. It does on occasion influence the tint of the characters because if the scene is set at night, for example, we won't use the normal shade of red for Red. We think very carefully about how the character will fit, so if we are using Red, we won't use too much red color in the background, otherwise he

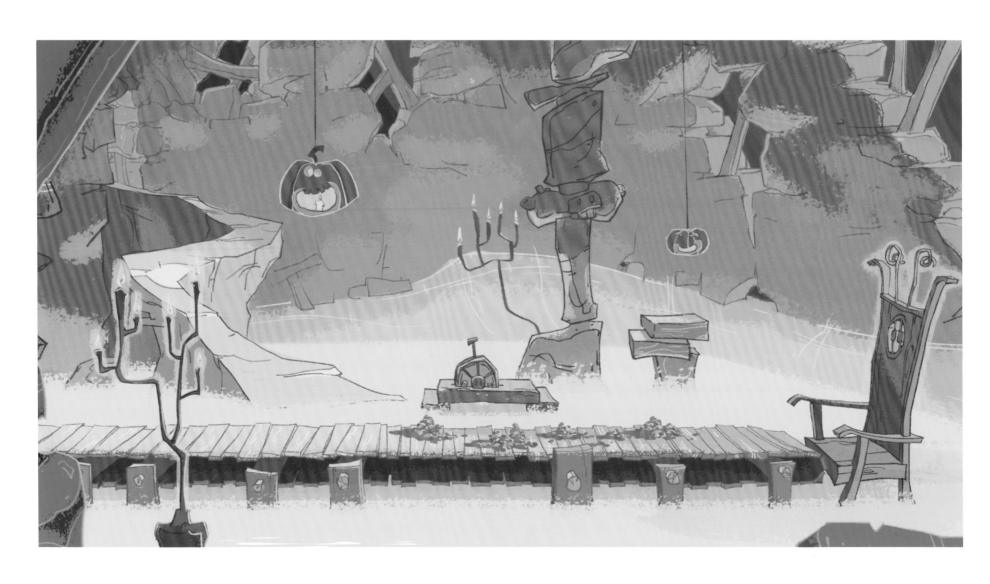

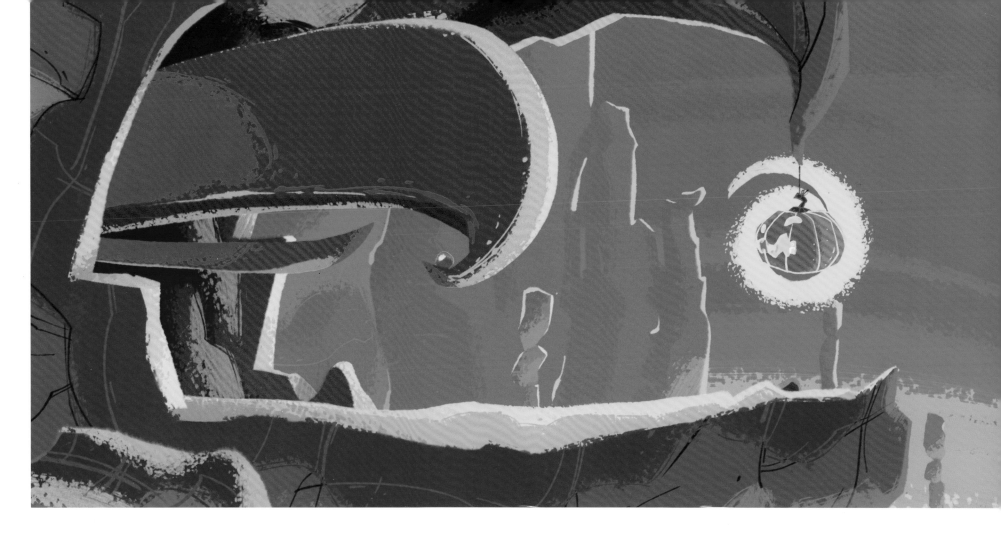

will just fade into it! Beyond that, we are trying to capture the theme of the story. With Ham'o'Ween it needed to be scary and weird, hence the very strong tone of green."

Color was, in fact, the anchor of Boesch's base design: "My focus with the new design was on the color, as it allowed for a faster and more streamlined process for everyone on the team. We were working with really strong color scripts. The style is very basic: We use Photoshop brush strokes to give texture and try to avoid gradient. We aimed for something basic but dynamic that reflects Rovio's way of doing things.

"Generally, we like to keep things as approachable as possible," Boesch continues. "For example,

the birds don't speak in the animation, but with dynamically written scripts we can convey many different emotions. The problems are straightforward—the birds are mad or jealous, etc.—and they react according to their personalities. We add more details to the world in just three minutes."

The Ham'o'Ween short was a stunning success, racking up in excess of thiry-five million views on YouTube and counting. "The animation brings so much more story to the characters," says Boesch. "The games are very fun, but the narrative is somewhat limited to the illustrations that appear between the levels. The animation is a way that we reach new fans while also maintaining the existing fanbase."

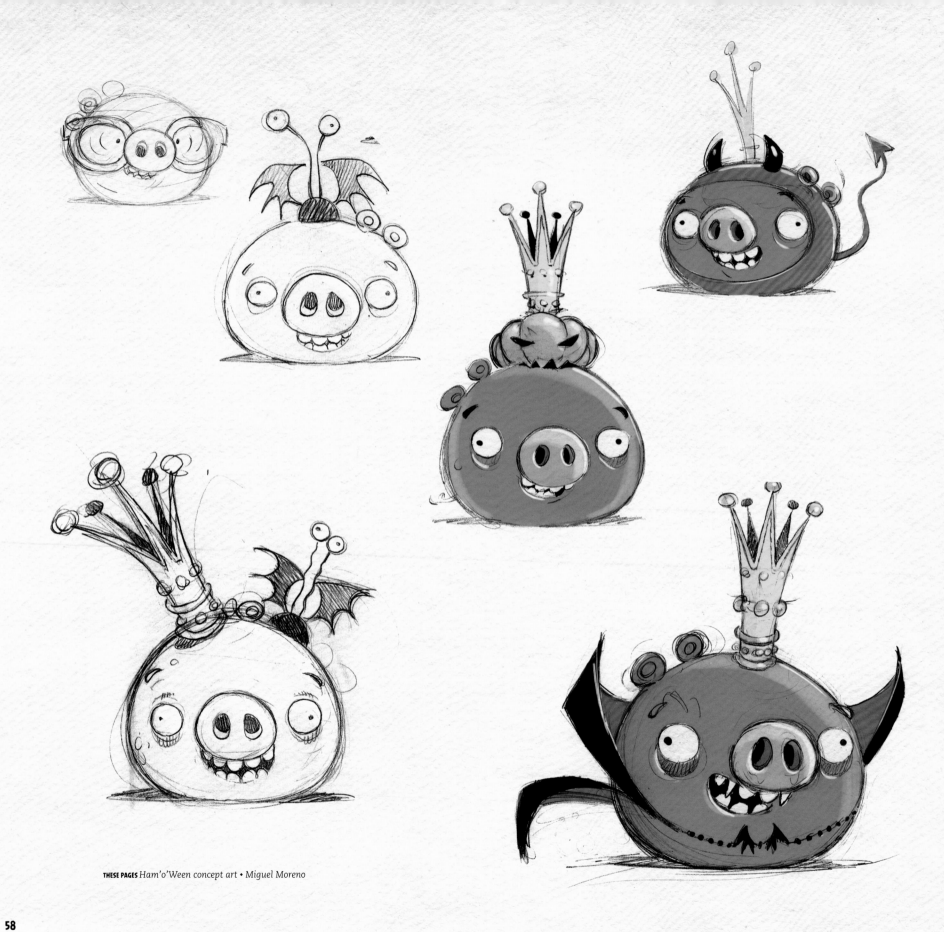

THESE PAGES *Ham'o'Ween concept art* • Miguel Moreno

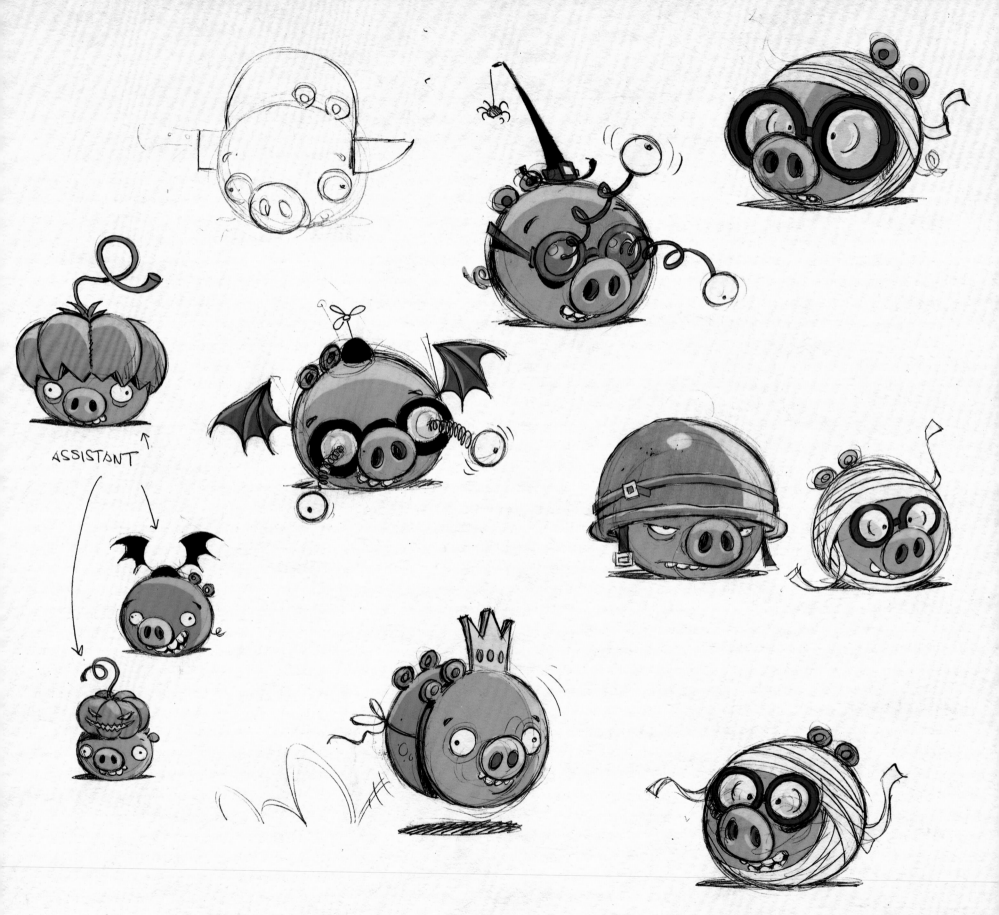

ASSISTANT

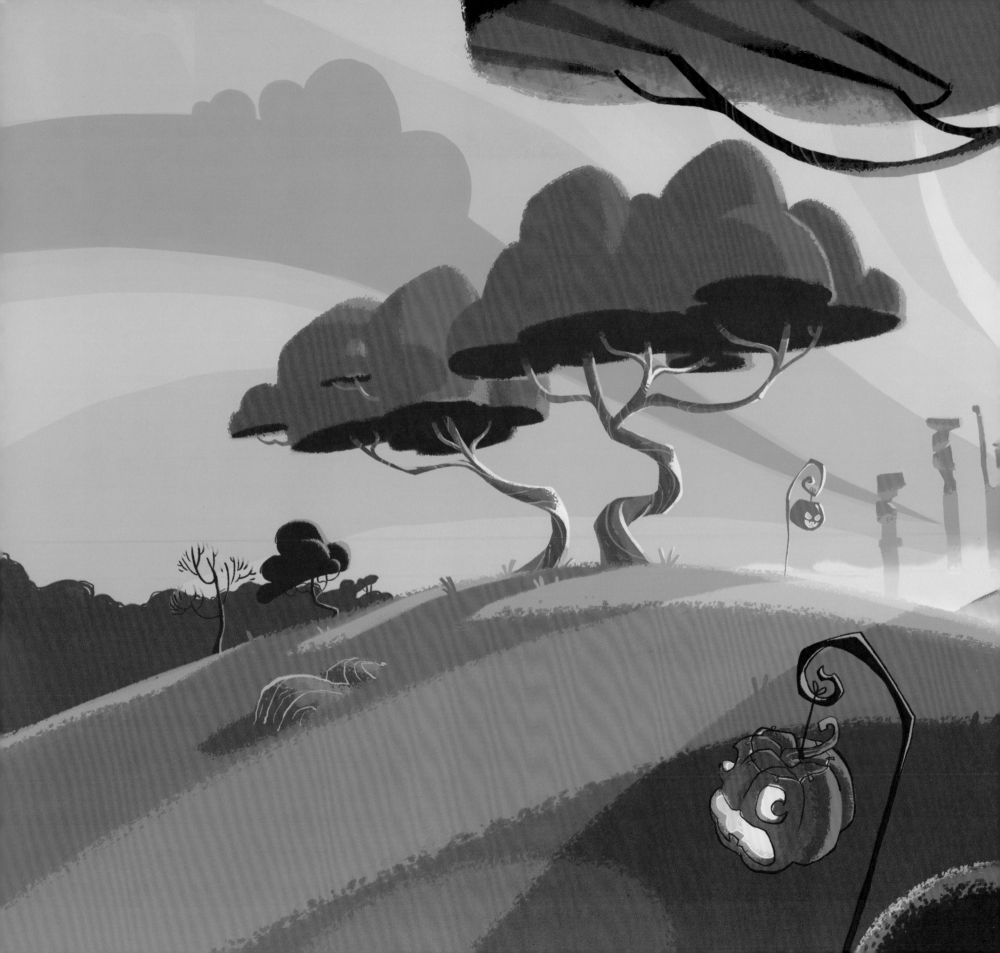

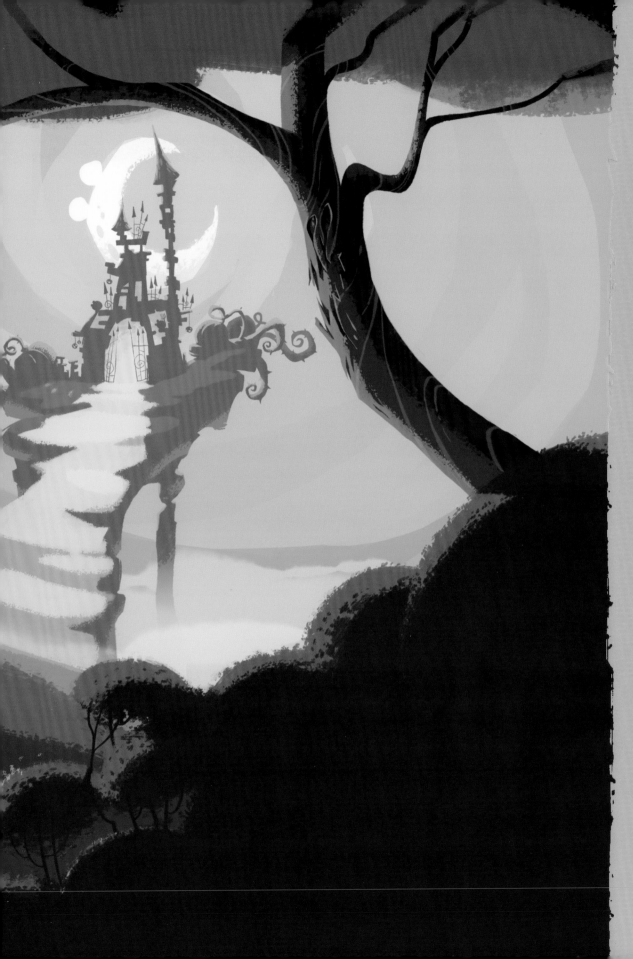

# MEET THE *Flock*

## JEAN-MICHEL BOESCH

"I OVERSEE THE LOOK AND FEEL of the animation produced for *Angry Birds*," says Art Director Jean-Michel Boesch of his role at Rovio. "I am focused on the design style. My job is really about keeping everything in the same direction. We have so many projects going on at the same time."

Prior to joining Rovio, Boesch had no exposure to the games, but he sees this as an attribute rather than a hindrance: "I think that really helps me bring something new in terms of design. Otherwise, I imagine I would be too concerned about how far I could go from the existing design. When I started, my brief was to do something new."

Rovio's stunning success with *Angry Birds* led to an increased focus on ensuring there was overall cohesion between the brand's various elements, both in style and content. "Rovio couldn't have guessed how successful the games would be," Boesch explains. "In the beginning, there wasn't complete consistency in the world of *Angry Birds*; the Game Department was focusing more on the design of the level environments. Lauri Konttori's team made big strides in creating the world, and that's what we have drawn from. What we introduce in the animation is already in the game. But through the animations we can develop our characters even further and give them more depth."

As a result, Boesch's work is anchored on an effort "to maintain the moods of the animation and games and keep them consistent, so every update is purposely designed to look fresh and intriguing. Working on *Angry Birds* is a big challenge, and it's been that way from the very start."

For Boesch, Rovio's constant interaction with fans provides him with a highly effective sounding board for his work and that of his colleagues: "I often check to see how our videos are received on YouTube, and whether people have found it interesting or not. The comments from fans are very valuable to us."

**LEFT** *Ham'o'Ween animation art • Antti Kemppainen*     61

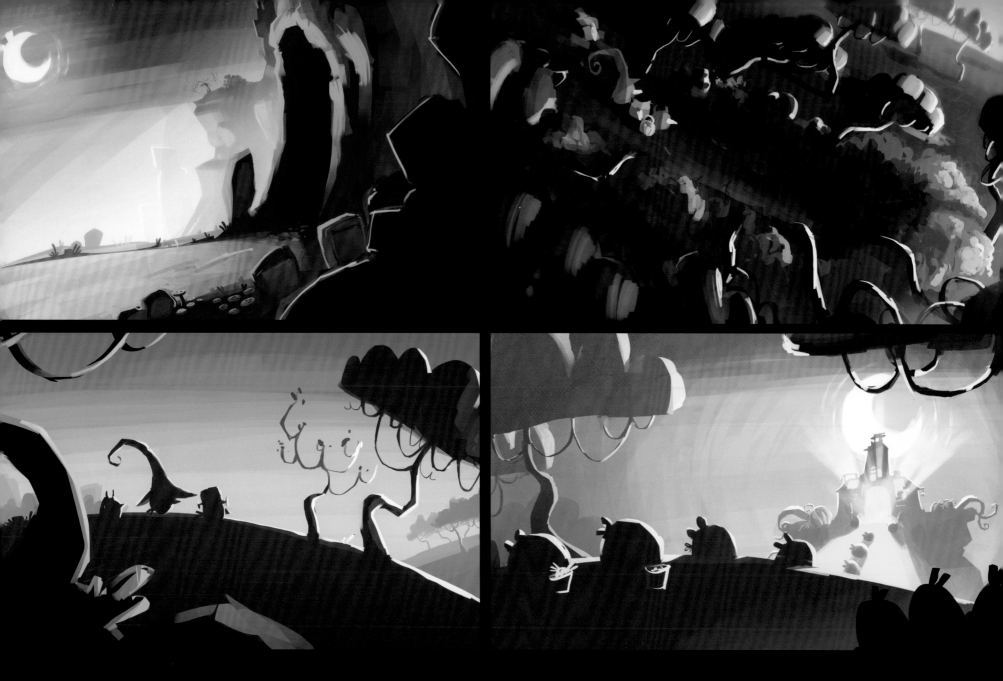

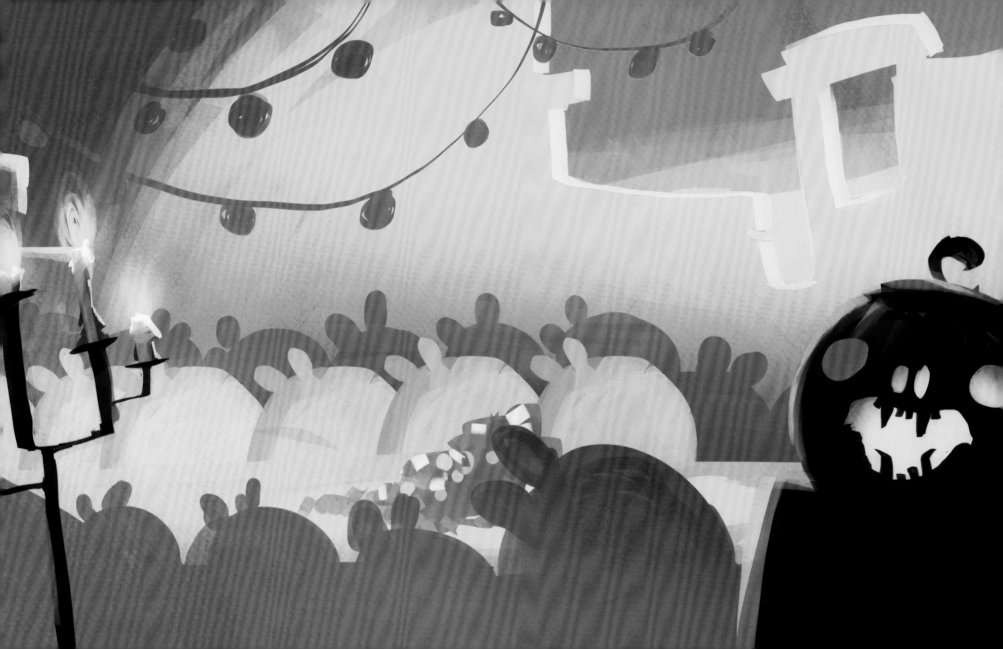

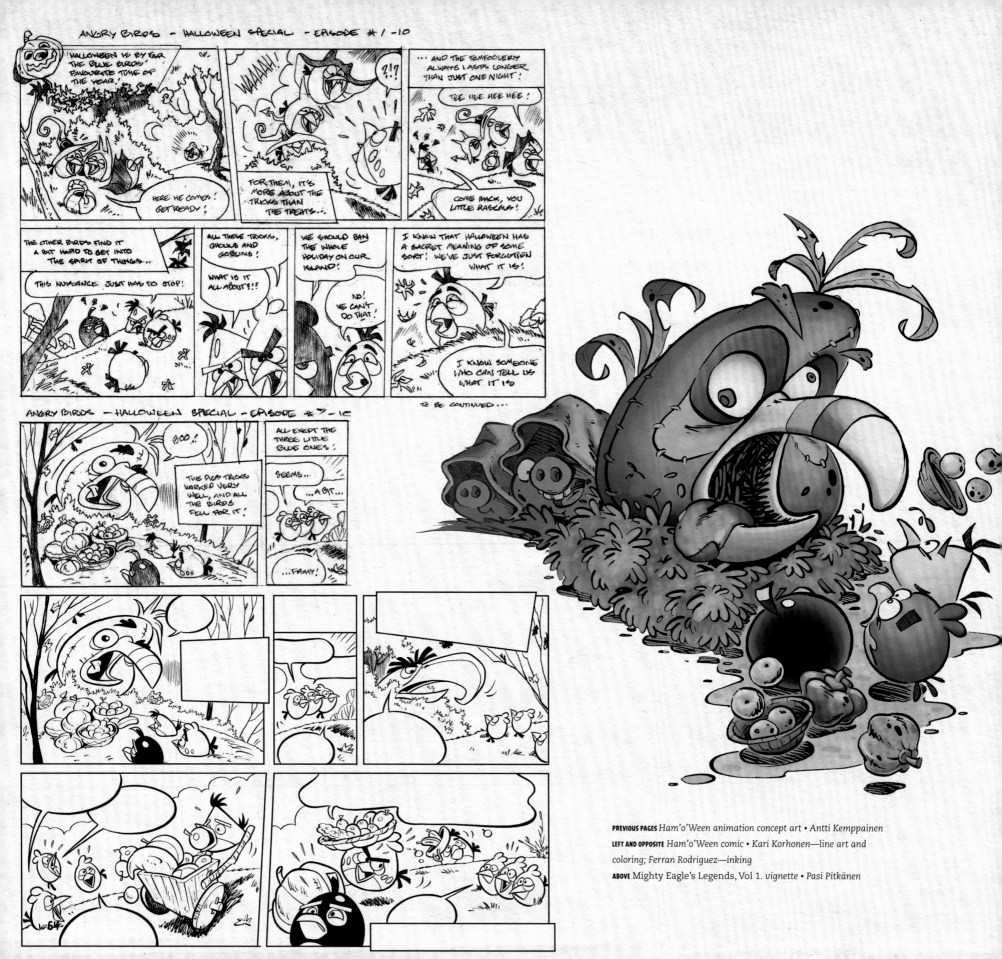

**PREVIOUS PAGES** *Ham'o'Ween animation concept art • Antti Kemppainen*
**LEFT AND OPPOSITE** *Ham'o'Ween comic • Kari Korhonen—line art and coloring; Ferran Rodriguez—inking*
**ABOVE** *Mighty Eagle's Legends, Vol 1. vignette • Pasi Pitkänen*

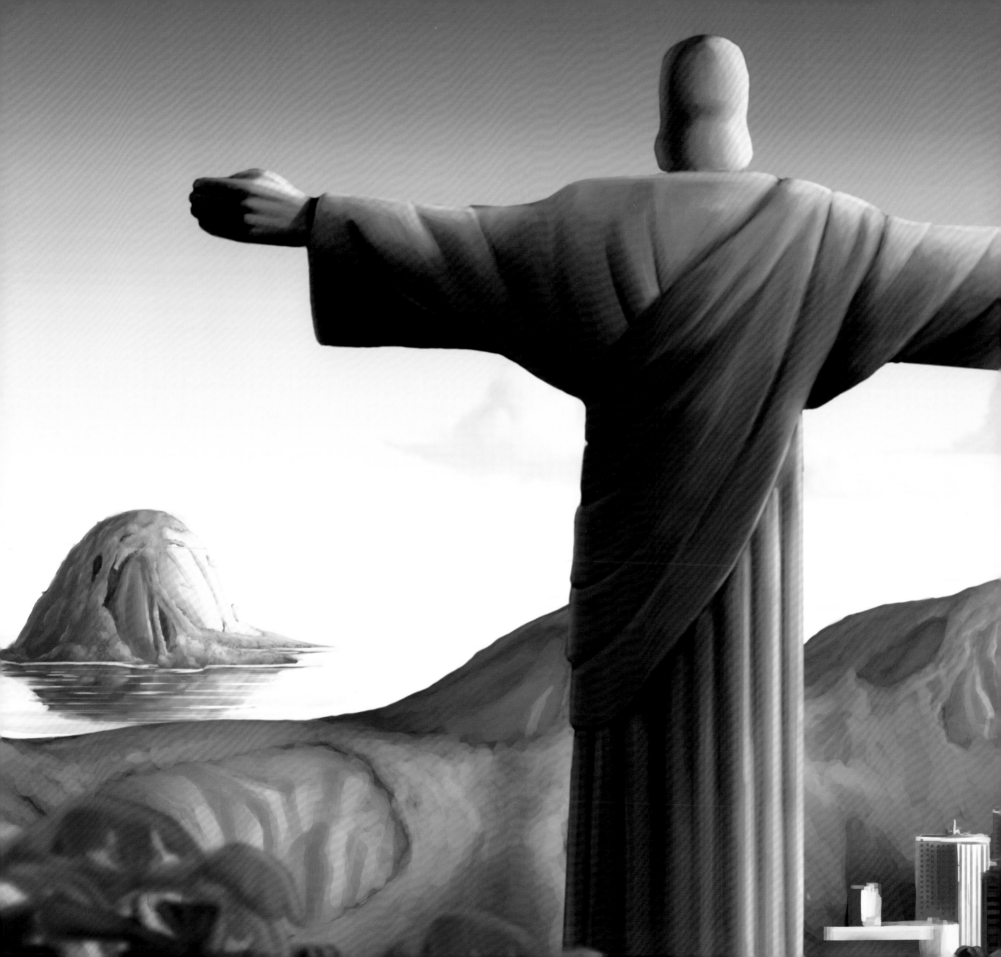

# MAYHEM IN THE MARVELOUS CITY WITH

**RELEASED IN MARCH 2011,** the third *Angry Birds* game, *Angry Birds Rio*, marked an added boost to Rovio's skyrocketing success, allowing the company to expand on its already considerable success in a key territory: America. Teaming up with Twentieth Century Fox, Rovio released the game in conjunction with the Hollywood studio's animated movie *Rio*. The idea was to blend the two worlds and styles in an organic way that made sense for both franchises.

"I was working at Twentieth Century Fox and was responsible for taking Fox's movie and television properties to mobile devices," recalls Andrew Stalbow, now Rovio's Executive Vice President, Strategic Partnerships. "We had a new film called *Rio* from Blue Sky Studios, the award-winning creators of the *Ice Age* movies. We were thinking about potential partners to create a great game. At the same time, *Angry Birds* was hitting the App Store and doing really well. We called Rovio—there were only about twenty people working there at the time—and offered them the opportunity to have some Hollywood-level marketing for their brand."

*Angry Birds Rio* showcased some major differences to prior *Angry Birds* games. In the game, the Angry Birds flock have been kidnapped from their natural habitat on Piggy Island and taken to Rio de Janeiro, Brazil, where they begin to interact

**THESE PAGES** Angry Birds Rio concept art • Sami Timonen

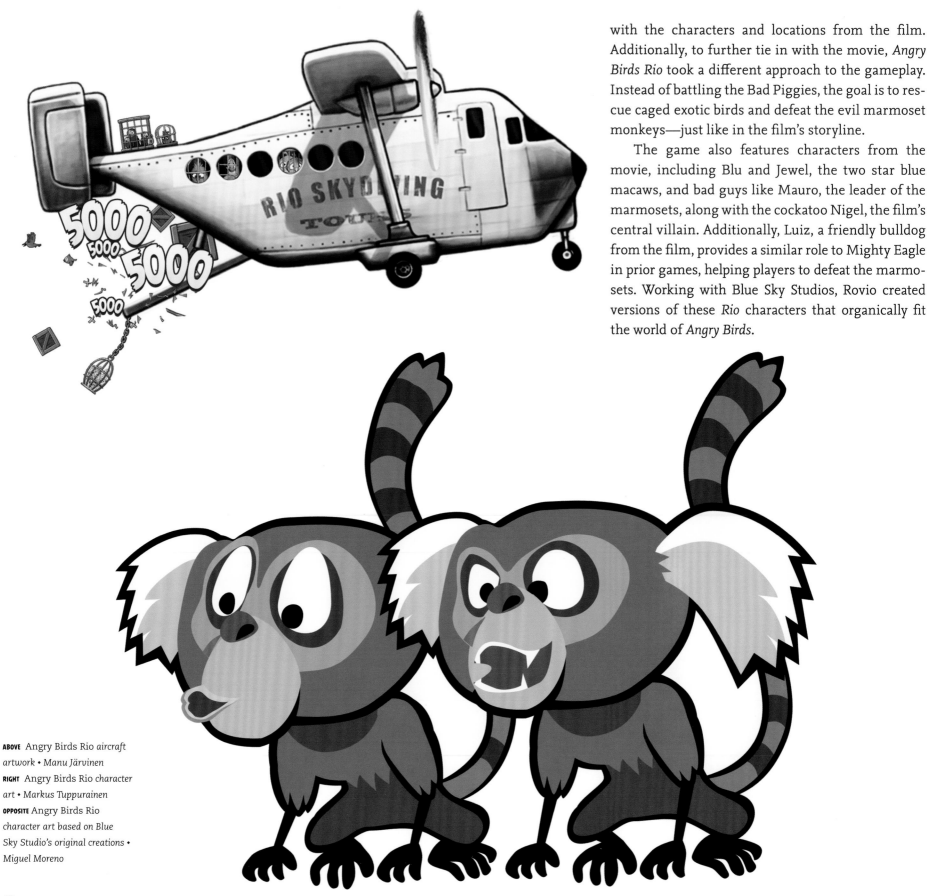

with the characters and locations from the film. Additionally, to further tie in with the movie, *Angry Birds Rio* took a different approach to the gameplay. Instead of battling the Bad Piggies, the goal is to rescue caged exotic birds and defeat the evil marmoset monkeys—just like in the film's storyline.

The game also features characters from the movie, including Blu and Jewel, the two star blue macaws, and bad guys like Mauro, the leader of the marmosets, along with the cockatoo Nigel, the film's central villain. Additionally, Luiz, a friendly bulldog from the film, provides a similar role to Mighty Eagle in prior games, helping players to defeat the marmosets. Working with Blue Sky Studios, Rovio created versions of these *Rio* characters that organically fit the world of *Angry Birds*.

**ABOVE** Angry Birds Rio *aircraft artwork • Manu Järvinen*
**RIGHT** Angry Birds Rio *character art • Markus Tuppurainen*
**OPPOSITE** Angry Birds Rio *character art based on Blue Sky Studio's original creations • Miguel Moreno*

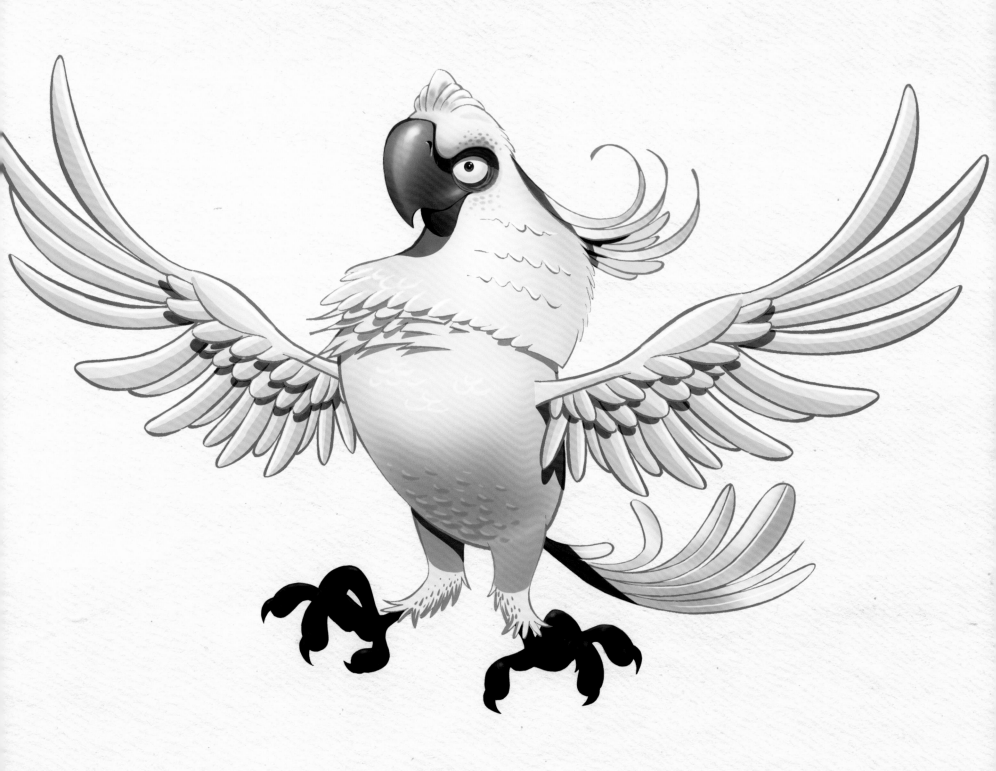

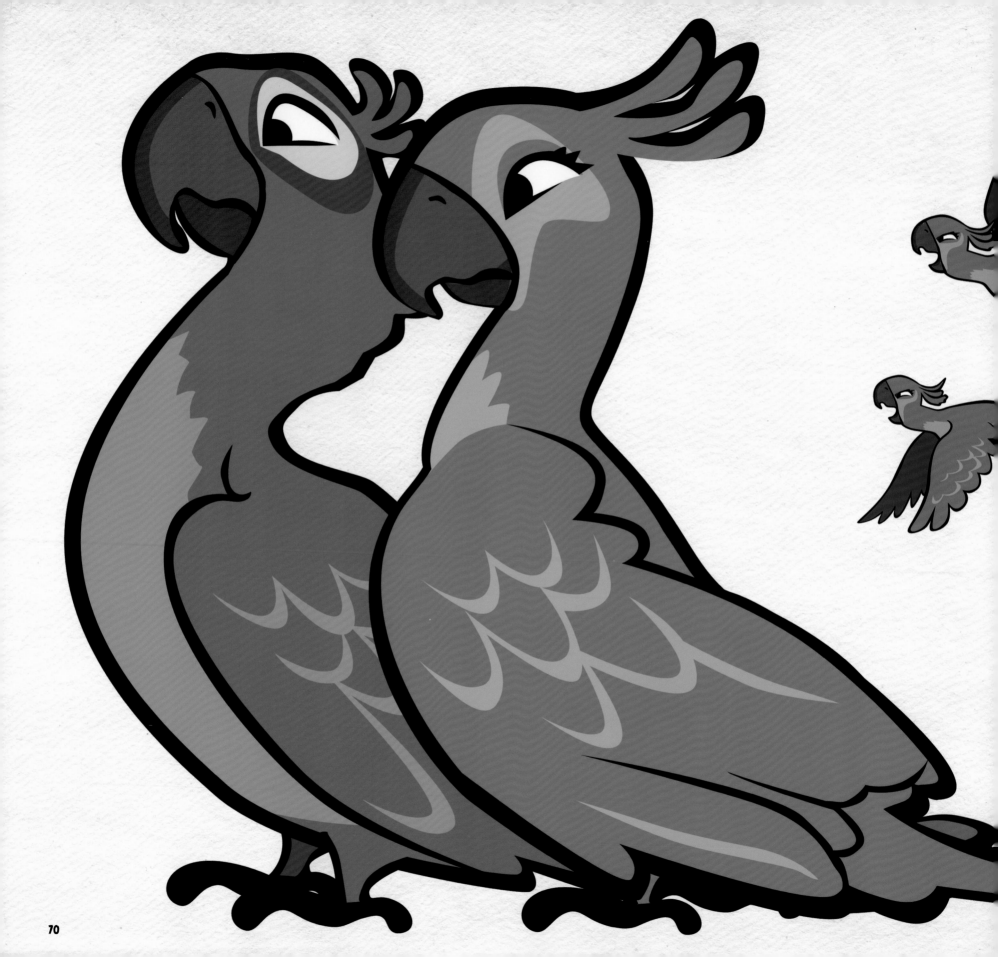

Jaakko Iisalo, the Lead Designer of the game alongside Markus Tuppurainen, remains proud of the game's contribution to the burgeoning franchise: "The whole goal was to make not just a movie-based game, but also something distinct, and I think we managed to do that quite well."

"This was the first time that a mobile game was marketed like a blockbuster movie is marketed," Peter Vesterbacka affirms. "We always wanted people to expect the unexpected, and I think that no one really saw this coming." The collaboration was a stunning success, resulting in the game achieving twenty million downloads via Apple's App Store within just twenty days of release. Plus, the game's success helped send the *Rio* movie to number one at the US box office. "The trailer for *Angry Birds Rio* was watched millions and millions of times—fans really embraced the game!" Stalbow says.

*Angry Birds Rio* won the title of Best Mobile Game at the Golden Joystick Awards 2011 in London as well as the iLounge 2011 Readers' Choice Award. Crucially, it secured the *Angry Birds* universe with a firm foothold in the all-important US market, providing a considerable expansion of the brand's audience. "It was a massive deal for us in the sense of visibility," says Ville Heijari, Senior Vice President of Brand Marketing at Rovio. "*Angry Birds Rio* also took us into the more storytelling-oriented direction that we will want to pursue with future *Angry Birds* titles."

"The *Rio* collaboration propelled Rovio and *Angry Birds* into the mainstream entertainment market and gave them a taste of marketing support they perhaps wouldn't have otherwise found, despite their huge success on digital platforms," Stalbow says. "It established their mainstream credibility and showed the world that Hollywood acknowledged the power of the smartphone, as well as *Angry Birds* as a brand. And it was all achieved totally organically."

Above all, Mikael Hed notes, *Rio* provided the catalyst for *Angry Birds* to become a truly international brand: "We always felt that *Angry Birds Rio* was a brilliant way to get visibility for the brand, and to build a huge audience for it. This was the first step."

**THESE PAGES** Angry Birds Rio *character art based on Blue Sky Studio's original creations • Markus Tuppurainen*

# MEET THE *Flock*

## OSSI PIRKONEN

"**I am Senior Graphic Designer** for the Consumer Products Department," explains Ossi Pirkonen of his role at Rovio. Given that *Angry Birds* has licensed tens of thousands of products in less than two years, it's clearly a job of massive scope for the whole Consumer Products Department.

"We want to ensure that we have high-quality products with excellent partners," Pirkonen says. And this vast array of products shows no sign of slowing down: "*Angry Birds* is growing so rapidly that it is penetrating so many different categories. There are all kinds of products.

"I have a character-design background and, for me, the reason *Angry Birds* is so successful is because the characters are very relatable. There is an unexplainable and undeniable charm to them.

"The success has brought a wide variety of global partners to Rovio," adds Pirkonen. "The fact that there are so many large brands who are approaching Rovio with a desire to collaborate says a great deal. But we also work with many Finnish companies and enter the international markets together."

# AN ADDICTION TO
# READING

As *ANGRY BIRDS HAS EXPANDED* beyond the games at a furious pace, each new department of the company has been committed to telling the story of the characters and expanding the mythology, particularly so in the case of Rovio's Publishing Department, established in 2011.

"The one motivating factor for us in publishing books is that we wanted to be in control of telling the story," Mikael Hed explains. "We did not want to have an external partner writing our stories for us. The development of the franchise is so important to us that we wanted to commit to telling the stories by ourselves."

This is echoed by Sanna Lukander, Vice President of Rovio's Books and Learning Department. "People already know our characters and love them, but they might not know anything about them or their world," she says. "Publishing allows us to share that story. The *Angry Birds* story that most people know is just a little glimpse. The fans have been actively communicating with us about this, so we know there is a hunger to find out more."

The genesis of Rovio's entry into publishing ultimately came from Mikael Hed's experiences during his three-year hiatus from the company between 2006 and 2009. "When I was gone from Rovio, I wanted to do something in the entertainment industry and had very limited finances, so I thought the one thing I could do is comics," he recalls. "I had a little book publishing business and one of the things I learned, and which I

**THESE PAGES** Bad Piggies' Egg Recipes
*cookbook artwork • Pasi Pitkänen*

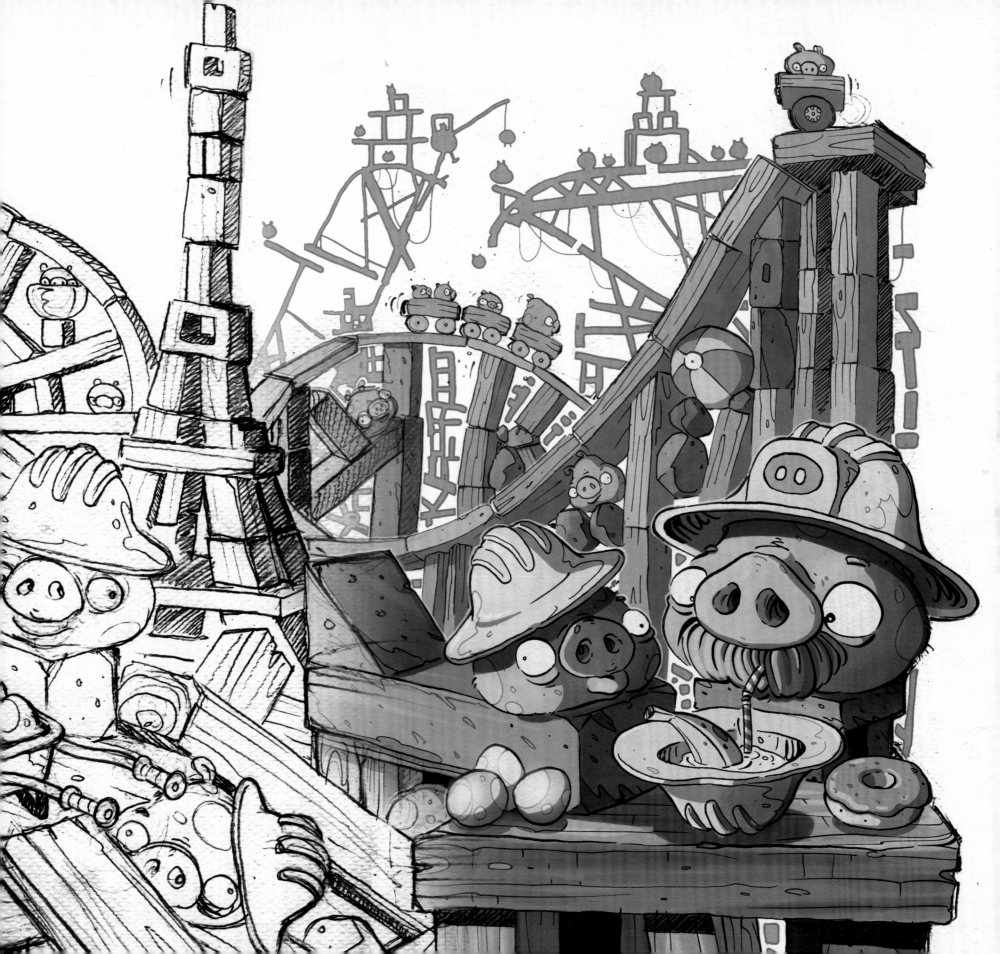

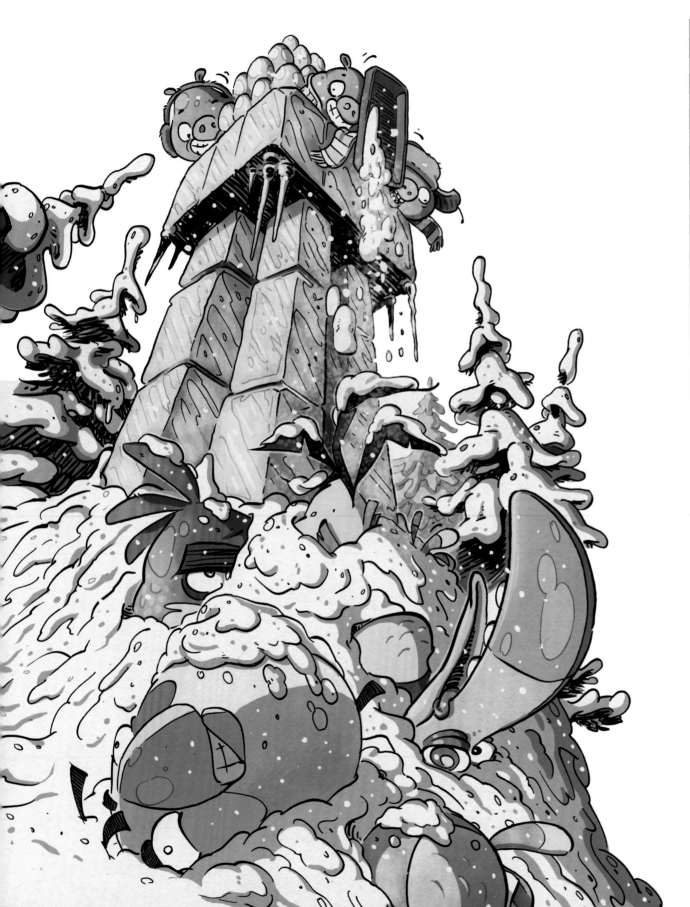

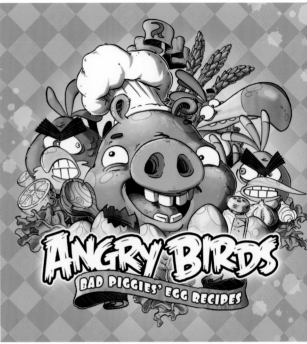

**THESE PAGES** Bad Piggies' Egg Recipes *cookbook artwork • Pasi Pitkänen*

brought back to Rovio, was that when we design a game, let's do something that, if it works well, can be used in a number of other media."

With *Angry Birds* working phenomenally well, Rovio enthusiastically embraced the potential to produce a large array of high-quality books, also branching into the comic book arena that Hed was already familiar with. Indeed, it was comics and books that allowed for a specific development in the characters. "We always wanted to do comics, which I felt were a good way of giving the characters a voice," Hed explains. "In our games and animations, the birds don't speak, but in the comics and literature they can. Also, we can extend the *Angry Birds* universe considerably."

The department's initial releases had a specific aim, according to Lukander: "The first books brought together families or highlighted hobbies in the home, placing the fans with the characters they know and love. Something people of all ages could do. It was a funny way to start a publishing company—the *Bad Piggies' Egg Recipes* cookbook [which earned a Gourmand award for the Best First Cookbook in the World category 2011]—but it certainly worked for us."

Moving in this direction, Lukander and her team made a crucial realization. "We continued developing and creating our publishing list, but during that phase, we realized that we could utilize the brand for 'Edutainment' purposes," she says. "The Rovio management were very interested in this, and from there we developed the Rovio learning program."

Rovio's dedication to promoting learning has become a key aspect of the company's reputation, which, according to Lukander, neatly ties in to one of *Angry Birds'* core attributes. "Our learning initiatives may seem surprising, but, after thinking about it for a few seconds, it seems obvious," she says. "Finland has a good reputation in education, so why not use a brand like this for a good

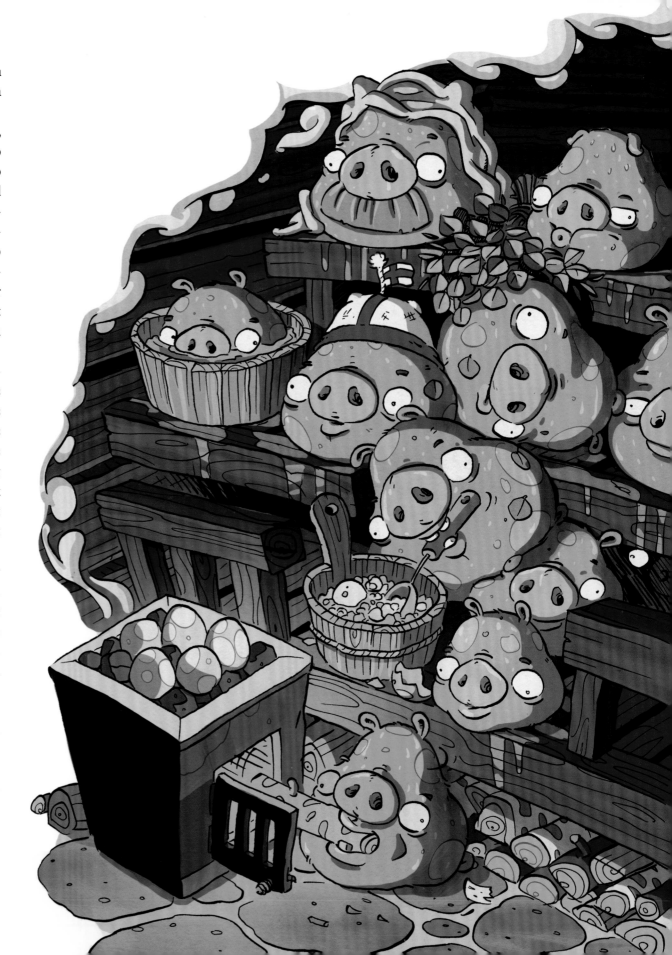

cause? Learning is fun when it becomes a healthy addiction. People get so worried about kids playing games and sitting at their computers, but it's so obvious that kids are motivated by these characters and their world, so why not use it for creating a positive attitude toward learning?"

Hed wholeheartedly agrees, noting the importance of using Rovio's vast success for altruistic ends that benefit society. "We have a brand that is very popular and profitable, so it occurred to us that we actually have an opportunity to make a difference," he says. "We can combine what we do with something good: teaching kids and advancing learning by leveraging the brand. It's the right thing to do, rather than the most profitable."

As Hed affirms, Rovio's publishing output allows for a greater artistic freedom: "On the books side, we have a lot more liberty for the artist to let their own style show through. In the games, on the other hand, we need a very uniform view of the characters and the world. The same is true of the animation, where the style is set once and we stick to that. In comics and books we can have individual illustrators who can bring their own style to it. I love this, because there are many wonderful examples of beautiful artwork that have emerged from this approach. It's yet another way of delighting the fans."

Ultimately, Rovio's books—whether for entertainment or education—give the brand a pleasing depth. "Our publishing ventures give the fans the opportunity to discover elements of the *Angry Birds* universe that they cannot receive from the other areas of the brand," Lukander says. "Even if they are familiar with the games, they can discover new things about the characters and the world that make the games an even richer experience. All the departments at Rovio are doing the same thing from their perspective: sharing the story."

# MEET THE *Flock*

# SANNA LUKANDER

"**THE SIMPLICITY OF *ANGRY BIRDS*** was what got to me originally," recalls Sanna Lukander, Vice President of Rovio's Books and Learning Department. "I saw that there are these pigs who are trying to steal the eggs and the birds are angry about it. That's the essence of the story and it further entices the imagination. We have to start telling the story."

Joining Rovio in mid-2011, Lukander soon had a key realization about the burgeoning *Angry Birds* universe: "*Angry Birds* has endless possibilities, providing that we do smart things with it. We can't make too many mistakes, but we can make some. There's so much potential there, being a transmedia company."

The promotion of learning has turned out to be one of Rovio's best-received ventures, demonstrating an altruistic side that will always pay dividends. "Learning is fun when you are appreciated for who you are; learning is fun when the environment is safe; learning is fun when the environment is inspiring," says Lukander. "These are things we keep in mind when we produce different projects and share them with the partners we work with. Everyone should be able to understand what we mean by 'learning is fun.'"

**LEFT** Bad Piggies' Best Egg Recipes *iPad application* artwork • Jackie Alpers

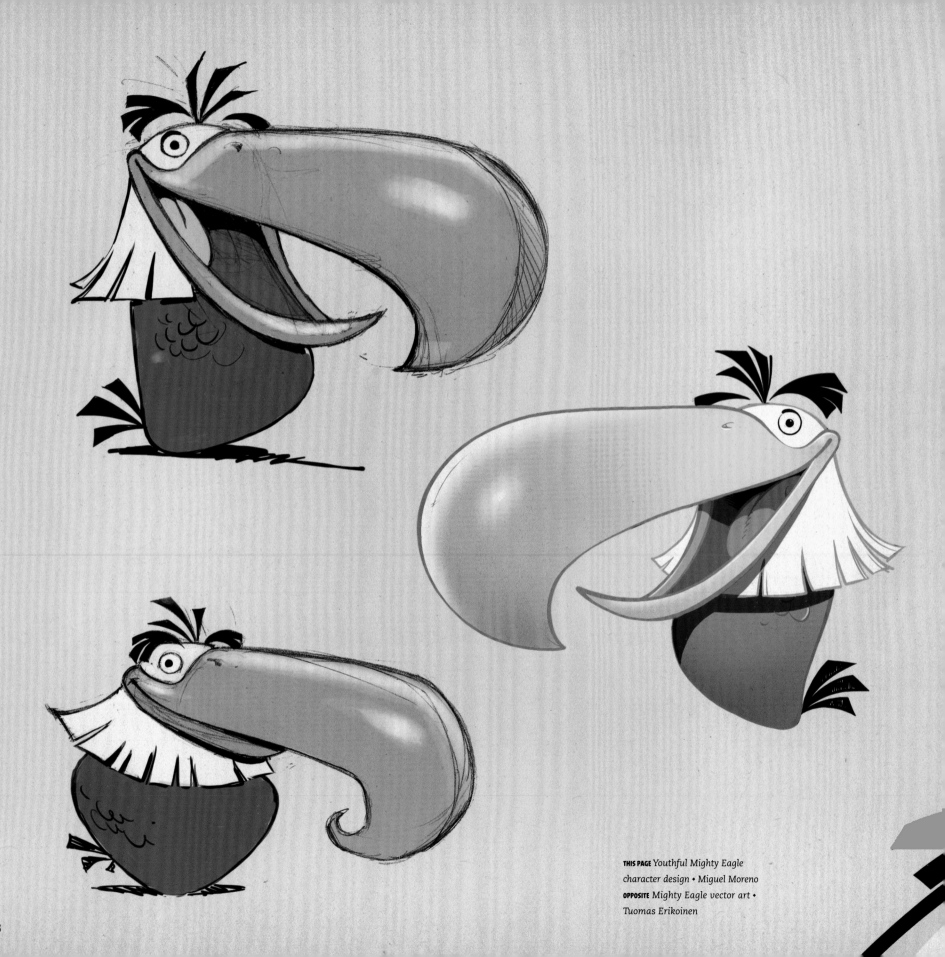

THIS PAGE Youthful Mighty Eagle
character design • Miguel Moreno
OPPOSITE Mighty Eagle vector art •
Tuomas Erikoinen

# MIGHTY EAGLE

## HAS LANDED

**WHILE RED MAY BE** the undoubted icon of *Angry Birds*, Mighty Eagle certainly ranks as a cult figure. An enormous bird who is not so much angry as profoundly grumpy and antisocial, Mighty Eagle resides in a cave on Piggy Island. He is by far the strongest of the *Angry Birds*, with the ability to unleash a formidable destructive force.

In the wider story of *Angry Birds*, Mighty Eagle is revealed to have once been the mightiest warrior. Unfortunately, he blames himself for once failing the flock—although the exact details of this failure have been lost in the mists of time—and he cannot live with the shame. Wracked with self-pity and addicted to sardines, he stays far away from the pigs and the birds.

In his absence, he has become something of a legend, particularly to Jim, Jake, and Jay, who mimic his antics. To the amazement of the rest of the flock, he acts like an indulgent grandfather to them, regaling them with tales of his former exploits. However, Red refuses to have any contact with Mighty, believing that his real failure is staying isolated and not helping the birds in their ongoing battle with the pigs.

Mighty Eagle was introduced via a short animation that preceded the release of the "Ham 'Em High" episode of *Angry Birds* in December 2011. Lauri Manninen, Rovio's Head of 3D Animation, was team leader for the Mighty Eagle animated segment, recalling that the character was introduced in a "very sneak-peek fashion."

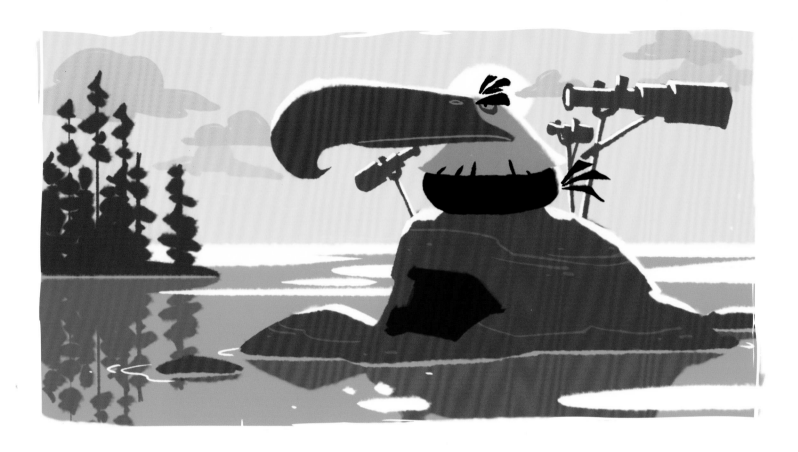

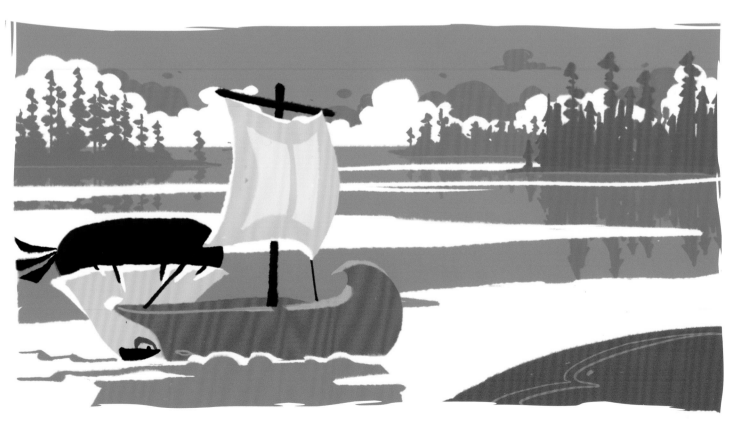

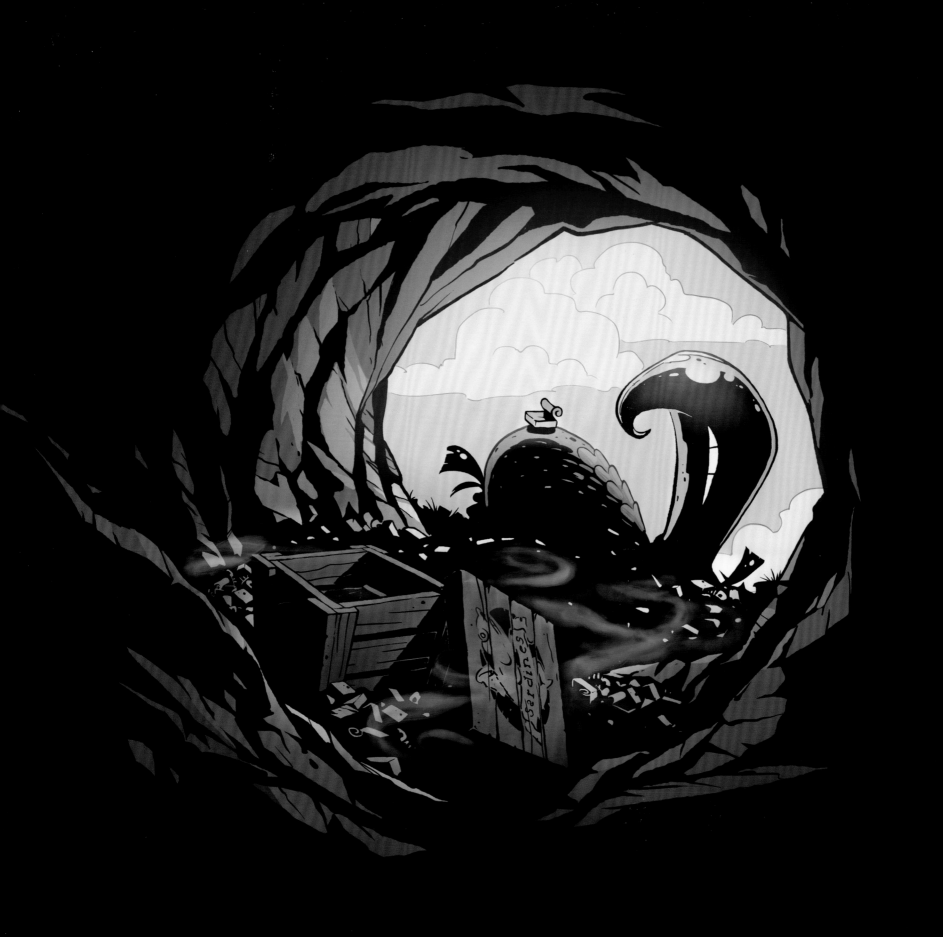

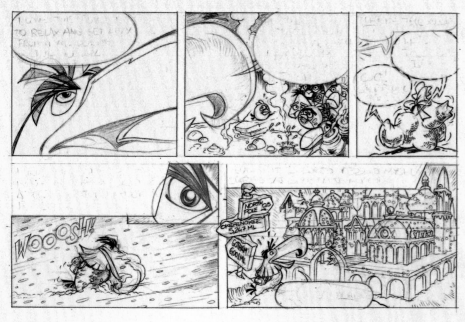

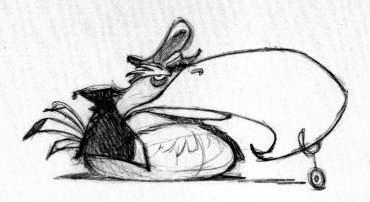

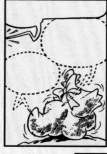

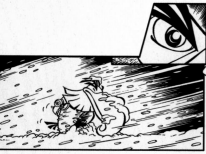
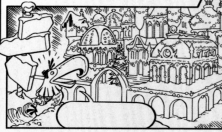

In the sequence *Angry Birds & The Mighty Eagle*, the core flock of birds are happily tending to their beloved trio of eggs, when a butterfly accidentally knocks one of the eggs over, provoking the birds' rage. As they chase the butterfly, the Bad Piggies take advantage of the distraction and steal the eggs, retreating to a fortress that the birds cannot penetrate.

All seems lost, until Red approaches a cave and offers a can of sardines to the exceedingly large creature inside. On the lookout for the return of the birds, Chef Pig fails to see the growing vast shadow from directly above. In a panic, Chef Pig throws the eggs back to the Angry Birds before the whole fortress is squashed.

"We like to launch the new games with an animation, as it allows the story to be explored a little deeper," says Manninen. "It's a nice little extra for the fans, so they have something besides the game to enjoy."

Outside of the games, Mighty Eagle has become a firm favorite with fans—NASA has even named a prototype robotic lander vehicle after the brand's biggest bird! "I think the character is very important to *Angry Birds*," says Manninen. "Mighty Eagle represents an older and wiser version of the birds, and he is very much a source of knowledge for them. He is the experienced one. I would count him as part of them, but he's a loner, separated by choice."

**OPPOSITE** Mighty Eagle's Legends, Vol. 1
artwork • Pasi Pitkänen
**LEFT** The Mighty Eagle comic panels •
Kari Korhonen—script; César Ferioli—
line art; Cris Alencar—coloring
**ABOVE** Mighty Eagle character sketch •
Miguel Moreno
**FOLLOWING PAGES** The Mighty Eagle comic
panel • Kari Korhonen—script; Cèsar
Ferioli—line art; Cris Alencar—coloring

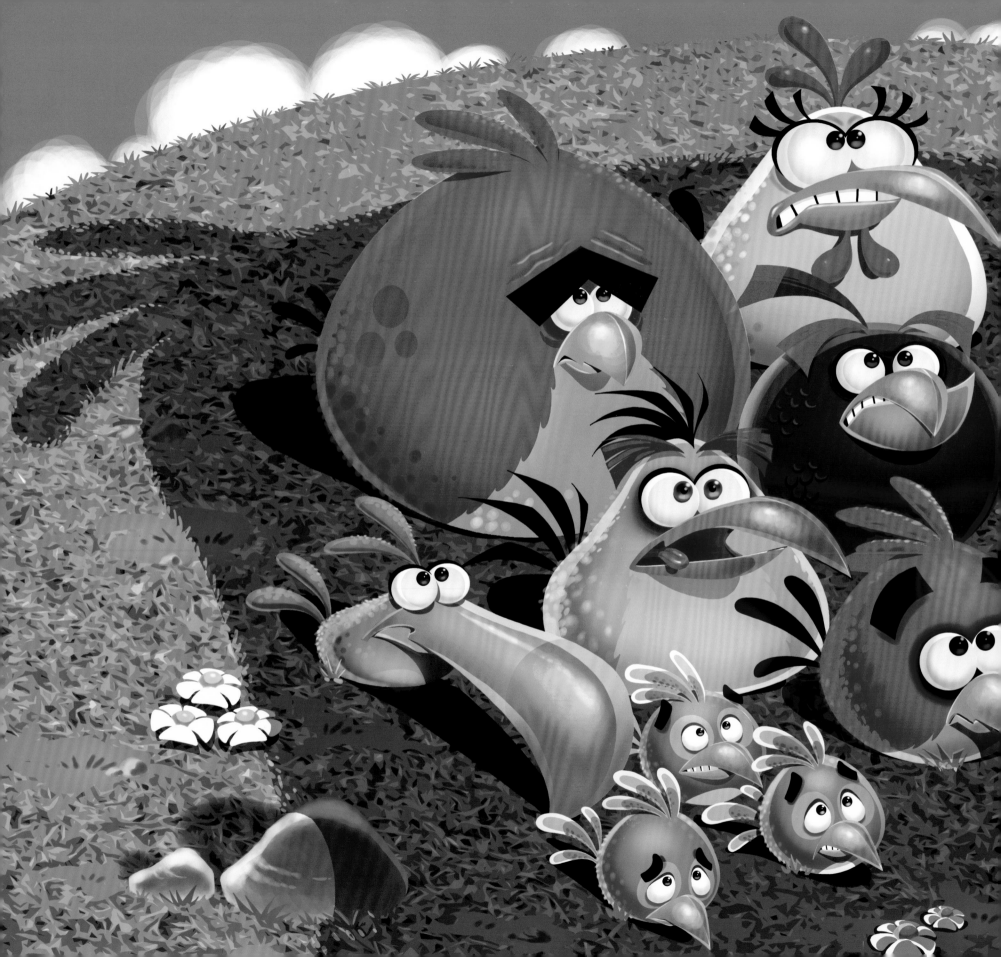

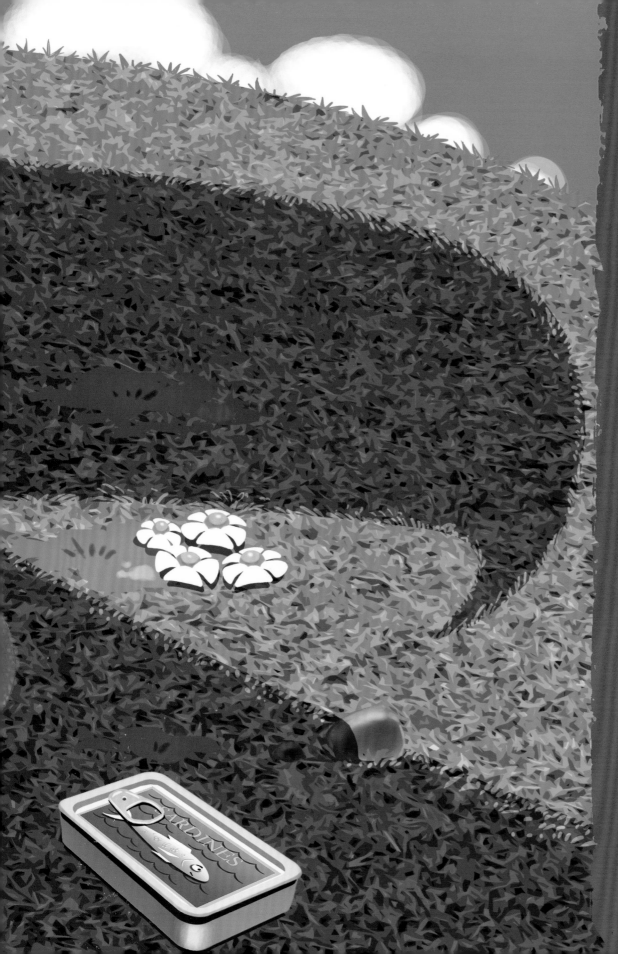

# MEET THE *Flock*

## PETER VESTERBACKA

**FREQUENTLY CLAD IN A RED HOODIE,** Peter Vesterbacka—Rovio's Chief Marketing Officer and de facto "Mighty Eagle" (with the latter title emblazoned on his business card)—is the public face of *Angry Birds* and the man who has spearheaded the brand's global expansion.

Following the fateful victory of Niklas Hed, Jarno Väkeväinen, and Kim Dikert at the mobile game development competition in 2003—which Vesterbacka organized—it was the "Mighty Eagle" himself who convinced the trio to start the company that would eventually become Rovio.

Vesterbacka formally joined Rovio in 2010. "When I started helping them with this and that in the United States, I realized that *Angry Birds* is much bigger than any of us ever thought," he recalls. "I decided then that I was not happy with making *Angry Birds* big. I wanted to make it huge.

"We've managed to get off to a good start in the past few years," he explains somewhat understatedly. "It starts with the name, which begs the question, 'Why are the Angry Birds angry?' There's instantly the viral hook for audiences.

"Of course there is a sense of accomplishment knowing that we've done great things, but there's still an atmosphere of tangible hunger and ambition at Rovio, and what we've accomplished so far feels small. It's just the beginning. When we look at our future plans and the ambition of what we're working on, it's really fierce. It's as if we've done nothing yet."

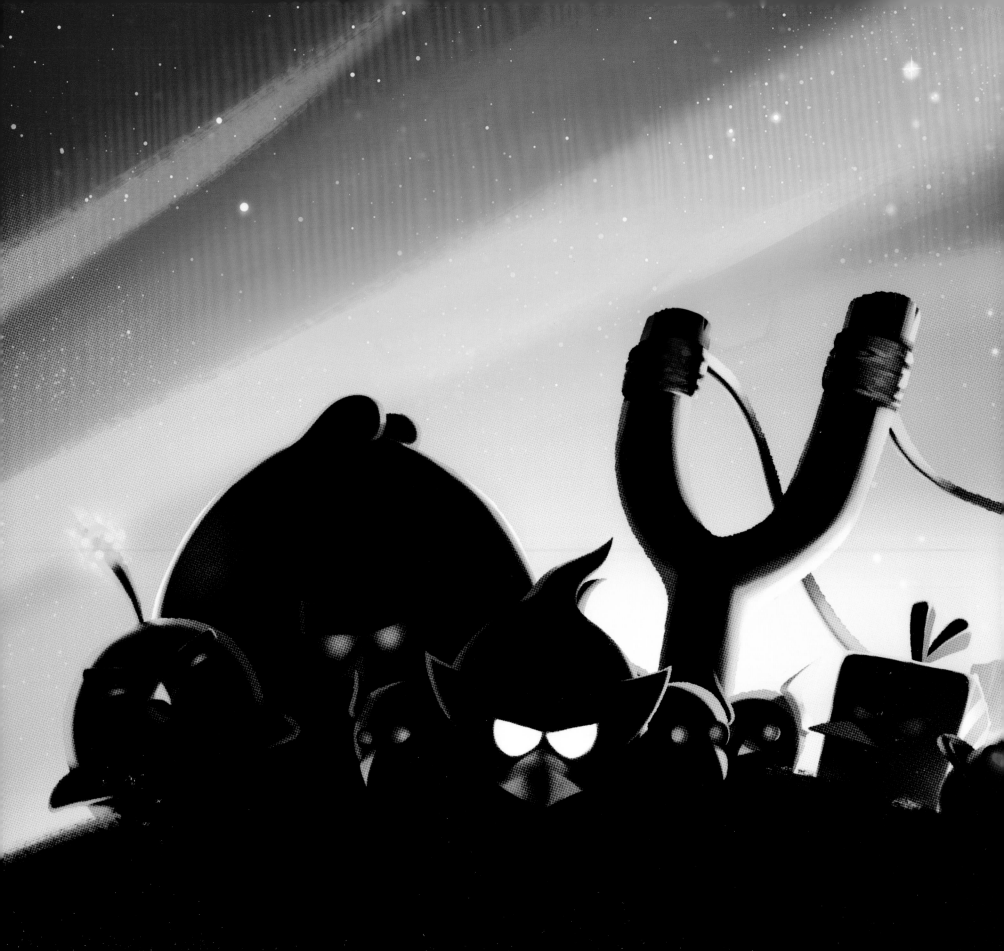

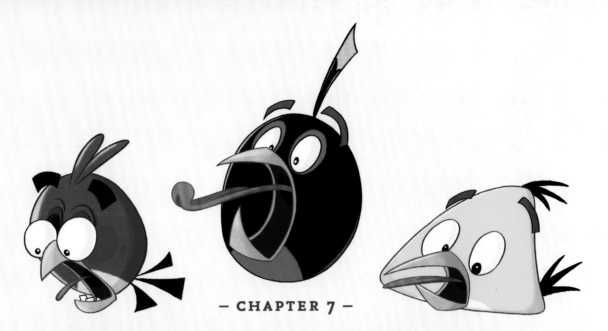

— CHAPTER 7 —

# IN SPACE, NO ONE CAN
# HEAR YOU OINK

**Announced in February 2012,** the fourth *Angry Birds* game was hugely anticipated, not least of all because the battle between the Angry Birds and the Bad Piggies was now heading toward the Final Frontier.

The game was launched the following month with a truly grand event where Seattle's iconic Space Needle was transformed into a massive 330-foot-long slingshot with a 35-foot-wide model of Red suspended from the viewing platform.

Fans first got to see gameplay footage from *Angry Birds Space* beamed from the appropriately spectacular locale of the International Space Station. "It was a crazy idea!" recalls Peter Vesterbacka. "But we thought: Why not? It's a game about space—where better to launch it?" NASA astronaut Don Pettit was on hand to demonstrate to fans just how zero gravity would affect the birds in a segment that also showcased footage from the game revealing some remark-

able differences to prior *Angry Birds* titles. The playing area was no longer flat, instead comprising several different planets, each with its own gravitational field that would affect the trajectory of the birds after launch.

According to Ville Heijari, it was time for the games to step up to the next level. "In terms of the gameplay, you still have the 2D experience, but you have the new dimension of your trajectories having to work with different gravity wells," he says. "What we felt throughout the development was that this game had to be something new. I think we accomplished it very well."

Peter Vesterbacka confirms this sentiment: "Every game we do, we are always learning. The result is what you see in the *Angry Birds Space* game. It's really taking things to the next level. You have richer graphics, more power. As the game takes place in space, there's a completely different dynamic. The designers did an amazing job of

**LEFT** Angry Birds Space *concept art* • Antti Kemppainen
**ABOVE** Angry Birds Space *character pose concepts* •
*Antti Kemppainen and Miguel Moreno*

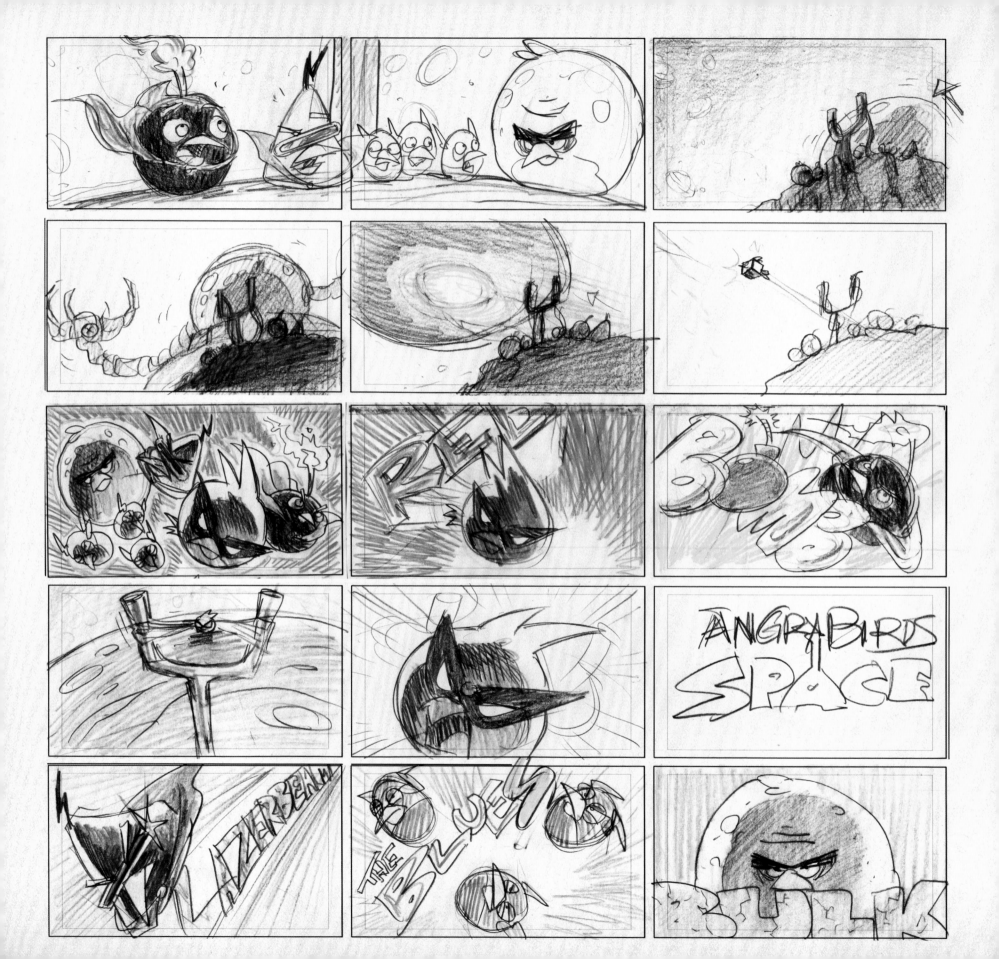

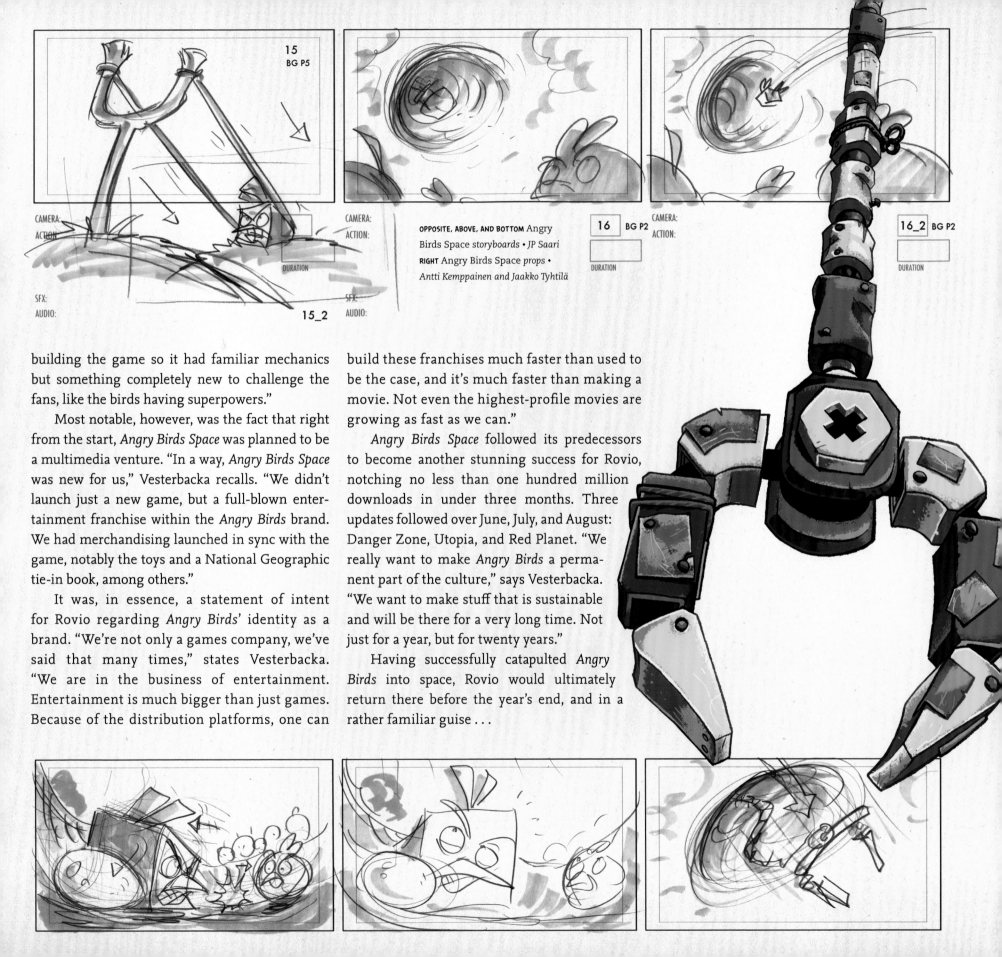

CAMERA:
ACTION:

DURATION

SFX:
AUDIO:

15_2

CAMERA:
ACTION:

SFX:
AUDIO:

**OPPOSITE, ABOVE, AND BOTTOM** Angry
Birds Space *storyboards • JP Saari*
**RIGHT** Angry Birds Space *props •*
*Antti Kemppainen and Jaakko Tyhtilä*

16    BG P2

DURATION

16_2   BG P2

DURATION

CAMERA:
ACTION:

building the game so it had familiar mechanics but something completely new to challenge the fans, like the birds having superpowers."

Most notable, however, was the fact that right from the start, *Angry Birds Space* was planned to be a multimedia venture. "In a way, *Angry Birds Space* was new for us," Vesterbacka recalls. "We didn't launch just a new game, but a full-blown entertainment franchise within the *Angry Birds* brand. We had merchandising launched in sync with the game, notably the toys and a National Geographic tie-in book, among others."

It was, in essence, a statement of intent for Rovio regarding *Angry Birds*' identity as a brand. "We're not only a games company, we've said that many times," states Vesterbacka. "We are in the business of entertainment. Entertainment is much bigger than just games. Because of the distribution platforms, one can

build these franchises much faster than used to be the case, and it's much faster than making a movie. Not even the highest-profile movies are growing as fast as we can."

*Angry Birds Space* followed its predecessors to become another stunning success for Rovio, notching no less than one hundred million downloads in under three months. Three updates followed over June, July, and August: Danger Zone, Utopia, and Red Planet. "We really want to make *Angry Birds* a permanent part of the culture," says Vesterbacka. "We want to make stuff that is sustainable and will be there for a very long time. Not just for a year, but for twenty years."

Having successfully catapulted *Angry Birds* into space, Rovio would ultimately return there before the year's end, and in a rather familiar guise . . .

**TECHNICAL DIRECTOR**
JUSSI KEMPPAINEN
**3D SUPERVISOR**
LAURI MANNINEN
**PIPELINE TD's**
JUSSI LEHTO,
TIMO RONGAS,
PAULI SUURAHO

**LEAD CHARACTER DESIGNER**
MIGUEL MORENO

**2D PRODUCTION DESIGNER**
JEAN-MICHEL BOESCH
**3D PRODUCTION DESIGNER**
JP RÄSÄNEN

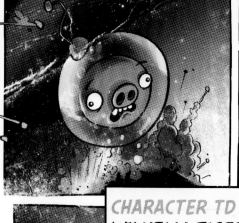

**2D ANIMATORS**
MARKUS LEHTOKUMPU,
THOMAS LEPESKA,
ERKKI LILJA,
PINJA PARTANEN,
JANNE ROIVAINEN,
VERONICA VOUTILA,
SARA WAHL

**CHARACTER TD**
WILHELM TIGERS
**LEAD 3D ARTIST**
MANU JÄRVINEN
**3D ARTIST**
SAMI TIMONEN

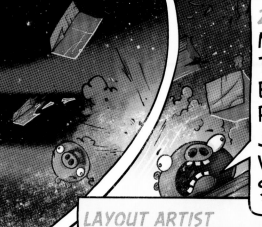

**LAYOUT ARTIST**
CARINE BECKER
**SENIOR GRAPHIC ARTIST**
ANTTI KEMPPAINEN
**GRAPHIC ARTISTS**
MARIJA DERGAEVA,
JANNE KORSUMÄKI,
JAAKKO TYHTILÄ

**SENIOR COMPOSITOR**
VILLE WESTERLUND
**COMPOSITORS**
MARKUS LEHTOKUMPU,
ELINA PENNINKANGAS
**FX ARTIST**
SAKARI LEPPÄ

**MUSIC**
ILMARI HAKKOLA,
SALLA HAKKOLA

**MUSIC**
**MASTER**
HARRI

There's no need
for competition!

RYBOARD &
MATIC ARTIST
SAARI

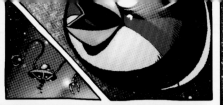

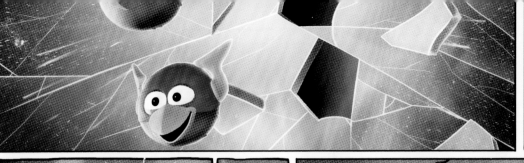

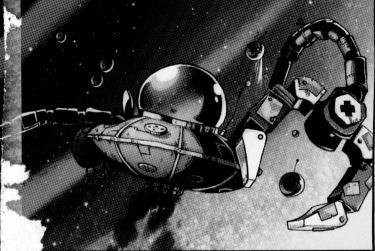

CRUSH

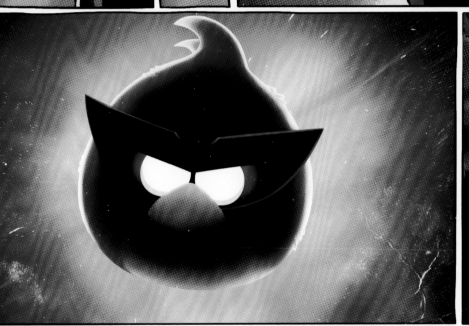

**3D ANIMATORS**
THOMAS LEPESKA,
MICKY SMEDS,
JARI VAARA

DUCTION ARTIST
RSUMÄKI

A Lone Pig emerged from the ruins.

The birds caught a glimpse of the eggs hidden inside a box of donuts just in time.

**SOUND DESIGN**
SALLA HÄMÄLÄINEN,
EERO KOIVUNEN

**THESE PAGES** Angry Birds Space animation
end credit artwork • Antti Kemppainen
and Manu Järvinen

93

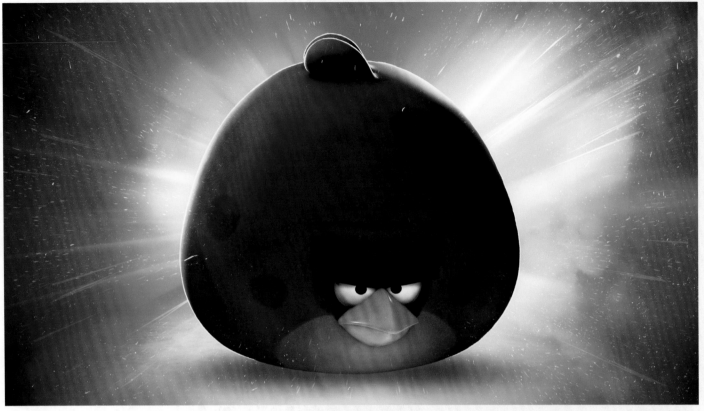

ABOVE Angry Birds Space *artwork • Lauri Manninen—
3D rendition; Manu Järvinen—paint-over*

OPPOSITE *Illustration based on NASA's* Curiosity *for
Angry Birds Space* Red Planet *update • Toni Kysenius*

# LAUNCHING WITH NASA

While every previous *Angry Birds* game had been released to great fanfare, *Angry Birds Space* generated even more interest thanks to Rovio's collaboration with NASA.

This meeting of the minds emerged courtesy of a key marketing channel for Rovio. "I was on Twitter and tweeting on behalf of Rovio at the time because I wanted to communicate with our fans," says Peter Vesterbacka. "One day, I got a tweet from NASA, asking if we'd like to send some pigs into space. We exchanged a few tweets with the NASA guys. One thing led to another, so I thought: What if we build a space game? So the whole idea started with a Twitter exchange."

It was, as Vesterbacka reveals, a match made in heaven. "We've been working with NASA very closely,"

he says. "We went to the last shuttle launch and handed out T-shirts that said 'Shoot for the stars.' NASA and *Angry Birds* go pretty well together."

Most important, the collaboration would feed into Rovio's increasing commitment to education, which was also expressed in their space-based venture with National Geographic, *National Geographic Angry Birds Space: A Furious Flight into the Final Frontier*—an *Angry Birds* book full of fun space facts.

"NASA has been very keen to work with us," says Vesterbacka. "It works beautifully, as they are the leading authority on space, and because education and learning are very close to our hearts, they can help us communicate this. NASA loves the fact that they can get their message out to a big audience via *Angry Birds* in an easy-to-understand and fun way."

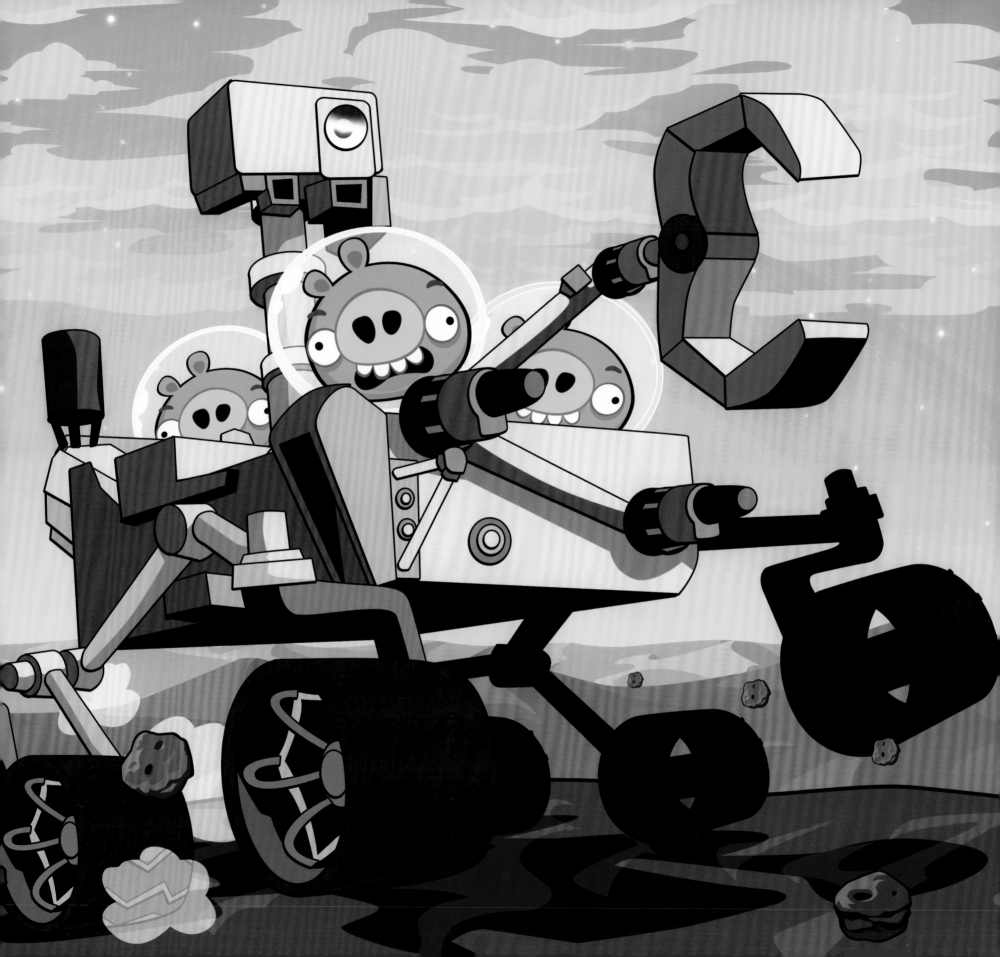

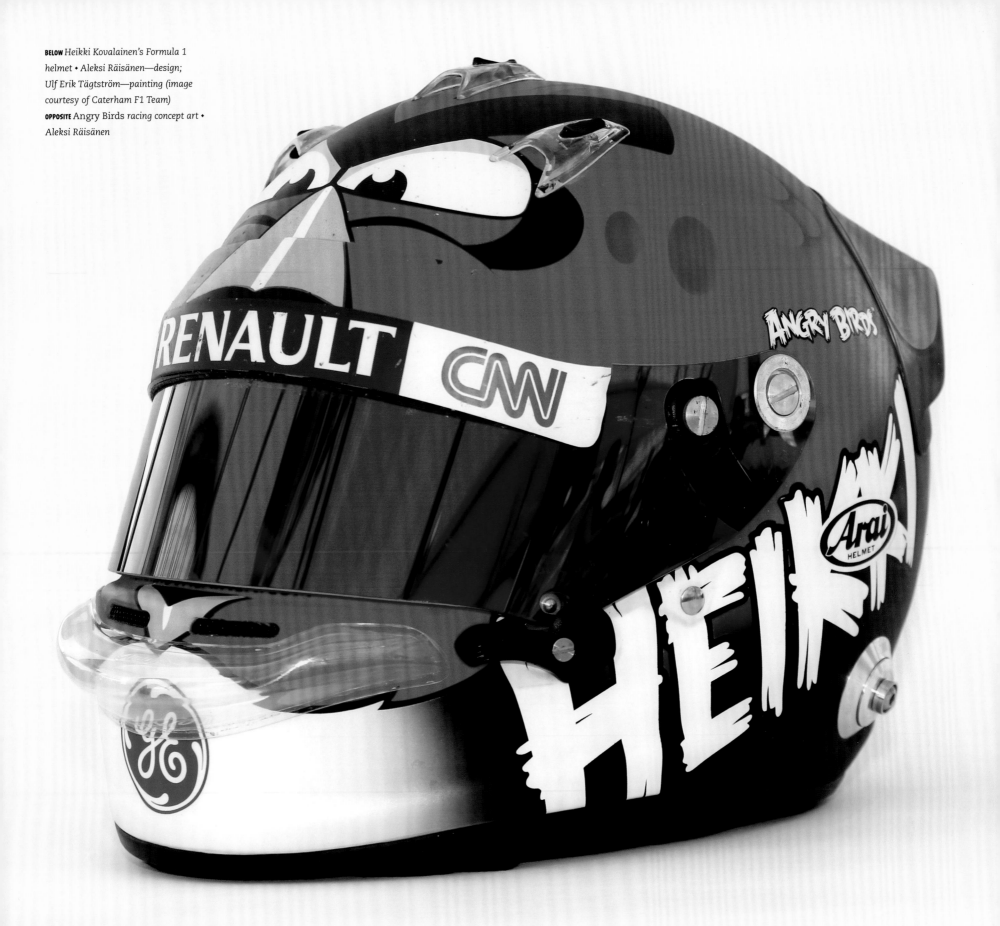

BELOW *Heikki Kovalainen's Formula 1 helmet • Aleksi Räisänen—design; Ulf Erik Tägtström—painting (image courtesy of Caterham F1 Team)* OPPOSITE *Angry Birds racing concept art •* *Aleksi Räisänen*

# STARSTRUCK

**THE METEORIC RISE OF *ANGRY BIRDS*** has led to a diverse array of collaborations with internationally recognized names in the worlds of sports, science, music, and film. These partnerships have helped *Angry Birds* to not only exponentially expand beyond its roots as a game but also to educate as well as entertain.

"With all our partnerships," says Peter Vesterbacka, "there has to be a central idea that makes sense. It's all about putting the fans first. What will they get from this collaboration? It's not about making money solely; it's about building the brand."

In March of 2012, Rovio teamed up with Finnish Formula 1 driver Heikki Kovalainen. As a result, Kovalainen wore a cobranded *Angry Birds* helmet at that season's inaugural Formula 1 race in Melbourne, Australia. "It was a great partnership," said Kovalainen at the time. "As a Finn, I was happy to be backed by a Finnish company on a global platform. Most importantly, I'm a huge *Angry Birds* fan!"

Late that summer, Rovio announced a collaboration with Grammy Award–winning US rock band Green Day. The band starred in a new episode of the *Angry Birds Friends* game on Facebook, which included pig characters based on the three band members: Billie Joe Armstrong, Mike Dirnt, and Tre Cool. The band's single "Oh Love" was featured in the game, alongside an additional, exclusive track called "Troublemaker."

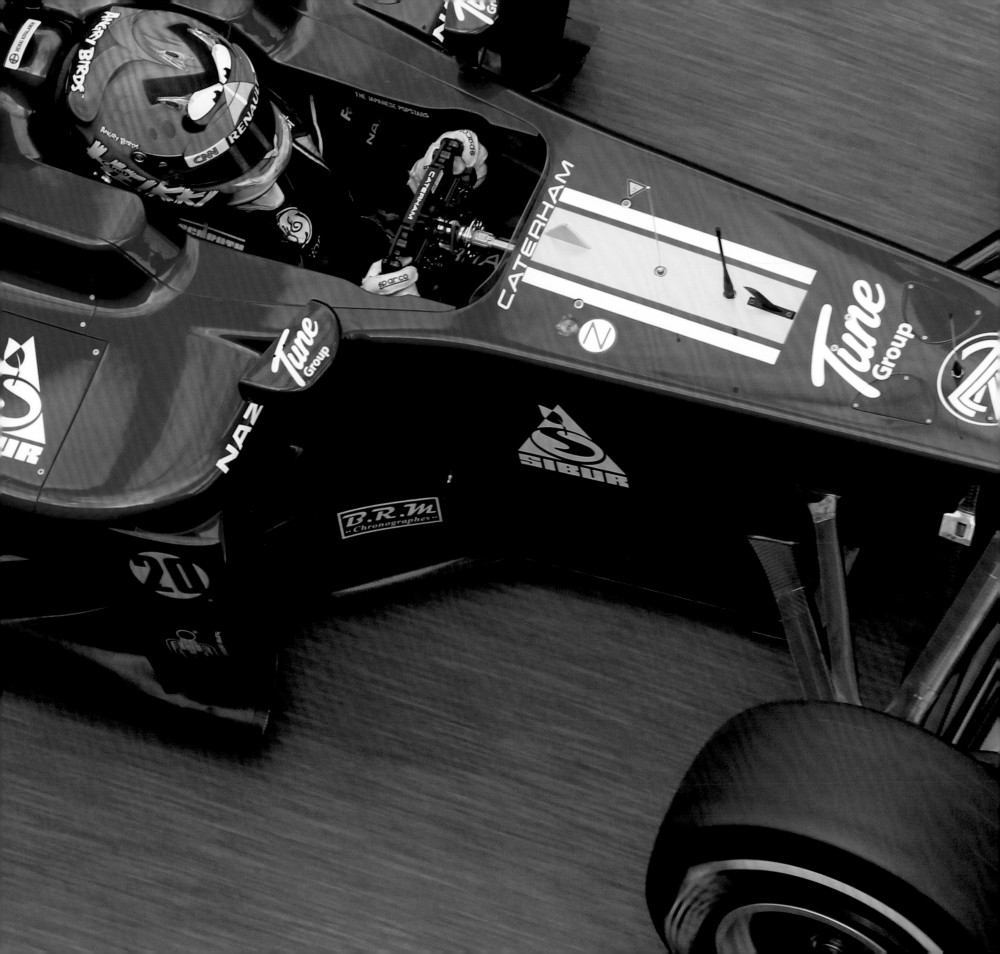

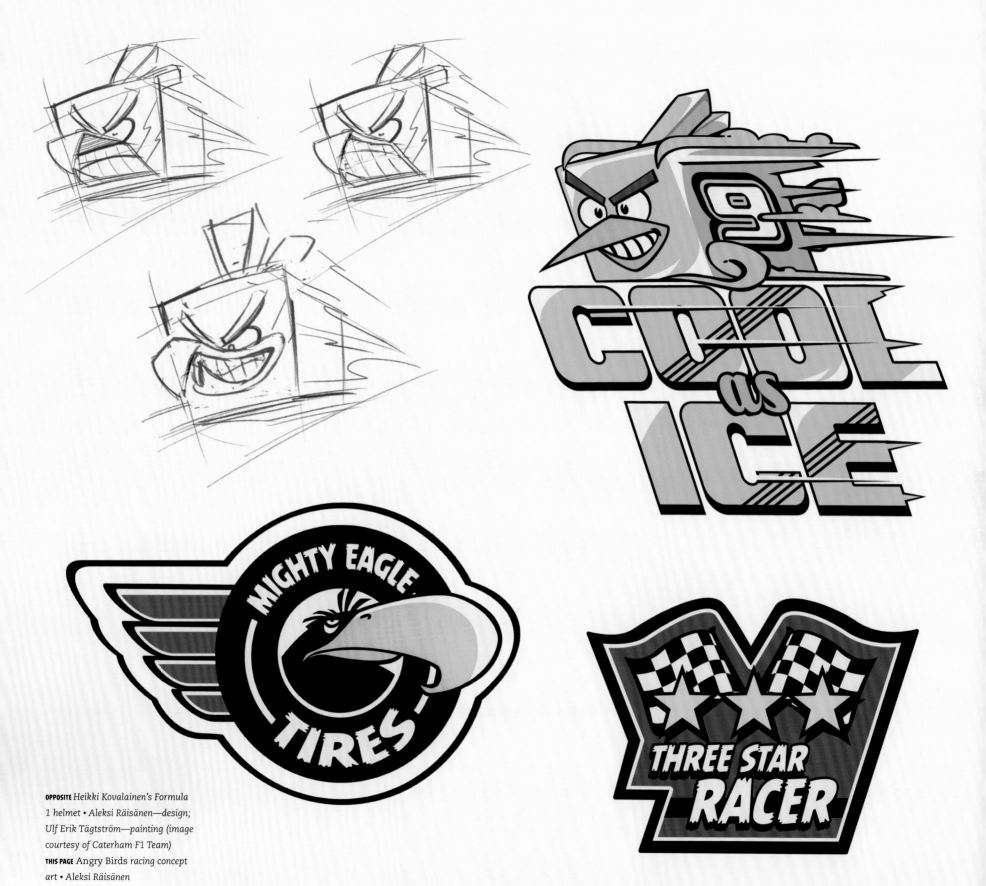

**OPPOSITE** *Inspirational concept art •*
*Miguel Moreno*
**ABOVE** *Character design • Miguel*
*Moreno*

"We had been looking to give the pigs a more prominent role in the games, and when we started talking to the Green Day management, we realized it was a very good fit," said Vesterbacka when the deal was announced. "For us, it's bringing *Angry Birds* to a wider audience, and it's the same thing for Green Day. It's two big green brands coming together!"

In the midst of such international promotional opportunities, Rovio also eagerly pursued collaborations that directly benefitted Finland. In October 2012, Rovio announced a partnership with CERN (the European Organization for Nuclear Research) that would help teach Finnish children about physics using content based on the Finnish national curriculum. "Modern physics has been around for one hundred years, but it's still a mystery to many people. Working together with Rovio, we can teach kids quantum physics by making it fun and easy to understand," said CERN's Head of Education, Rolf Landua. "It's a great fit for both sides, combining physics and *Angry Birds* in a fun way. We get a great channel to communicate what CERN does."

While all these collaborations used existing *Angry Birds* characters, one project required the creation of an all-new character: HockeyBird. The Finnish Ice Hockey Association approached Rovio in 2010, inviting them to create a new mascot for the forthcoming Ice Hockey World Championships 2012. The job went to Rovio's Art Director Toni Kysenius. "I offered to do it, being a sports fan," he says. "I was thrilled to be able to do something that could have a place in sports history."

Moreover, HockeyBird was an opportunity for Rovio to give something back to their country of origin. "It was very, very important to be part of this," Kysenius explains. "What would be a better way of expressing our devotion to our home country than doing something for what could be considered Finland's national sport? As a designer, this was a very nice opportunity to explore new territories in design. The project also involved new elements for us, like postage stamps, which were illustrated by Game Artist Olga Budanova. Designing stamps is a prestigious task here in Finland, and many graphic designers would be in awe to have an opportunity like this!"

For Kysenius, the design process had to blend two distinct requirements: "I spent a couple of weeks working out what a hockey-playing Angry Bird would be like! I made comparisons with our regular flock and their powers and

# HockeyBird

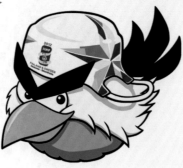
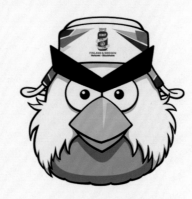
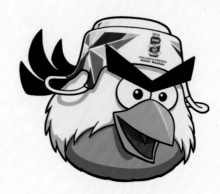

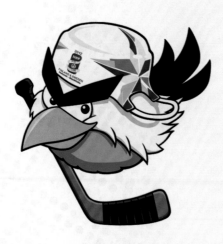

**THIS PAGE** *HockeyBird illustrations • Toni Kysenius*

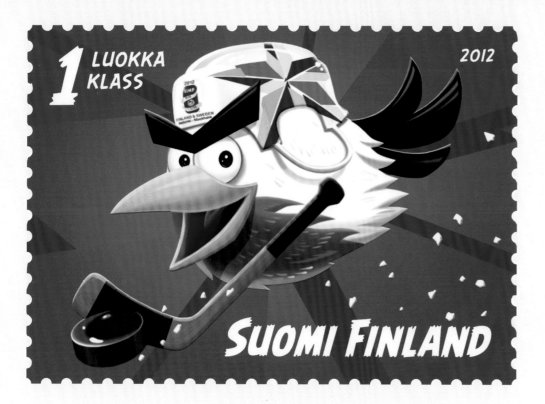

1 LUOKKA KLASS

2012

SUOMI FINLAND

MEET THE Flock

## TONI KYSENIUS

"Since I started here at Rovio I've had a hand in all the games, more or less, but most particularly *Angry Birds Space* and *Angry Birds Star Wars*." A comparative veteran of *Angry Birds*, Art Director Kysenius remains impressed at just how malleable the brand has become. "It's been a pleasant surprise to see how Rovio has been able to create such a wide variety of partnerships with *Angry Birds*," he says. "It seems that *Angry Birds* works very well in these different combinations in all these different areas and industries."

It was the result of Kysenius's work on HockeyBird that underlined the beneficial effect that *Angry Birds* can have on fans. "The feedback for HockeyBird was extremely positive," he says. "I had a great experience where I was with the mascot on the ice during a Finnish junior tournament at New Year's. We had

personalities. HockeyBird was massive with long feathers, because he's from an Arctic environment and likes ice! The official logo had to appear somewhere and since the birds do not wear clothes, the helmet was the obvious place for it to go. The aspect that really made this project tick was the tail and the decision to make it like a mullet. When I first showed this to the people at the Finnish Ice Hockey Association, they were instantly sold.

"We realized from the start that being part of the games would give us good visibility," adds Kysenius. "It enabled us to reach a new fanbase with this character they instantly recognized and had a lot of love for."

a costume made up and I was there in a referee's outfit standing next to HockeyBird. Seeing how all these kids reacted to this character almost brought tears to my eyes! I realized that this is the reason I do this job—delighting the fans."

**TOP LEFT** *HockeyBird stamp illustration • Olga Budanova*
**FAR LEFT** *Airplane HockeyBird graphics • Toni Kysenius*

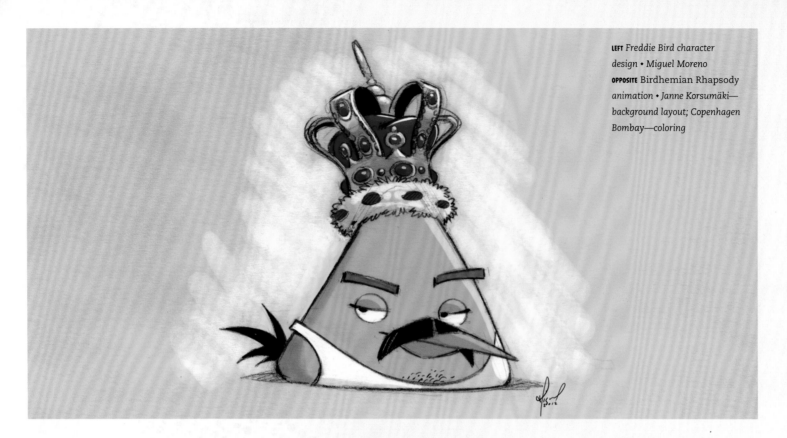

LEFT *Freddie Bird character design* • Miguel Moreno
OPPOSITE Birdhemian Rhapsody *animation* • Janne Korsumäki—*background layout; Copenhagen Bombay—coloring*

# BIRDHEMIAN RHAPSODY!

Of all the collaborations Rovio has pursued, one of the most striking was the sight of Freddie Mercury, the frontman of legendary rock band Queen, as an Angry Bird! Despite his tragic early death in 1991 from AIDS, Mercury has lived on as an enduring pop culture icon and the prime inspiration behind AIDS-awareness charity The Mercury Phoenix Trust. So, how did one of the unrivaled greats of rock music come to be involved with *Angry Birds*?

"Freddie For A Day is an annual charity event created by The Mercury Phoenix Trust," explains Ville Heijari. "They have a campaign where they link with a person or a brand to become Freddie Mercury for a day, and they asked us how *Angry Birds* could contribute to this worthwhile cause." As a result, there was really only one way to go—for Freddie to join the flock! Miguel Moreno perfectly merged the two distinct icons with a triangular bird clad in a tight T-shirt wearing Freddie's black moustache and, in a nod to Queen's later tours, the crown that Mercury himself sported during encores.

"But what really brought the awareness," notes Heijari, "was a short forty-second animation that utilized Queen's classic track 'Bicycle Race.'" In it, Freddie Bird sits in a slingshot atop a bicycle being furiously driven by Red and the Blue Birds. They screech to a halt when they see King Pig in their path, but when he sees how the shimmering beauty of Freddie's crown compares to his own comparatively spindly one, he deflates in embarrassment, allowing the gang to continue.

"It has absurd comedy!" Heijari enthuses. "I was born in the '70s and when I think of Queen, the first thing that comes to mind is how the music is really playful. It is vastly dramatic at times but almost always fun, energetic, and surprising, and we really wanted to catch those attributes."

Peter Vesterbacka wholeheartedly agrees. "Freddie For A Day was a great way to honor Freddie's fun and flamboyant spirit while delivering an important message," he says. "Giving to charity is simple, but we wanted to make it a fun experience. We wanted to give something to the fans via the animation and the T-shirts—which sold very, very quickly—and we donated the profits to The Mercury Phoenix Trust."

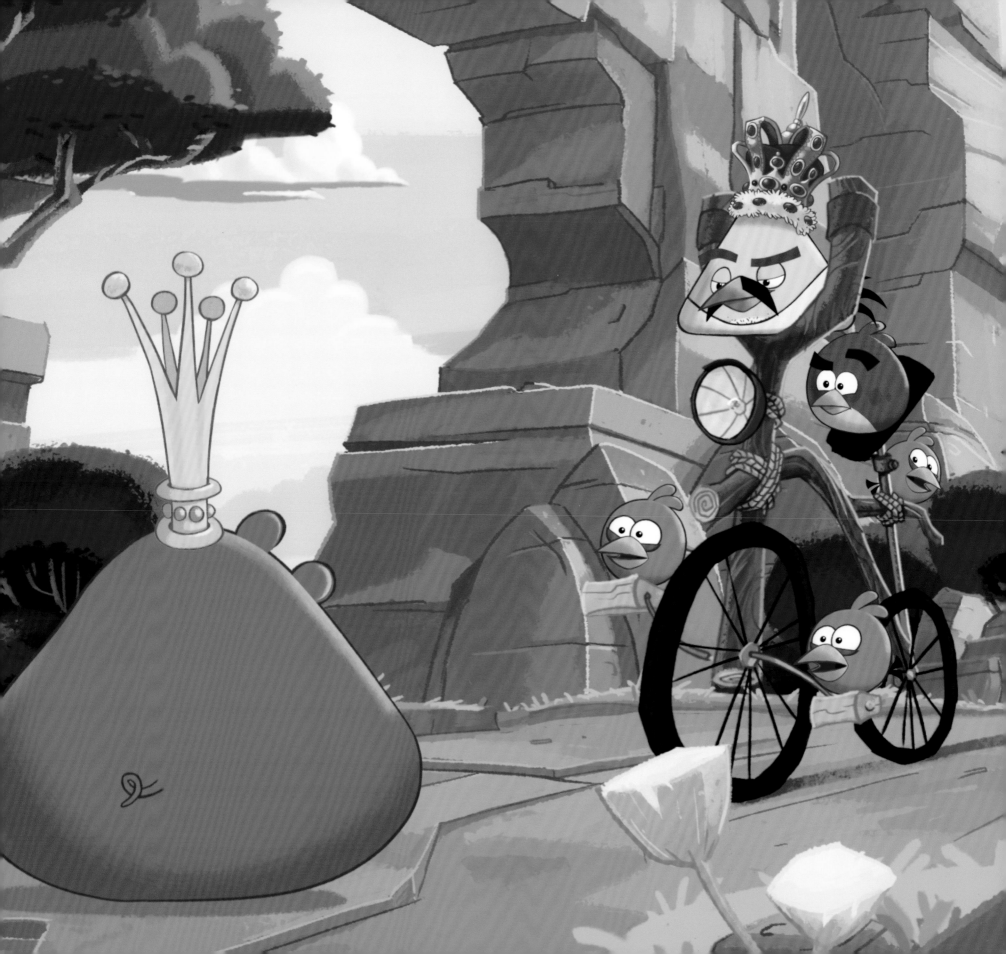

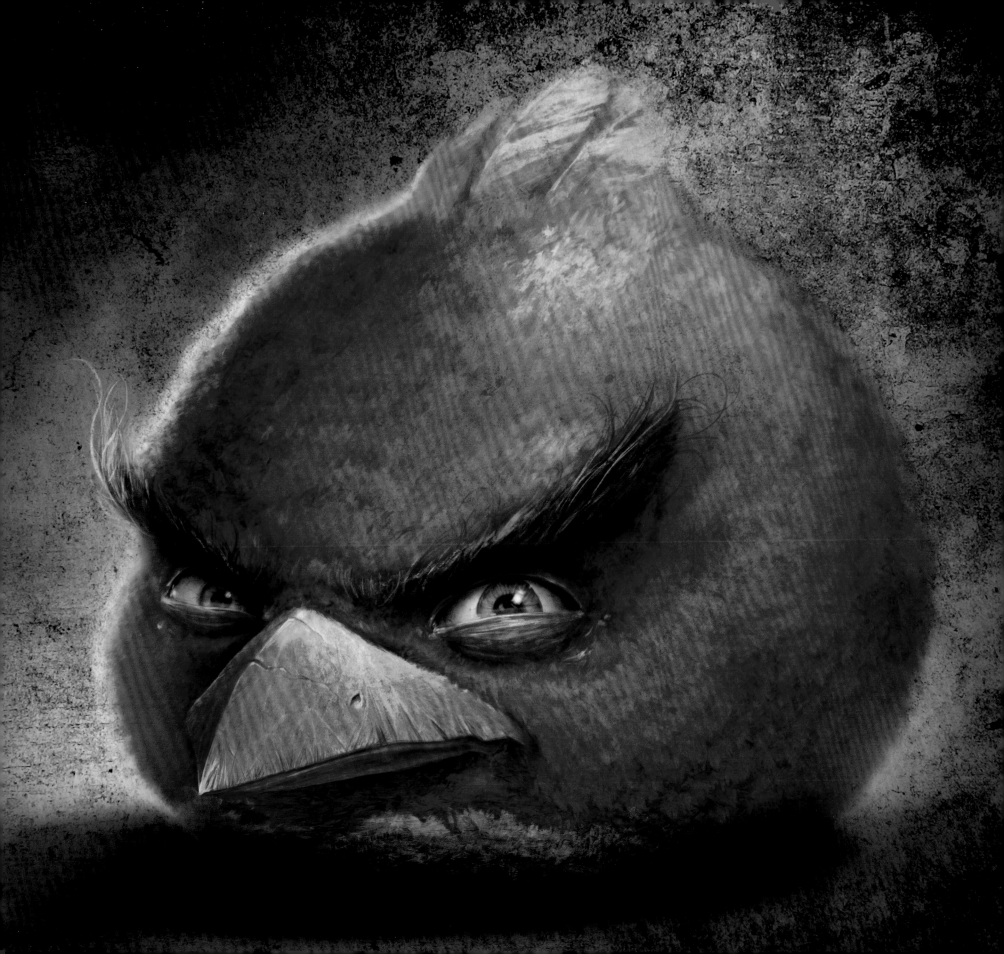

# — CHAPTER 9 —

# INTRODUCING
# SAM SPRATT

**EVER WONDERED WHAT** the Angry Birds might look like in real life? In 2011, fans got a vivid idea via a series of paintings by American artist Sam Spratt. Then twenty-three years old, Spratt received the commission after Rovio spotted his work on the Internet. "I actually drew a quick picture of a scared pig in a semirealistic style called 'Pig in the Dark' just for fun," Spratt recalls. "It made its rounds on the web and a month later Rovio contacted me out of the blue to paint ten of the main *Angry Birds* characters."

Unsurprisingly, Spratt is a fan of the *Angry Birds* games. "It's a wildly fun and charming game," he says. "The fact that I enjoy it in adulthood and my niece could play it at three years old is a testament to its accessibility."

Rovio gave Spratt free reign for the assignment, the only restriction being to not give the characters feet or wings as he had initially planned. With this in mind, Spratt maintained his plan for a version of the beloved characters that struck a delicate balance: "I wanted

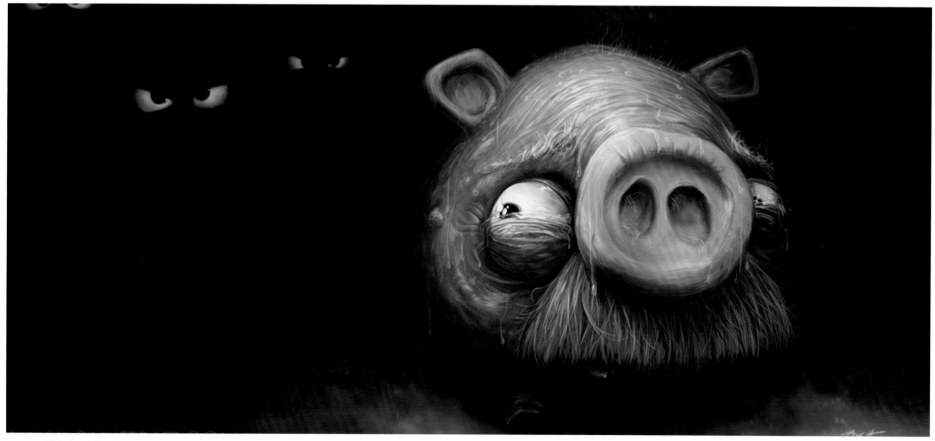

**PAGES 106–111** *Paintings • Sam Spratt*

them to be darker, meaner, and angrier than their cartoonish counterparts but only to a point where they didn't become overly gritty and lose their cuteness and charm."

And how best to evoke the character's signature anger? The answer lay in the eyes, Spratt says: "The characters have limited anatomical features and their eyes are really the big tools for any representation of emotion. Drawing the focus there was just the logical thing to do." Of the ten characters he painted, Spratt confesses to a favorite: "I love the three Blue Birds. They just have this very tweaked-out, crazed expression that was a blast to make!"

From an artist's perspective, Spratt's small but potent contribution to the *Angry Birds* universe allowed him to truly appreciate the design qualities of the characters: "They are incredibly unified in design and simple, yet simultaneously totally individualized and unique. The original designs are iconic. It wouldn't be the widely recognized hit that it is if the artists hadn't done such a fantastic job initially."

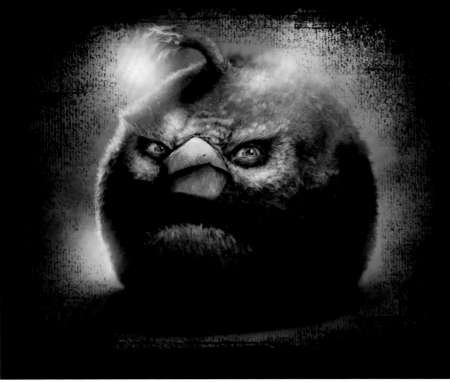

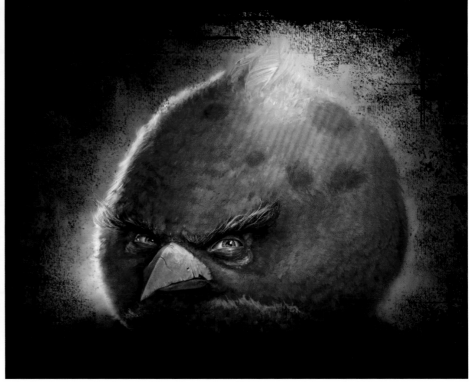

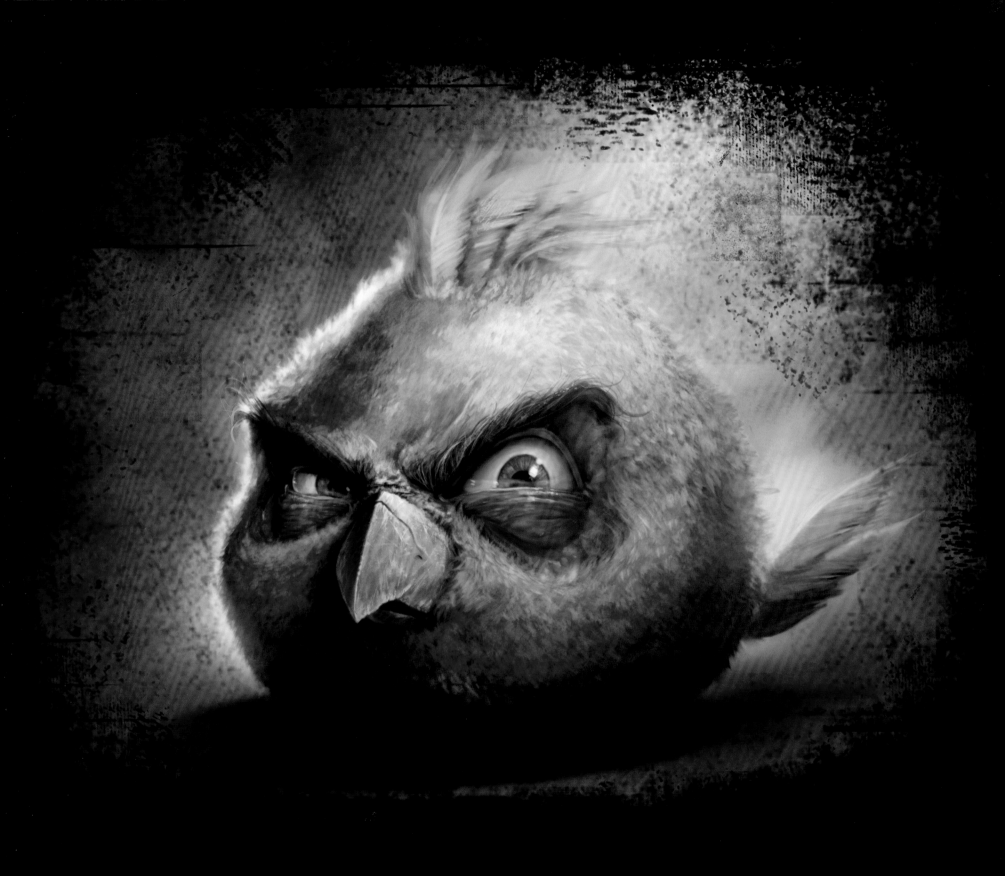

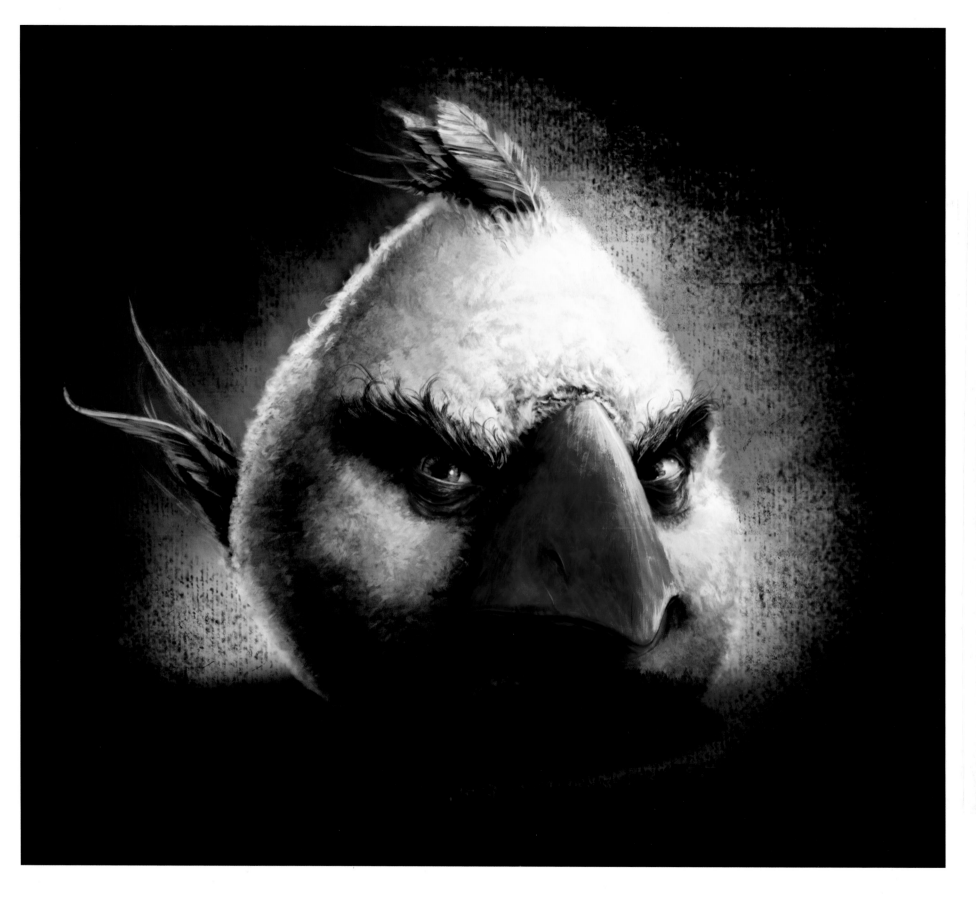

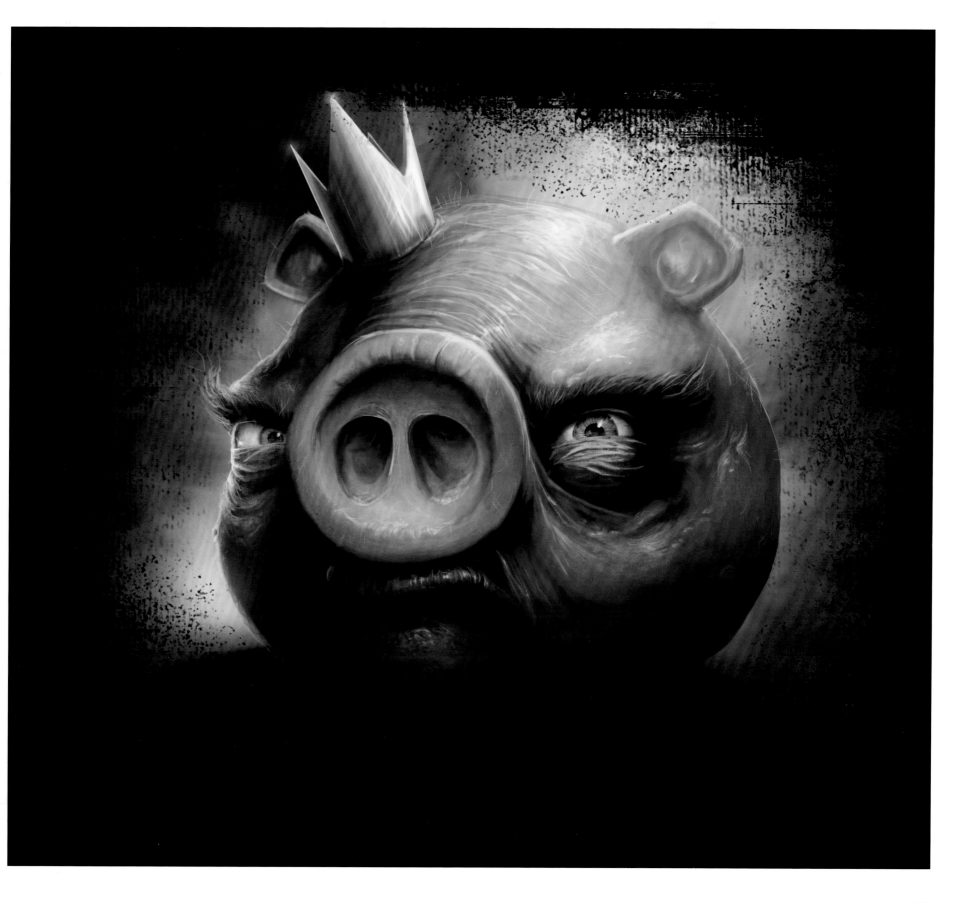

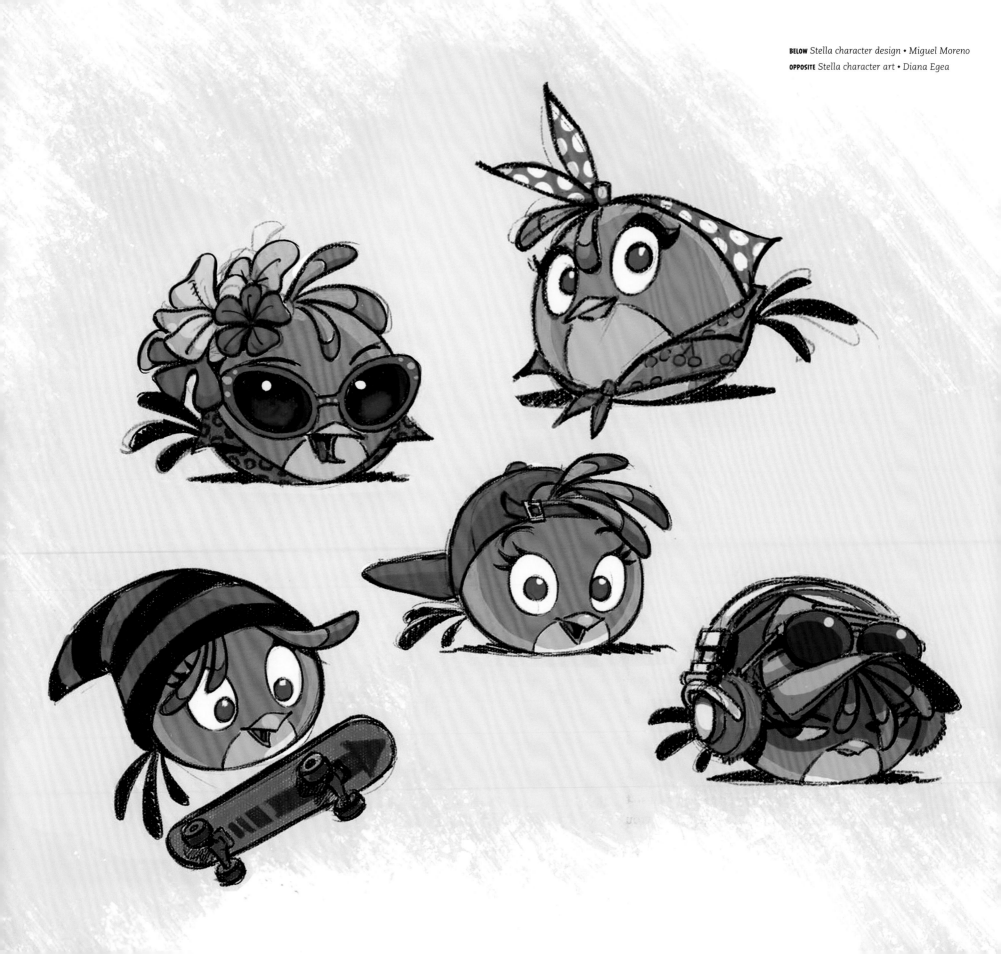

**BELOW** Stella character design • Miguel Moreno
**OPPOSITE** Stella character art • Diana Egea

# HELLO THERE, STELLA!

IN THE EARLY DAYS of *Angry Birds,* Piggy Island was almost entirely dominated by male birds, with Matilda being the only exception. In August 2012, however, all that changed with the introduction of the feisty and irrepressibly cute Stella.

Although not part of the main flock, Stella quickly made a huge impression in both the games and the wider *Angry Birds* universe. A teenager who is something of a mystery to the other birds, Stella is a fearless addition to the fight against the pigs, with her primary power being the ability to trap objects in bubbles.

With her innocent, wide eyes and arresting pink plumage, Stella might look like a chick who needs rescuing, but she is far from helpless. As befits her youth, she doesn't look before she leaps and often gets into trouble because of it, although she is always lucky enough to get away unharmed. Despite her air of mystery, Stella is

very much liked by the other birds, who find her adorable, charming, and absolutely irresistible. The young bird—who is modeled after the exotic galah, a type of cockatoo—is aware of this and knows only too well how to use her charm to her advantage!

The team at Rovio pride themselves on having a constant dialog with their fans through various channels, including social media sites like Facebook and Twitter. It was through feedback like this that they discovered fans were craving a new female character. The "birth" of a new *Angry Birds* character is an organic process that begins with dozens of initial concepts, which are ultimately shaped into the final version, informed by the needs of the stories that the Rovio team want to tell.

"Originally we had a design for a girl bird that was essentially Red, but with a bow and

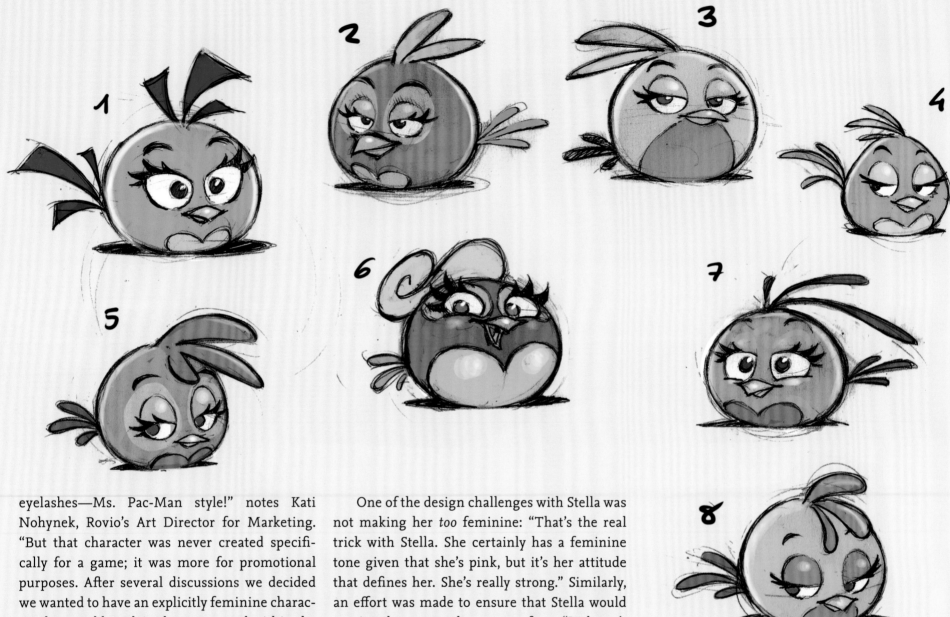

eyelashes—Ms. Pac-Man style!" notes Kati Nohynek, Rovio's Art Director for Marketing. "But that character was never created specifically for a game; it was more for promotional purposes. After several discussions we decided we wanted to have an explicitly feminine character that would work in the games and within the context of the overall *Angry Birds* universe. We needed something pretty!"

Stella came from a mixture of influences that included Japanese cosplay, the Powerpuff Girls and, notably, best-selling American singer Gwen Stefani. "We were inspired by role models who were independent with strong personalities and who could create trends," Nohynek says. "We want Stella to be tough, but not too tough: an independent, modern girl."

One of the design challenges with Stella was not making her *too* feminine: "That's the real trick with Stella. She certainly has a feminine tone given that she's pink, but it's her attitude that defines her. She's really strong." Similarly, an effort was made to ensure that Stella would not just have appeal to young fans. "It doesn't matter if you're seven or seventy," says Nohynek, "Stella will be cute to *everyone*!"

Such broad appeal has ensured that the stubborn, strong-willed Stella looks set to take a much more prominent role in the *Angry Birds* universe—not least of all with her starring role in *Angry Birds Star Wars* as Princess Leia. As Nohynek says: "Stella has a great story to tell, packed with surprises, and she has a bright future as an important part of the flock."

**ABOVE** *Stella character design •*
*Miguel Moreno*
**OPPOSITE** *Stella vectors and color*
*defining • Kati Nohynek*

**TAIL**
CMYK: 40, 40, 40, 100
RGB: 247, 175, 192
PANTONE: Process Black C

**HAIR**
CMYK: 0, 58, 19, 0
RGB: 244, 138, 158
PANTONE: 1775 C

**BODY**
CMYK: 0, 38, 9, 0
RGB: 247, 175, 192
PANTONE: 1767 C

**PUPILS**
CMYK: 71,35, 1, 0
RGB: 71, 141, 200
PANTONE: 659 C

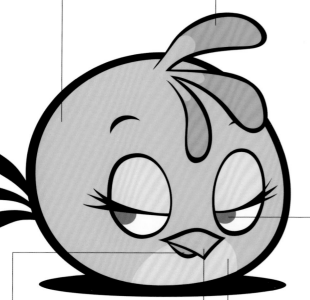

## CMYK

**BEAK (DOWN)**
CMYK: 2, 45, 98, 0
RGB: 243, 155, 35
PANTONE: 1375 C

**BELLY & EYELIDS**
CMYK: 3, 18, 6, 0
RGB: 242, 214, 219
PANTONE: 7422 C

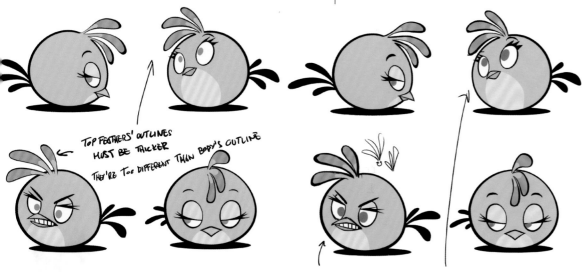

*TOP FEATHERS' OUTLINES MUST BE THICKER*
*THEY'RE TOO DIFFERENT THAN BODY'S OUTLINE*

*BIGGER PUPILS AND DARKER BLUE*

# MEET THE Flock

## KATI NOHYNEK

**AS THE ART DIRECTOR FOR MARKETING** at Rovio Entertainment, Kati Nohynek has played a key role in ensuring that there is a consistent feel to the myriad products on the market as the *Angry Birds* universe expands. "When I first got here," Nohynek recalls, "it was just fifty people and now it's ten times that! I was the first Marketing and Product Graphic Designer at Rovio, and there were really no rules or guidelines for the brand. We had few marketing assets and it was a massive undertaking, but now we have real consistency across everything that we do, and it looks great!"

With literally thousands of licensing partners and tens of thousands of products produced in the space of three years, that's a considerable challenge, yet it's something she relishes: "It's very exciting working on something like *Angry Birds*, because you really never know what each day brings."

While there are surely many contributing factors to the phenomenal success of *Angry Birds*, Nohynek feels that a

core part of it is accessibility: "*Angry Birds* is a brand for everyone. It doesn't matter what age you are; you can laugh at something that's funny, and that's what our brand is about. When anyone new joins Rovio, the first thing I tell them is that with anything that you create, you must ensure that it makes you laugh first, and then the fans will laugh, too."

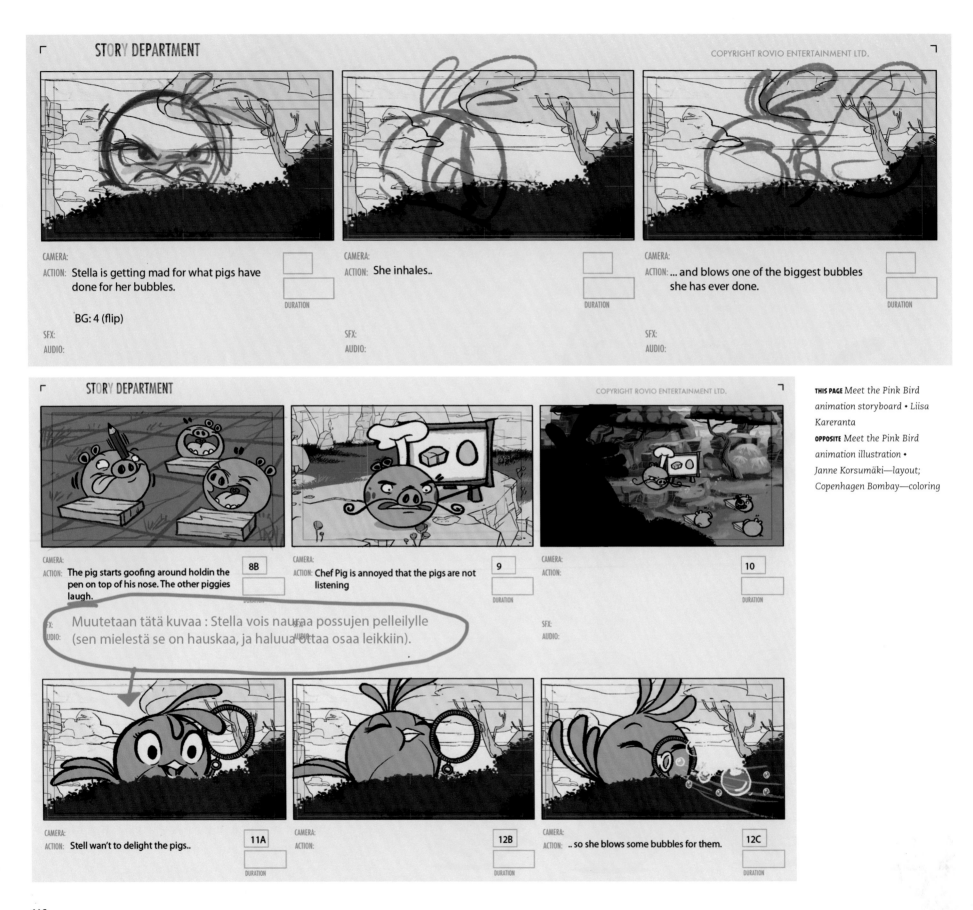

CAMERA:
ACTION: Stella is getting mad for what pigs have done for her bubbles.

BG: 4 (flip)

SFX:
AUDIO:

CAMERA:
ACTION: She inhales..

DURATION

SFX:
AUDIO:

CAMERA:
ACTION: ... and blows one of the biggest bubbles she has ever done.

DURATION

SFX:
AUDIO:

CAMERA:
ACTION: The pig starts goofing around holdin the pen on top of his nose. The other piggies laugh.

8B

CAMERA:
ACTION: Chef Pig is annoyed that the pigs are not listening

9

DURATION

CAMERA:
ACTION:

10

DURATION

FX: Muutetaan tätä kuvaa : Stella vois nauraa possujen pelleilylle (sen mielestä se on hauskaa, ja haluua ottaa osaa leikkiin).
AUDIO:

SFX:
AUDIO:

CAMERA:
ACTION: Stell wan't to delight the pigs..

11A

DURATION

CAMERA:
ACTION:

12B

DURATION

CAMERA:
ACTION: .. so she blows some bubbles for them.

12C

DURATION

**THIS PAGE** *Meet the Pink Bird animation storyboard •* Liisa Kareranta
**OPPOSITE** *Meet the Pink Bird animation illustration •* Janne Korsumäki—layout; Copenhagen Bombay—coloring

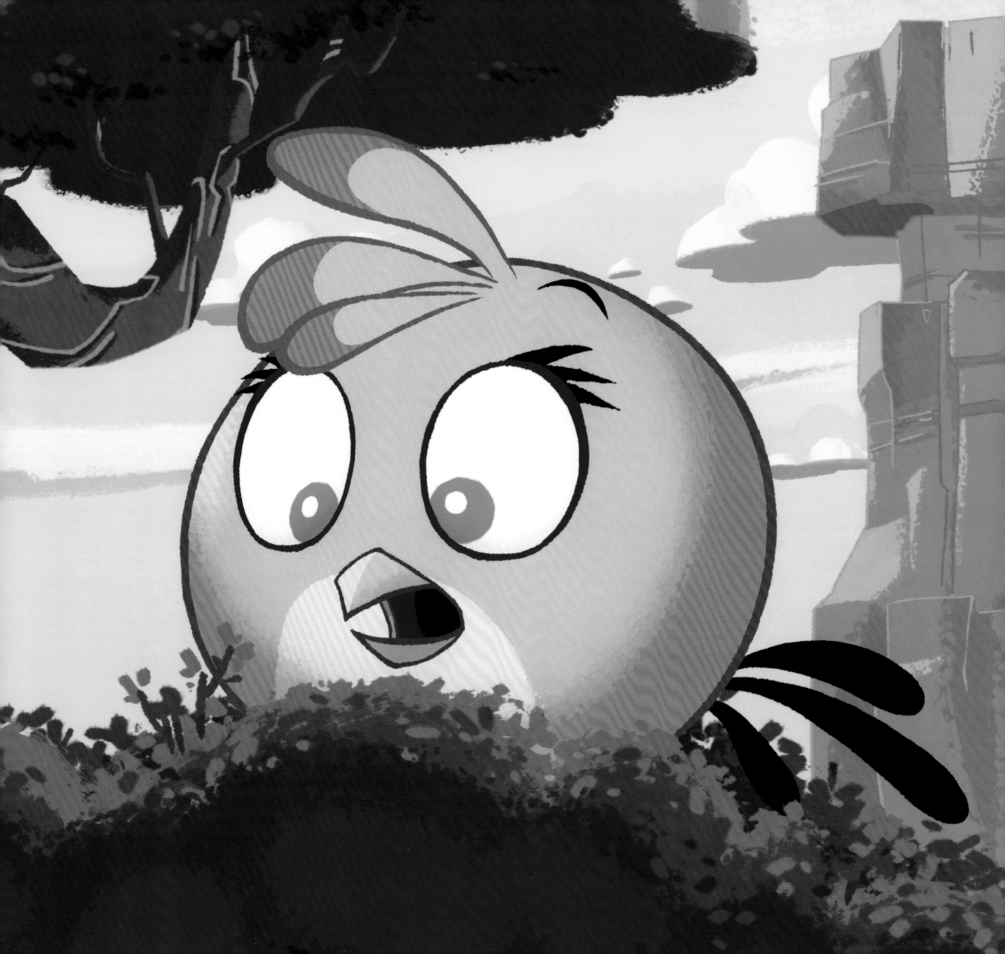

# — CHAPTER 11 —

## RISE OF THE
## Bad Piggies
## 捣蛋猪

"**Some kind of game involving the pigs** was inevitable," says Lead Designer Markus Tuppurainen of *Bad Piggies*, the much-anticipated new game. While *Angry Birds* showcased a simplicity designed to appeal to casual players, Tuppurainen says that *Bad Piggies* has so many different game elements that it's "really a game for gamers."

Similarly puzzle-based, *Bad Piggies* is distinguished by a greater complexity. "It has a two-level gameplay: First, you're building a simple machine on a grid, and then you pilot that machine into the goal area," Tuppurainen says. "*Bad Piggies* is based on entirely new mechanics, something that the pigs were perfect for!"

Despite the differences from the core dynamic of *Angry Birds*, *Bad Piggies* is by no means unrelated to the *Angry Birds* universe. "You can't really separate the birds and the pigs because they make such a good combination," says Tuppurainen. "Jaakko Iisalo always said that the birds are the aggressive ones and the pigs are just the idiotic ones who are trying to get something to eat. That's exactly how it is with *Bad Piggies*. I don't think there can be one without the other. The birds need an opposing force."

As such, the mischievous hogs have not altered their basic and now iconic intention: "The aim of the game is for the pigs to get the eggs in the end. In the first episode, they find a

**ABOVE** Bad Piggies *concept art* • *Carine Becker*
**RIGHT** Bad Piggies *key art* • *Toni Kysenius, Tomi Palonen, Aleksi Räisänen, and Kim Haataja*

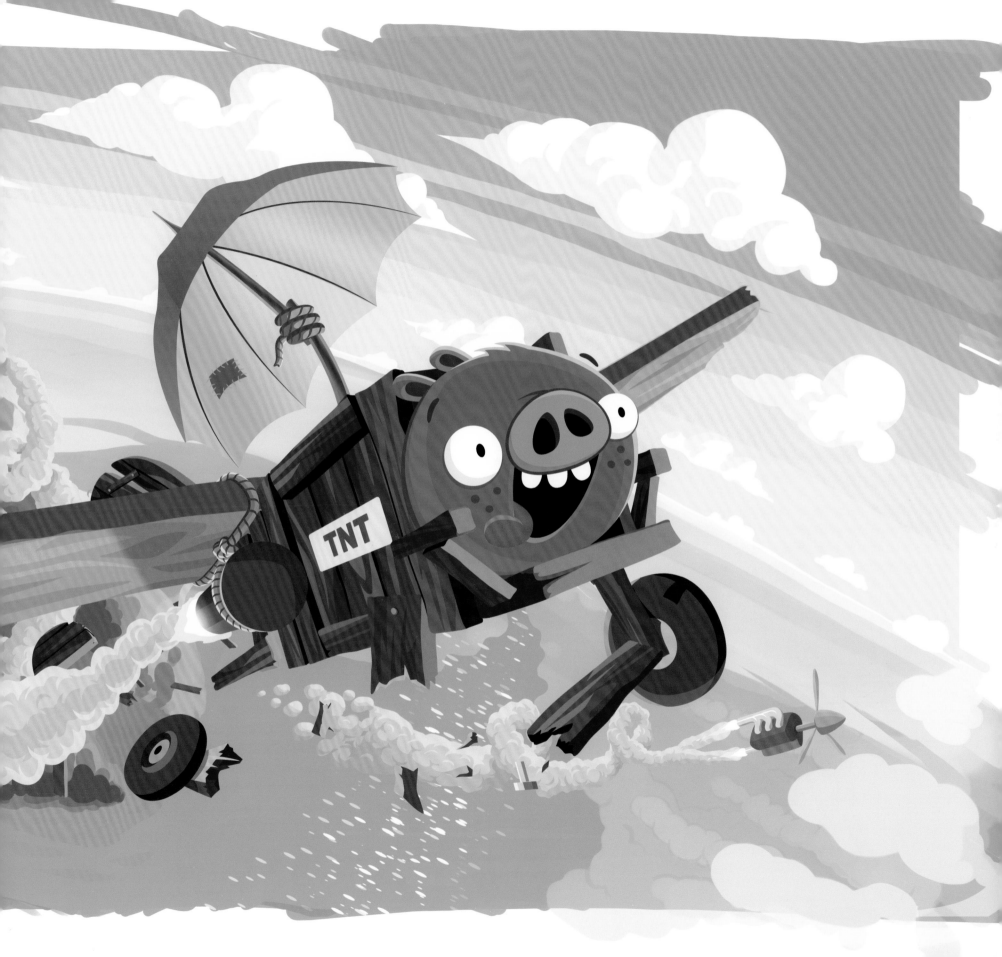

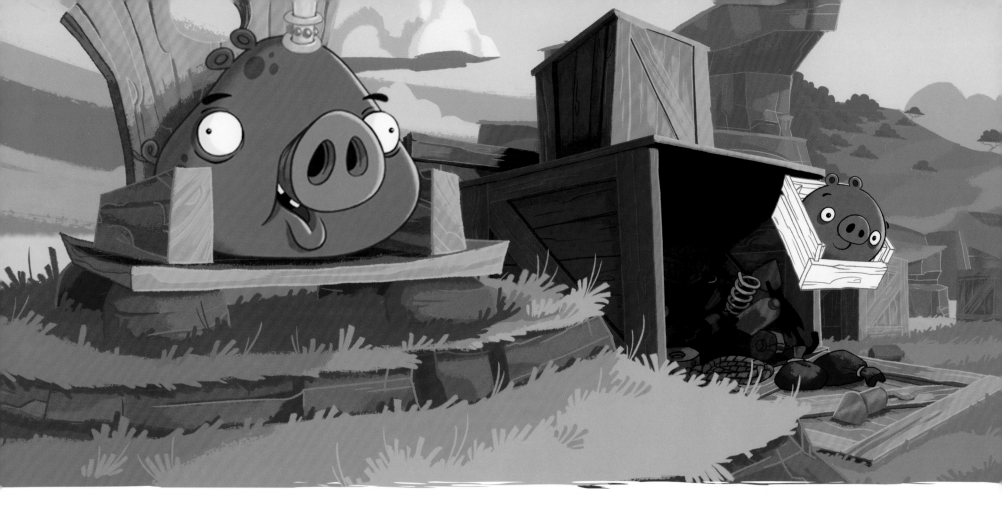

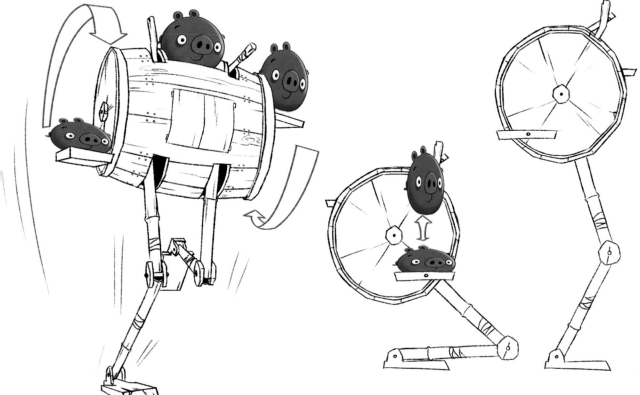

telescope and spy the eggs, so they draw a map to get to that location," he says. "But then the map gets shredded, so they have to collect the pieces in order to find the eggs. The vehicles they create enable them to get to these hard-to-reach spots."

With the Angry Birds' nemeses firmly in the spotlight, Tuppurainen and his team were aided by a general refinement of the *Angry Birds* look that had occurred prior to the game's development. "Before the *Bad Piggies* project," he recalls, "I revised all the game characters. I made cuter versions of them, which are now used in all the marketing materials. I started by giving them more expressions, although the birds did not change as much as the pigs. The pigs were more villainous-looking originally. This time, especially due to the animations, they have gained more positive characteristics. Part of the drive to do this was to make them more accessible."

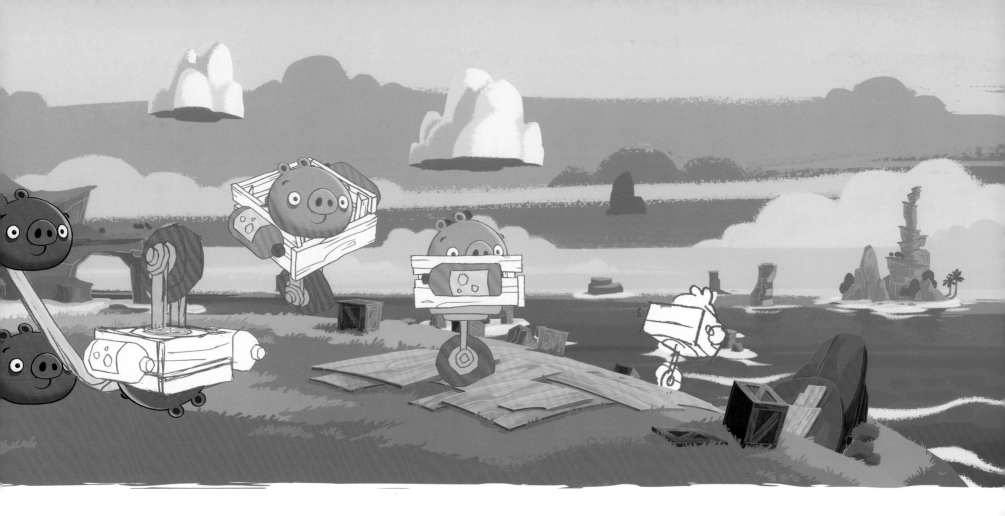

Following the hundreds of levels that have been created for *Angry Birds*, *Bad Piggies* presented an opportunity for a new direction. "This was a whole new game, so I was given the chance to make everything fresh, although the characters had to have a similar feel to what had come before," says Tuppurainen. "Game-wise, I had all the freedom I could get."

Yet, the game's ultimate outcome was directly affected by the wider lore that had been implemented around *Angry Birds*. "The initial story that was pitched was about the pigs going after the eggs, but they can't actually reach them and eat them, as that goes against everything in the story!" states Tuppurainen. He believes, however, that this is no impediment to the game's overall addictiveness: "Finding the map pieces to get to the eggs, but being thwarted, leads you to try again."

Much like *Angry Birds*, though, *Bad Piggies* drives the player on even in the face of frustration. "The design ideology was that failing has to be as much fun as succeeding," he continues. "I think we have achieved that: You enjoy seeing the cars crash and the pigs tumble around. It's funny, so that's a reward in itself and there's no fail screen in the game."

There's an ambition for *Bad Piggies* to equal the scale of the *Angry Birds* games, with Tuppurainen asserting that "eventually, it will have the same number of levels as *Angry Birds*, but that's a lot, so it will take time to get there." Above all, Tuppurainen knows that the game's genesis being linked to a genuine phenomenon makes all the difference: "It's been perfect timing in that respect, and a great opportunity to have the pigs as part of the gameplay. *Bad Piggies* had a ready-made world waiting for it."

**ABOVE** Bad Piggies *concept art* • Jaakko Tyhtilä—layout; César Chevalier—line art; Marija Dergaeva—background painting
**OPPOSITE BOTTOM** Bad Piggies *props design* • Carine Becker
**BELOW** Character design • Diana Egea

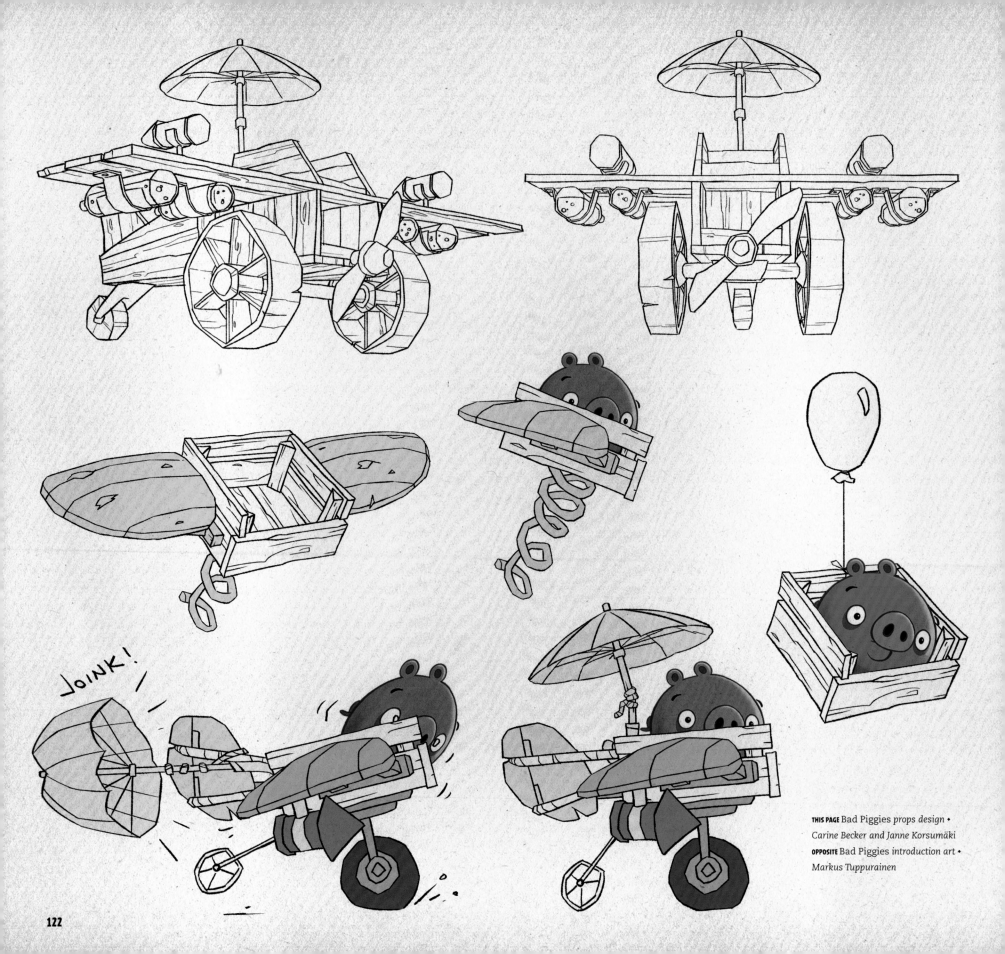

JOINK!

THIS PAGE Bad Piggies props design •
Carine Becker and Janne Korsumäki
OPPOSITE Bad Piggies introduction art •
Markus Tuppurainen

# PIGGIES ON THE PAGE

Ten days before the launch of *Bad Piggies*, Rovio released a teaser comic for the game on their official website. The two-page tale was designed to make the game's storyline even more rich and detailed. Yet it was but a very small piece of a comics publishing program that promised to be a major canvas on which the wider mythology of *Angry Birds* would be told.

According to Mikael Hed, whose experience in comics publishing informs his approach to Rovio's output, comics "are pure entertainment. Their primary function is to entertain." That said, he adds, "The biggest seller in Finland is *Donald Duck* magazine. It's very highly appreciated because, since 1952, it's inspired generations of children to read." What better inspiration could there be for Rovio's concerted efforts to publish books that entertain and inform?

Rovio's Comics Team is led by Jukka Heiskanen, an industry veteran and comics aficionado who spent seventeen years at Disney Comics, eventually becoming Editor-in-Chief of the best-selling *Aku Ankka* magazine (the Finnish for *Donald Duck*). Now, Editor-in-Chief of Rovio's Comics Team, having joined in mid-2012, Heiskanen explains that he already has "several stories in the pipeline, all at different stages of production. They will primarily be published digitally, but we will also be working with publishers to do print editions."

As with all the other Rovio teams, the comics division will not stray from the established *Angry Birds* characters that the fans love. "The characters will always be the same in the comics as they are in the games and animations," Heiskanen explains, "but we will have a certain visual style in the comics that is more free. Ultimately, they are closer to the animated versions of the birds and the pigs. The characters are pretty simple, and in the stories we do, we have the opportunity to add more complexity to them and make them more fully rounded. The stories have to be clear and understandable, so when you enter the world of *Angry Birds*, you know what you're getting, despite the surprises!"

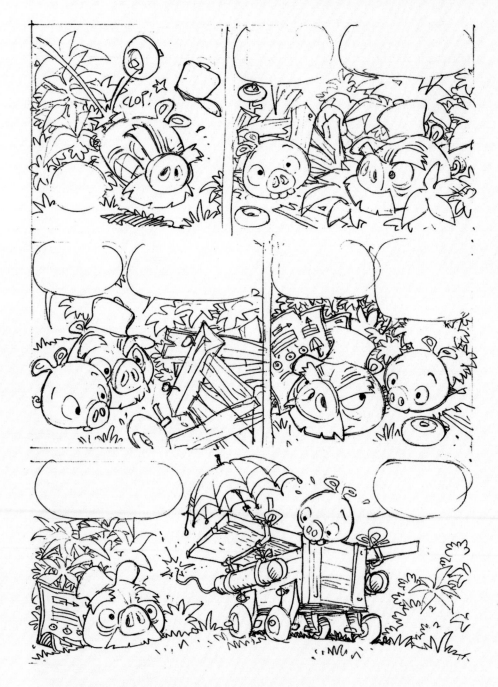

Although the comics program is relatively new for Rovio, it's just as ambitious as the other aspects of the company. "We are producing a large range of comics, and I am really proud of the team," says Hed. "We are already creating enough to the extent that we are aiming to provide a daily comic page offering." Just as Hed always surmised, Heiskanen agrees that comics are a natural fit for *Angry Birds*. "I want all the comics to be as good as possible," he says. "I want the stories to be funny and entertaining and to reflect what the fans want from our characters."

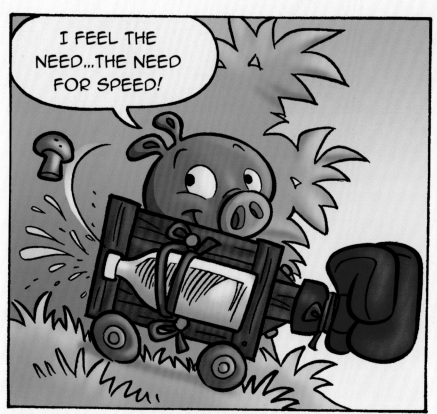

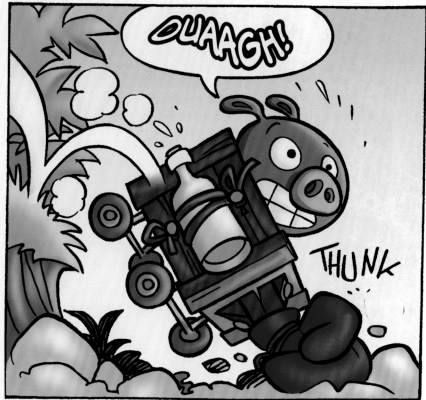

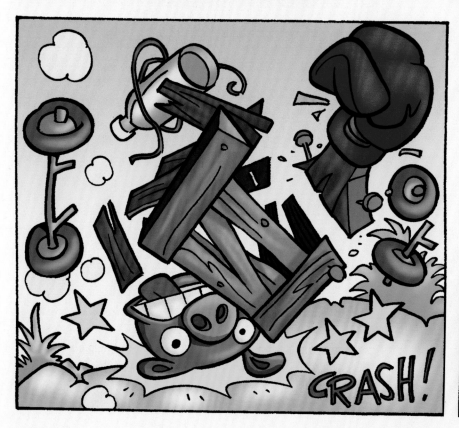

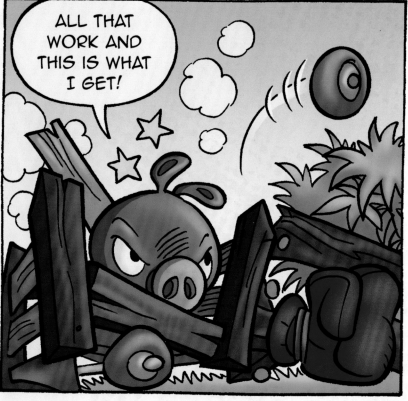

**THESE PAGES** Bad Piggies *teaser comic* • *Jukka Heiskanen—script; Giorgio Cavazzano—line art; Digikore Studios, India—coloring*

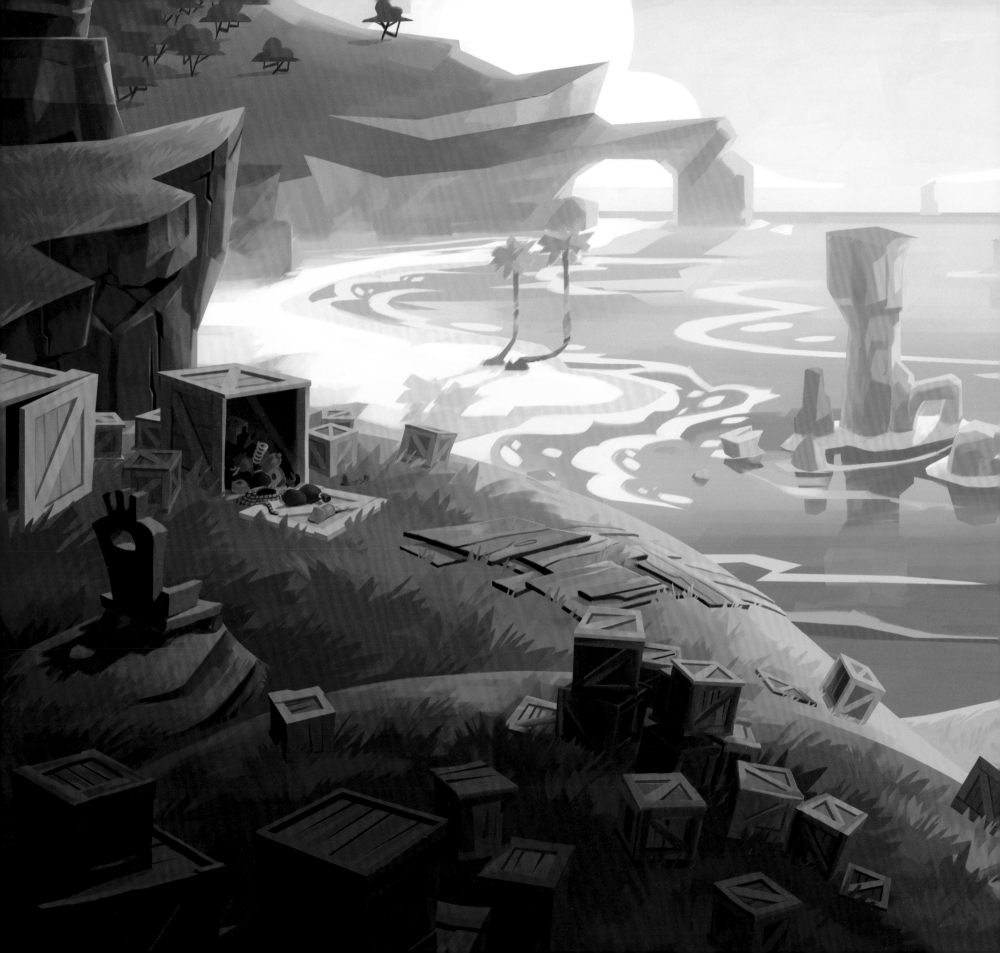

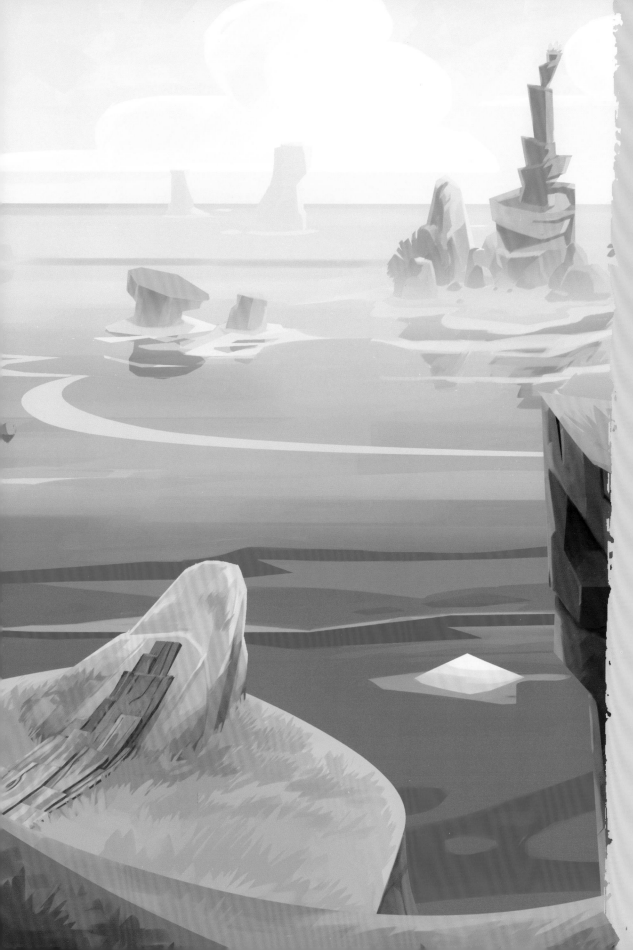

# MEET THE *Flock*

## MARKUS TUPPURAINEN

**Now Lead Designer in Mobile Games,** Markus Tuppurainen's entry into the world of *Angry Birds* was marked by his versatility. "I joined Rovio in the role of Lead Designer," he says, "but at the time there was the need and scope for being a Lead Artist and a Game Designer and almost everything in between."

The simplicity of *Angry Birds* is something that greatly appeals to Tuppurainen's creative sensibilities. "I personally like things straightforward and elegant," he says. "Too many details can make things fuzzier and more difficult to understand."

One aspect of Tuppurainen's work that has altered tremendously is the nature of fan feedback: "In the old days, you made games and there was no way you would get feedback of the sheer intensity that we receive now. In a way, that was so much simpler, because you would get the game out and just hope people like it. Now, games are services, and we can keep updating and enhancing them. Today it's so much easier to get feedback from our fans and react accordingly. We want to listen to our fans and give them what they want."

**LEFT** Bad Piggies *concept art •
César Chevalier—line art;
Meryl Franck—coloring*

127

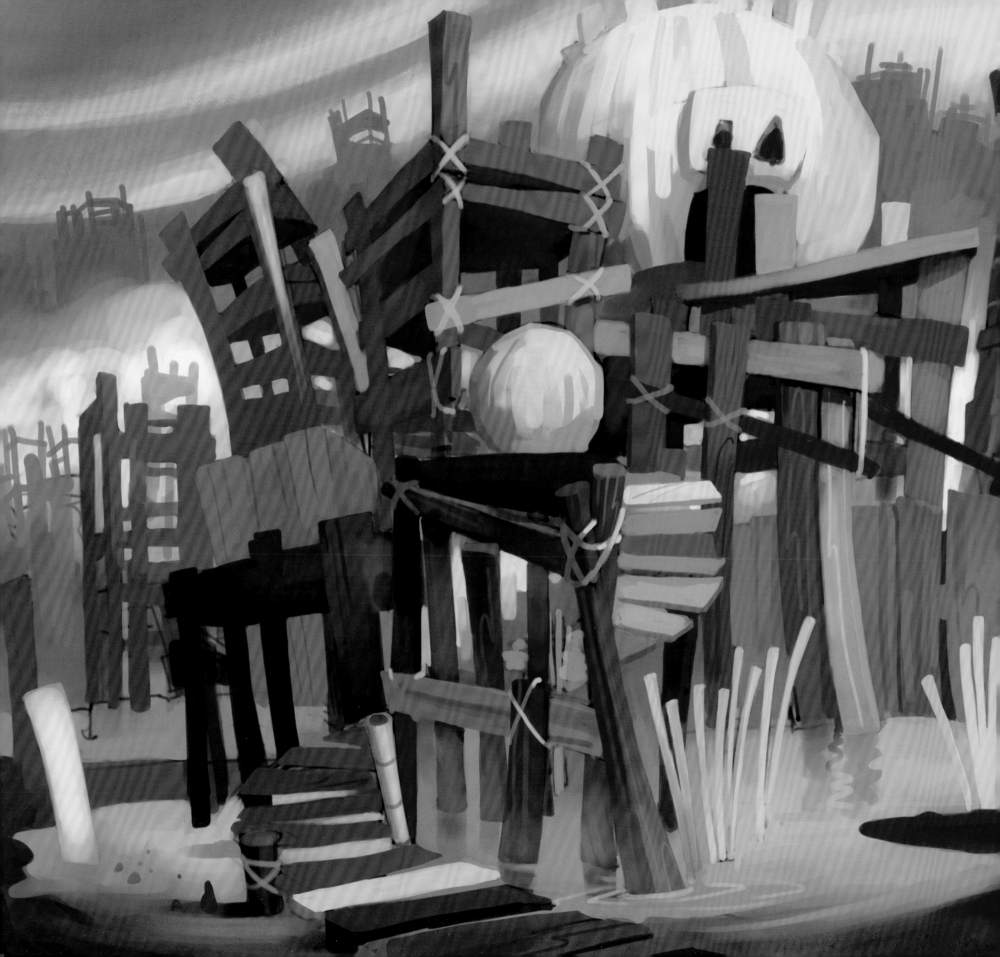

**OPPOSITE** *Angry Birds Toons concept art • Jukka Rajaniemi*

**BELOW** *Character expressions sketches • Joiku Rauhala*

— CHAPTER 12 —

# ANGRY BIRDS
# TOONS

**IN THE FIRST YEARS** of *Angry Birds*, the role of animation was a supportive one, utilized to effectively promote the latest aspects of new games, as, for example, the *Ham'o'Ween* short film did for *Angry Birds Seasons*.

It's a maneuver that has been a huge success for Rovio, explains Lauri Manninen: "The animations used to be a side product for *Angry Birds* but then got bigger and bigger. As a result, the animations kept getting larger in scope. These short films often generate tens of millions of views on YouTube, and the teasers also get millions too."

Given the rampant popularity of these animated *Angry Birds* shorts, it was a natural step for Rovio to pursue animation on a far grander scale. In 2012, the company announced the development of *Angry Birds Toons*, a fifty-two-part series that would be distributed digitally and broadcast on television. It made its debut in March 2013.

Beyond their promotional abilities, the key role of the first animations was to add depth to *Angry Birds'* world and characters, and it is precisely this enriching of the universe that is the focus of *Angry Birds Toons*.

"The basic concept of the game is very strong," explains *Angry Birds Toons* Director Janne Roivainen, "but animation needs more than that. Animation will not eclipse the games, but the two can coexist perfectly. We can get material from the games and use that in the animation. For the animation, it's a great way to concentrate on the characters and make the universe larger than the game. What we are doing with *Toons* is exploring the characters' distinct personalities."

Manninen concurs, adding, "*Toons* creates so much more depth and meaning to the entire world of *Angry Birds*. It will feed fans' imagination and get them to indulge in the universe more."

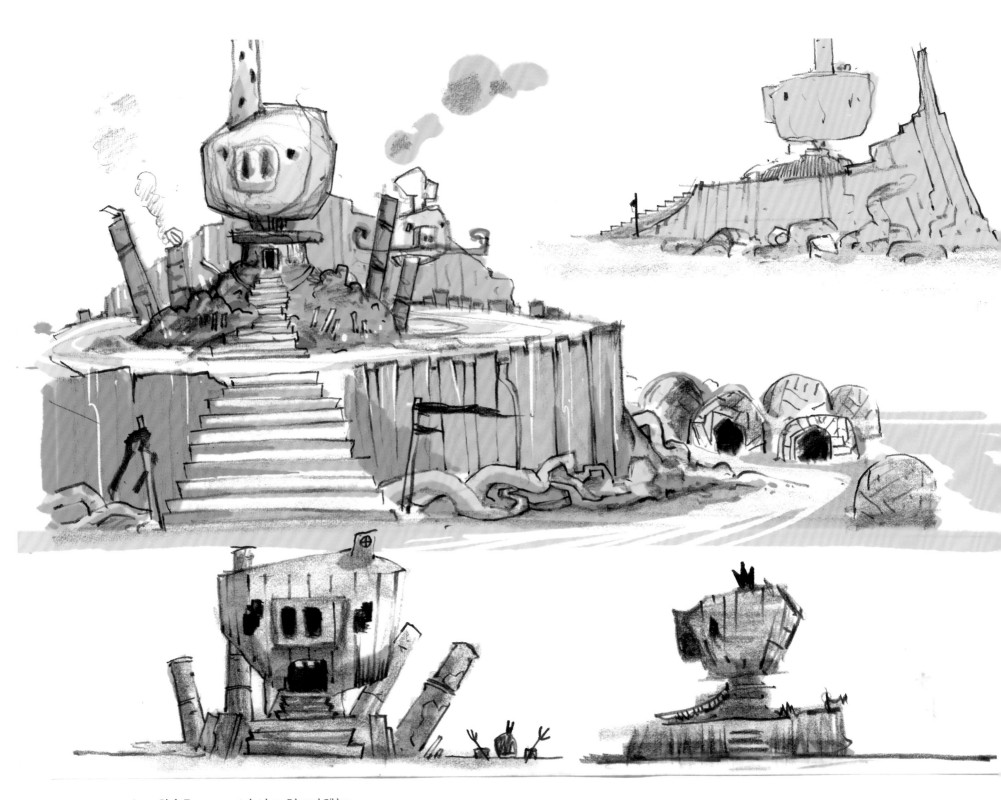

ABOVE AND OPPOSITE BOTTOM Angry Birds Toons *concept sketches* • Edouard Gibbes

OPPOSITE TOP Angry Birds Toons *concept art* • Meryl Franck

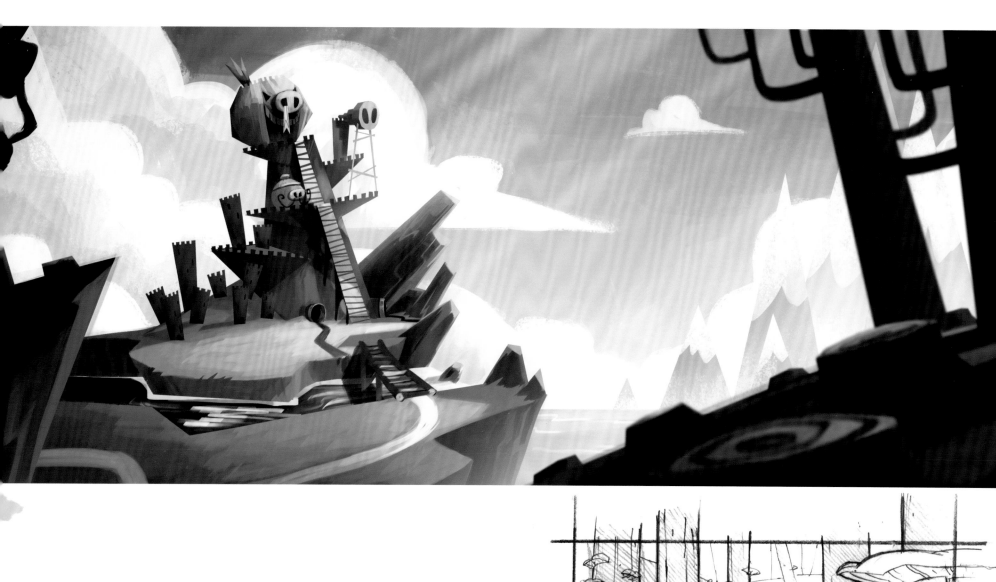

RIGHT Angry Birds Toons
concept art • Meryl Franck
OPPOSITE TOP Angry Birds
Toons concept art • Marija
Dergaeva—background
painting; Edouard Gibbes—
line art
OPPOSITE BOTTOM Angry Birds
Toons concept art • Jukka
Rajaniemi

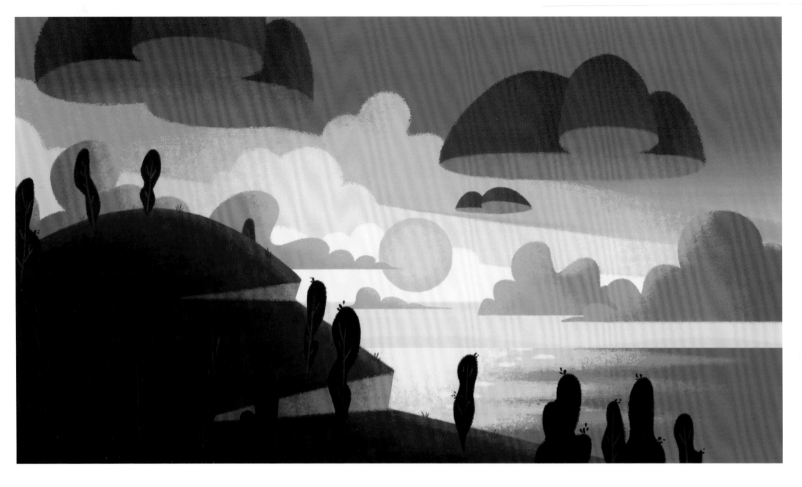

Importantly, in the development of the storylines, the series does not skimp on *Angry Birds'* trademark humor. "Our hearts are with the old-school slapstick of yesteryear," says Roivainen. "*Looney Tunes* is a big influence on me. There is no dialogue, but it is all very expressive. The humor comes from the characters. Even though it is absurd and surreal, we can still effectively tell stories."

Produced by Rovio's Animation Studio, *Angry Birds Toons* is not taking the characters in any drastic new direction. Nor is it a forum for the characters to start speaking, meaning that the production team has to make the most of the characters' innate characteristics.

Not that this is a problem, notes Roivainen: "Our everyday challenge—and one of the things that makes *Angry Birds* so wonderful—is that the characters have certain limitations in not having limbs or the ability to speak. In *Angry Birds Toons*, it's all about expressing the different personalities of the characters."

One thing that Roivainen highlights is that the animations have encouraged the audience to amend their perceptions about the birds and the pigs. "It's fascinating the way the audience sees these characters," he says. "Interestingly, I have noticed that the audience's sympathy for the pigs has grown. The birds are still the good guys, but people love the pigs for their innocence. People create the universe in their own minds."

*Angry Birds Toons* achieves a great deal in each episode's short timespan, and the animators are already turning their attention toward taking the characters and situations into feature-length format. "There is so much material available, so we are not deficient in that area," asserts Manninen. "Of course, it will be a huge challenge, and it has to be done really well and with a complete respect for the characters and their world."

Whether small screen or large, Roivainen is confident that the animation will thrive thanks to its storytelling potential. "I think the story can take many interesting turns," he says. "There's a lot of history with the pigs and the birds that we don't know about yet. What would be fascinating for the audience is finding out what caused all this animosity and conflict."

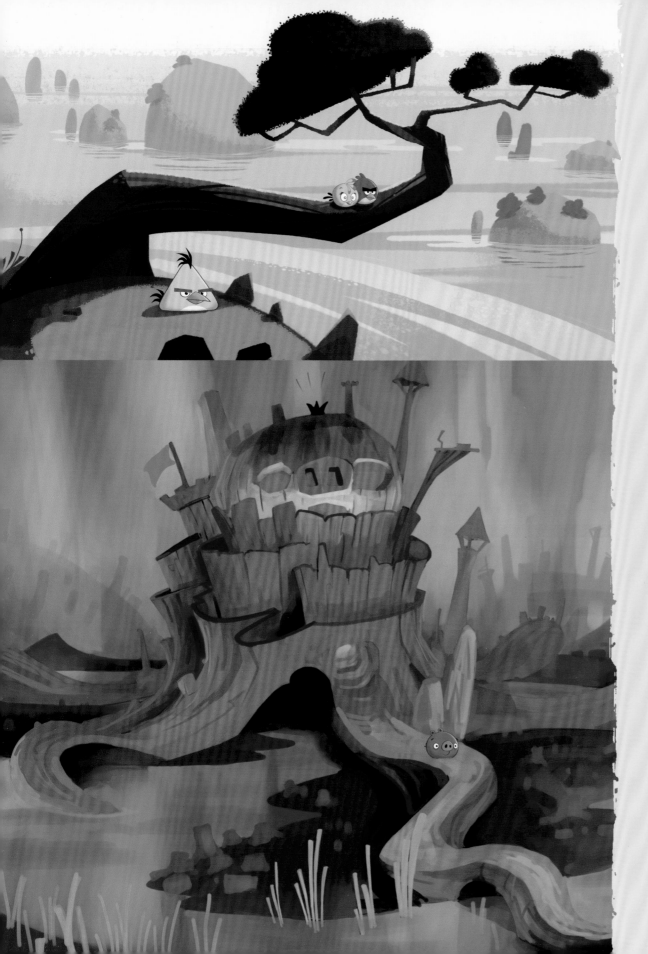

# ANGRY BIRDS™ TOONS

## MEET THE *Flock*

## JANNE ROIVAINEN

**HAVING COME TO ROVIO** and *Angry Birds* via the Helsinki animation studio Kombo, purchased by Rovio in 2011, Animation Director Janne Roivainen has played a key role in taking *Angry Birds* into this new territory, supervising the animation and developing its unique style.

Like the *Angry Birds* games, it's a fast and furious process. "Most of the time we are on a tight schedule," he says. "The story gets developed and transferred to storyboards and animatics. Then it goes to previsualization, to production, to postproduction, then to the editing room, so it's a huge process. It takes months, usually." In the case of *Ham'o'Ween*, however, that process was whittled down to merely two weeks!

Roivainen predicts that in the future the *Angry Birds* experience will be just as synonymous with animation as it is with games. "Eventually *Angry Birds* animation might become the first point of contact for fans," he says. "We are always aiming for character-driven animations that examine their personalities in the most efficient and enjoyable fashion. By keeping things simple, we can tell more stories and the characters shine through more effectively."

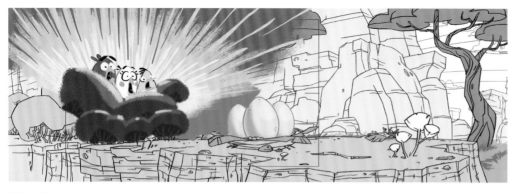

**TOP** Angry Birds Toons concept art • Jean-Michel Boesch and Janne Korsumäki—layout; Meryl Franck—coloring

**MIDDLE** Angry Birds Toons concept art • Edouard Gibbes—line art; Meryl Franck—coloring

**ABOVE** Angry Birds Toons concept art • Simon Dumonceau—layout; Jukka Rajaniemi—coloring

**RIGHT** Angry Birds Toons concept art • Jean-Michel Boesch—layout; Meryl Franck—coloring

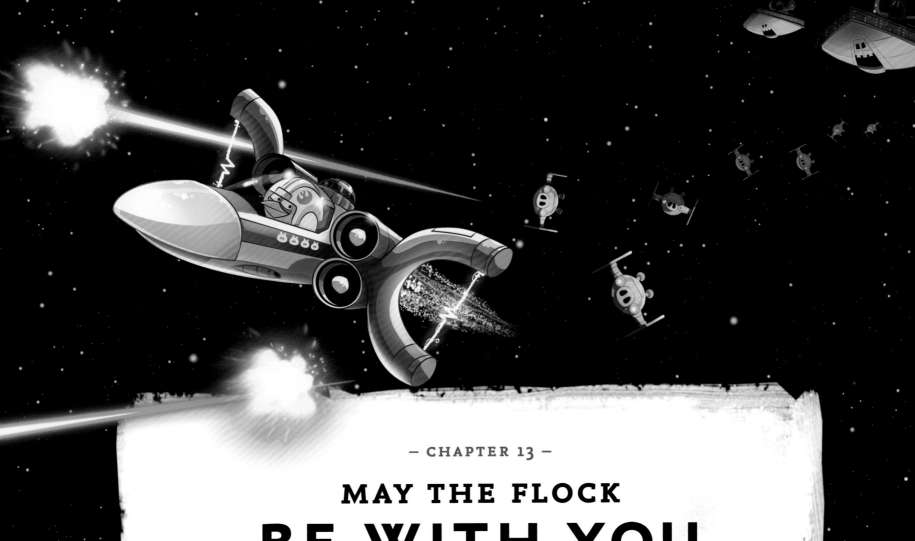

# MAY THE FLOCK
# BE WITH YOU

**THROUGHOUT 2012,** Rovio was working on a top-secret project, code-named "Black." Inevitably, rumors proliferated about what Rovio's latest venture could be, but in October, a small teaser animation revealed that *Angry Birds* was about to collaborate with one of the most beloved entertainment properties on the planet: *Star Wars.*

Of all the partnerships that Rovio has formed, this partnership with *Star Wars* creator Lucasfilm is surely the most striking and a clear sign of the sheer heights that *Angry Birds* has scaled in its comparatively short lifespan. Yet, in a curious way,

the collaboration is not that surprising. "Lucasfilm has partnered with many different brands," notes Rovio marketing guru Ville Heijari. "LEGO *Star Wars* is the obvious example on the games front; brands of this size are always on the lookout for different synergies."

Creating this seamless blend of the two worlds wasn't easy, though, and took an ongoing, but very productive, dialogue with Lucasfilm. "It was a long discussion regarding how we could collaborate together," says Heijari. "We wanted to bring to the table our experience with the

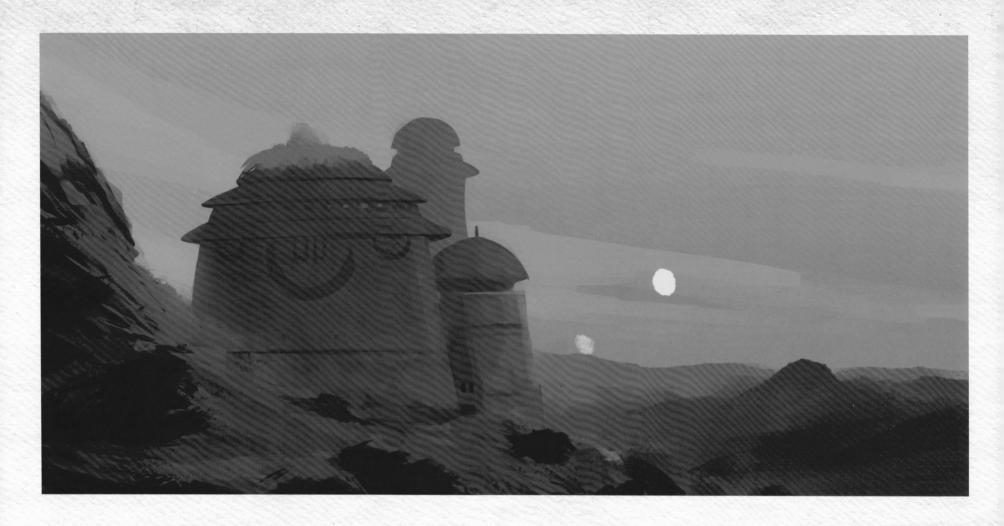

**PREVIOUS PAGES** *(left page) Death Star for Angry Birds Star Wars • Andrius Sliogeris; (right page) Spaceships • Jarrod Gecek and Toni Kysenius*
**ABOVE AND OPPOSITE TOP** Angry Birds Star Wars *concept art • Petri Järvinen*
**OPPOSITE BOTTOM** Angry Birds Star Wars *concept art • West Clendinning*

original game. *Angry Birds Space* was the trigger that proved to us that we can actually translate the game into science fiction."

According to Toni Kysenius, the influence of *Star Wars* was never far from Rovio's collective mind during production of *Angry Birds Space*: "When we were making *Space*, we considered whether or not we should have *Star Wars* references in there. We thought that it might just come later on, that perhaps we may start an official relationship with Lucasfilm. That's why there is no black star field in *Space*—we wanted to save it for later. There are many *Star Wars* fans here at Rovio, so we had a lot of people who had already been dreaming about how this might happen!"

When the green light was given for *Angry Birds Star Wars*, the biggest consideration was how best to bring together these two highly distinctive and very different worlds. "The core decisions came with casting our characters from the *Star Wars* universe," says Kysenius. "We needed to discern what the core elements of *Star Wars* and *Angry Birds* are and how we could mix those together and make something new. It was a big challenge to figure out just exactly how this was going to play out. However, as the development process began and the birds were 'cast,' there were a handful of birds that we knew immediately would fit with *Star Wars* characters: Han Solo as Chuck, Chewbacca as Terence, Luke Skywalker as Red and so on."

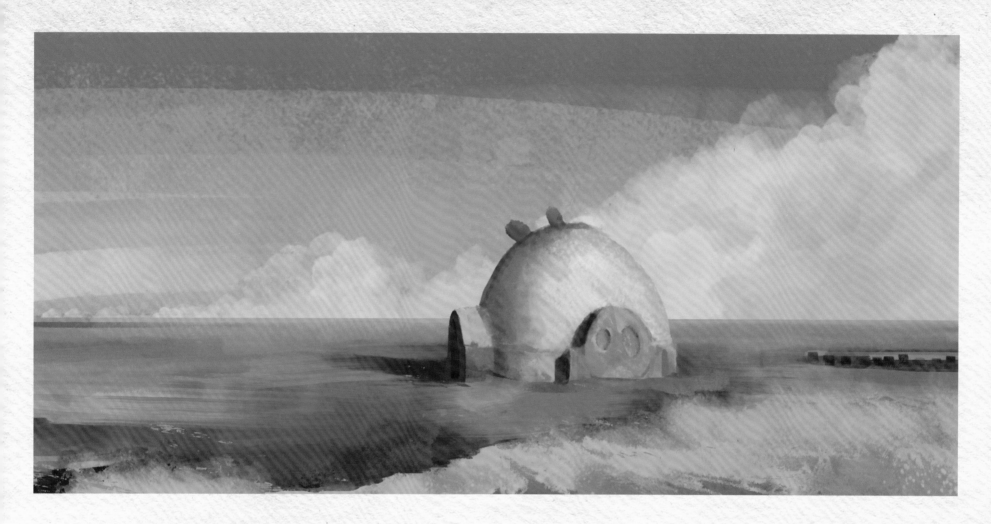

But, as any *Star Wars* fan knows, the characters are just the tip of the Hoth iceberg. "We designed a great deal of other material," reveals Kysenius. "To effectively create a world of our own, somewhere between the two universes, it was apparent that we would have to cover as much of the worlds as possible. That included the various iconic vehicles like the TIE Fighters, X-wings, Star Destroyers, and, of course, the Millennium Falcon. There was a lot of work to do, but we had to create designs that would make fans of both properties feel at home instantly."

"All the design delivery was well received by LucasArts," Kysenius recalls, speaking about the video game wing of Lucasfilm. "The challenge, it seems, was more on the amount of stuff we wanted to produce and keeping consistency with the whole line. We got a bit carried away and wanted to create all kinds of products."

The most enjoyable part of the enterprise for Kysenius was just how amenable Lucasfilm was to the project and how much creative freedom Rovio had. "Before I got in touch with the designers at LucasArts, I assumed that there would be limitations," he says. "I was concerned that we wouldn't get a say in the design. But it turned out to be amazing, because it was clear that they were as excited to be working with our brand as we were to be working with theirs! I really cannot think of a bigger combination than *Angry Birds* and *Star Wars*."

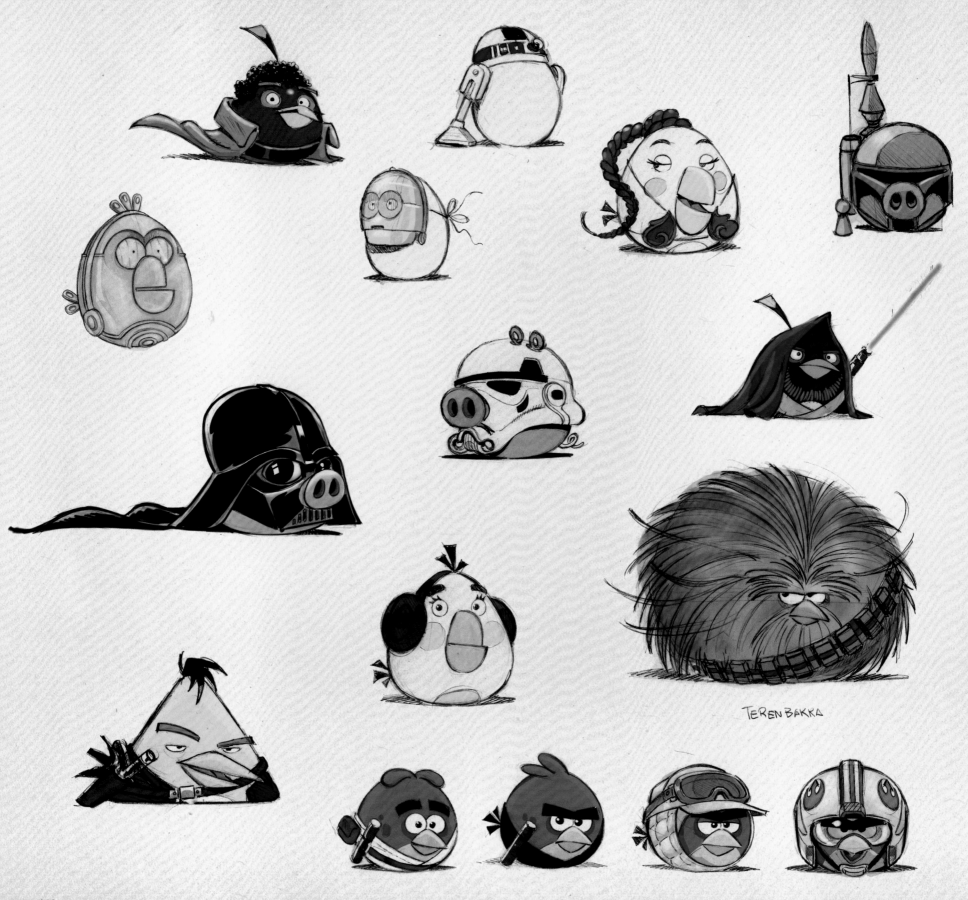

TEREN BAKRA

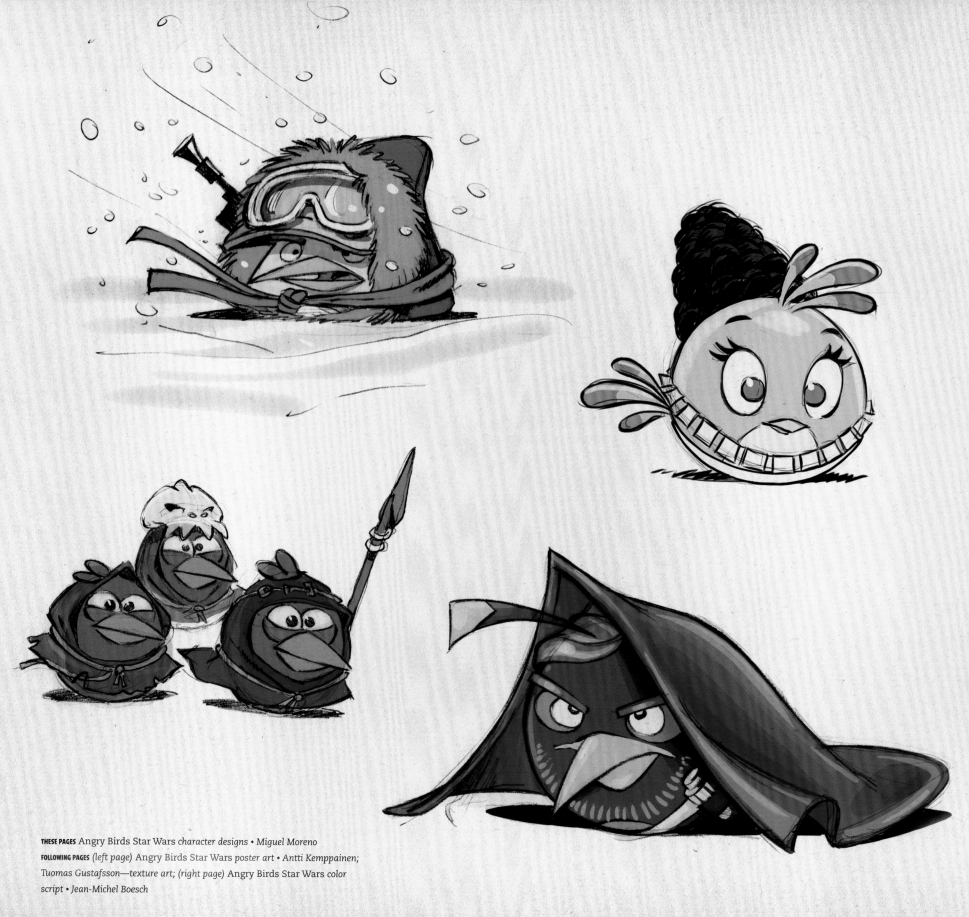

**THESE PAGES** Angry Birds Star Wars *character designs* • Miguel Moreno
**FOLLOWING PAGES** *(left page)* Angry Birds Star Wars *poster art* • *Antti Kemppainen;
Tuomas Gustafsson—texture art; (right page)* Angry Birds Star Wars *color
script* • *Jean-Michel Boesch*

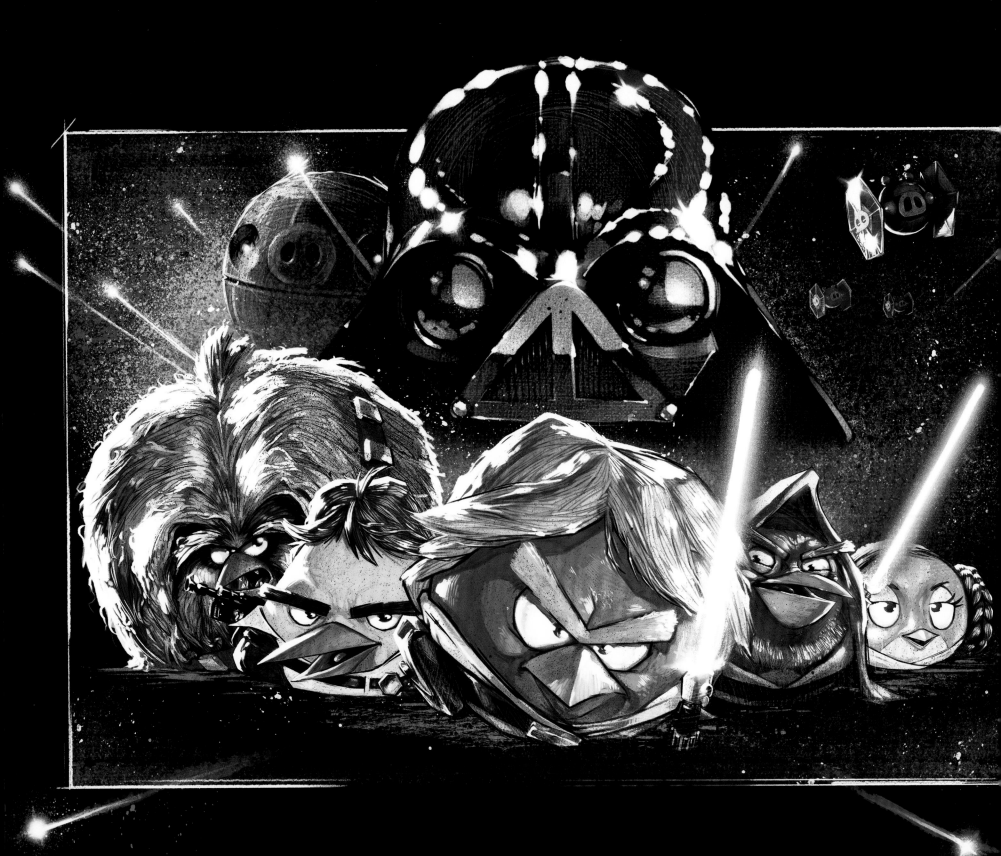

# JOHN WILLIAMS...
# *ANGRY BIRDS* STYLE!

John Williams's legendary orchestral scores for *Star Wars* provide a huge contribution to the franchise's atmosphere of adventure and drama and are beloved worldwide. The music for *Angry Birds*, on the other hand, is determinedly comedic and purposely haphazard. Could the two possibly meet? "One of the hardest parts to get right is the tone of both brands when they are mixed together, and this was especially true for the music," recalls Toni Kysenius. "We heard so many different arrangements of the main theme." The task fell to Ilmari Hakkola, the Head of Rovio's Audio Department, and brother of Rovio's in-house Composer, Salla Hakkola.

"The question was: Should we make *Star Wars* versions of the *Angry Birds* theme with live orchestra, or do we just use the original orchestrations, because they are awesome?" says Ilmari. "Then we thought that the funniest thing we could do is make *Angry Birds*–style arrangements of Williams's themes. We wanted to have a rhythm to it, with the notion of the pigs being in the orchestra, trying to be really epic, but failing really badly! They try to be scary and huge for 'The Imperial March' but actually end up sounding amusingly clunky!

"We didn't want to make our arrangements too small, because the originals have such an epic sound, and we needed to approximate that. So, we kept the Balkan elements but made the sound so much larger. We went through Williams's original arrangements and we used a lot of those elements in the background, adding folky live percussion and trumpets, xylophones and accordion. It's actually very hard to mix those two worlds together, but I think we nailed it! The comedy comes from the sheer contrast of the two styles colliding."

**OPPOSITE** Angry Birds Star Wars *concept art* • *Tuomas Gustafsson, Toni Kysenius, Joel Sammallahti, and Sami Timonen*
**TOP** Angry Birds Star Wars *concept art* • *West Clendinning*
**RIGHT** Angry Birds Star Wars *concept art* • *Toni Kysenius*

# MEET THE *Flock*

## VILLE HEIJARI

**THE *ANGRY BIRDS STAR WARS* COLLABORATION** has been one of the key achievements of Rovio's Marketing Department. "I oversee the marketing and communications activities, and work with our Sales Department to manage our brand partnerships," says Ville Heijari of his role as SVP of Brand Marketing, which provides him a bird's-eye view of the brand's stunning expansion.

More pertinently, Heijari is focused on ensuring that *Angry Birds* is in constant communication with its audience. "Our marketing is first and foremost a dialogue with our fans," he says. "Our biggest marketing channels are the games themselves, followed by Facebook and other social networks. *Angry Birds* is distinguished by very modern, cutting-edge digital marketing."

To this end, Heijari feels, Rovio has to ensure that their audience is fully aware that *Angry Birds* is a broad and rich consumer experience. "The original *Angry Birds* game was designed to be really accessible to anyone who uses a smartphone or similar touchscreen devices," he says. "Our gamer audience is always there—and *Angry Birds* is a video game first and foremost—but when you start marketing the whole *Angry Birds* universe, it's about the characters and the audio-visual experience. We strive to appeal to a multigenerational audience."

Yet, as *Angry Birds* continues its remarkable expansion worldwide, Heijari is ever mindful of the key challenges Rovio must face. "We have to maintain simplicity but keep it fresh," he says. "The game has worked beautifully as a portal for nongamers to get into gaming. Some people dismiss it on those grounds, but given that we have millions of people playing *Angry Birds*, surely there must be something appealing about the characters, the design, and the brand itself. That's where the power lies: the quirkiness and the humor."

**RIGHT** Angry Birds Star Wars *production art •*
*David Lopez and Carine Becker—layout; Jean-*
*Michel Boesch and Simon Dumonceau—coloring*

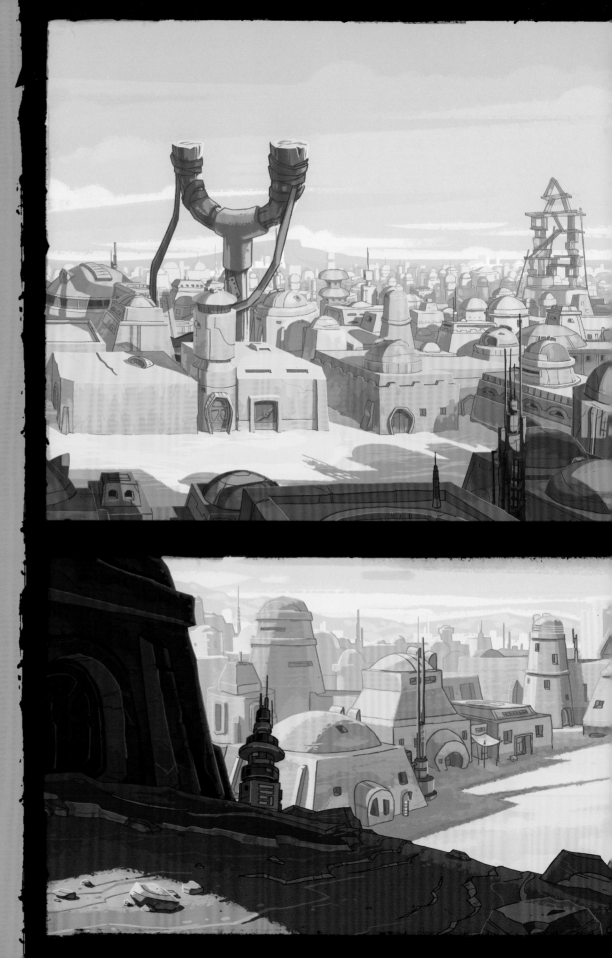

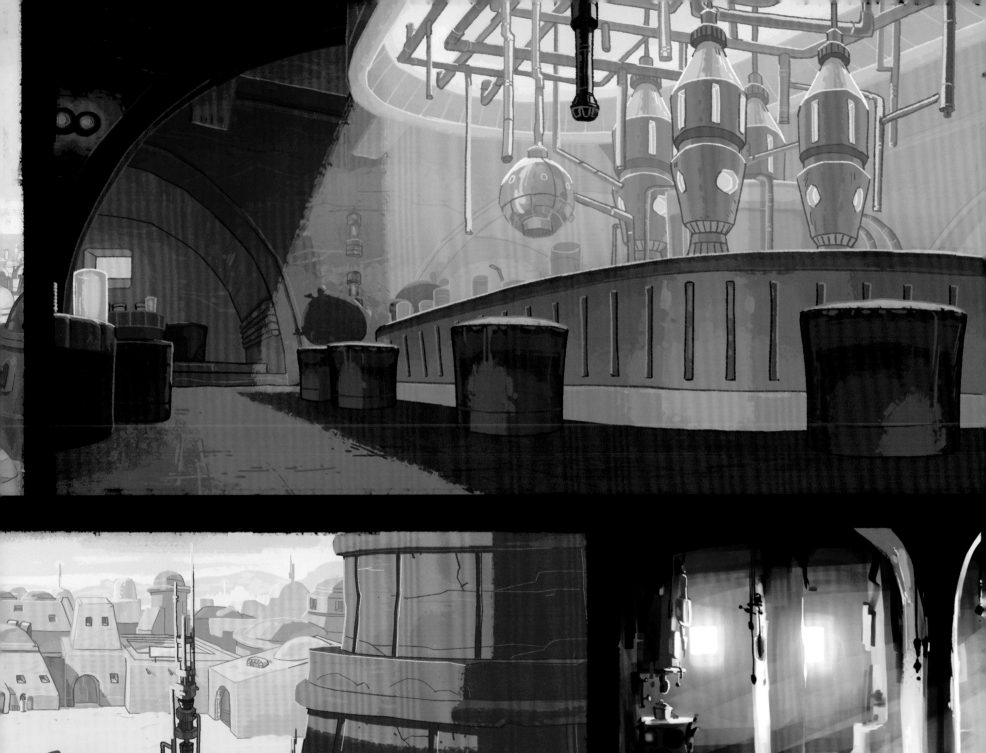

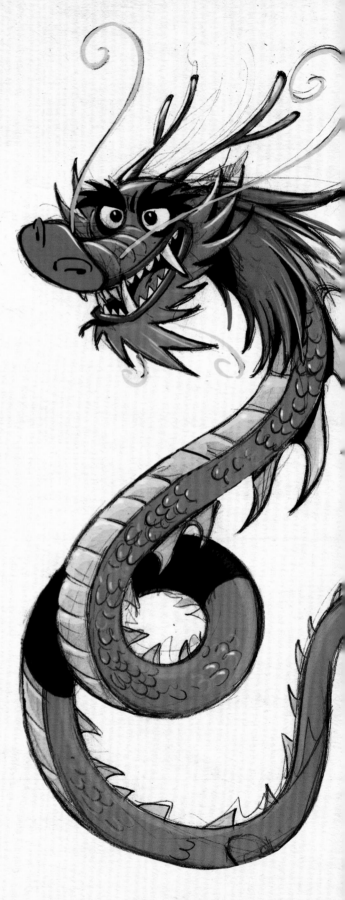

# — CHAPTER 14 —
# SLINGSHOT TO
# CHINA

**WHILE SUCCESSFULLY CRACKING** the American market with its games, Rovio was also in the process of catapulting *Angry Birds* to the Far East, specifically China, which harbors a potential audience of 1.3 billion people.

During its global expansion, Rovio has been sure not to assume that *Angry Birds*, despite its massive popularity, will be instantly embraced everywhere. An effort had to be made to recognize different cultures and adapt accordingly. As such, the first leg of Rovio's campaign in China was to launch an update for *Angry Birds Seasons*, entitled Mooncakes, which is based around China's Moon Festival.

"Localizing content is extremely important, but at the same time, we have globalized," explains Peter Vesterbacka. "We took the Moon Festival and put it into the game, which was expressly for China, but we also introduced it for the whole wide world. We have tens of millions of people playing the game and, for a great many of them, this would have been the first time that they had ever heard about the Moon Festival.

"People have become very adept at picking up on the distinct events of other cultures. Outside the US, for example, people know what Thanksgiving is, even though they don't celebrate it, and,

**THESE PAGES** *Year of the Dragon animation character design •* Miguel Moreno

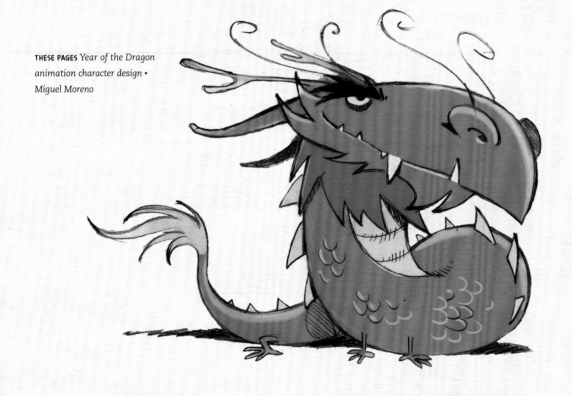

148

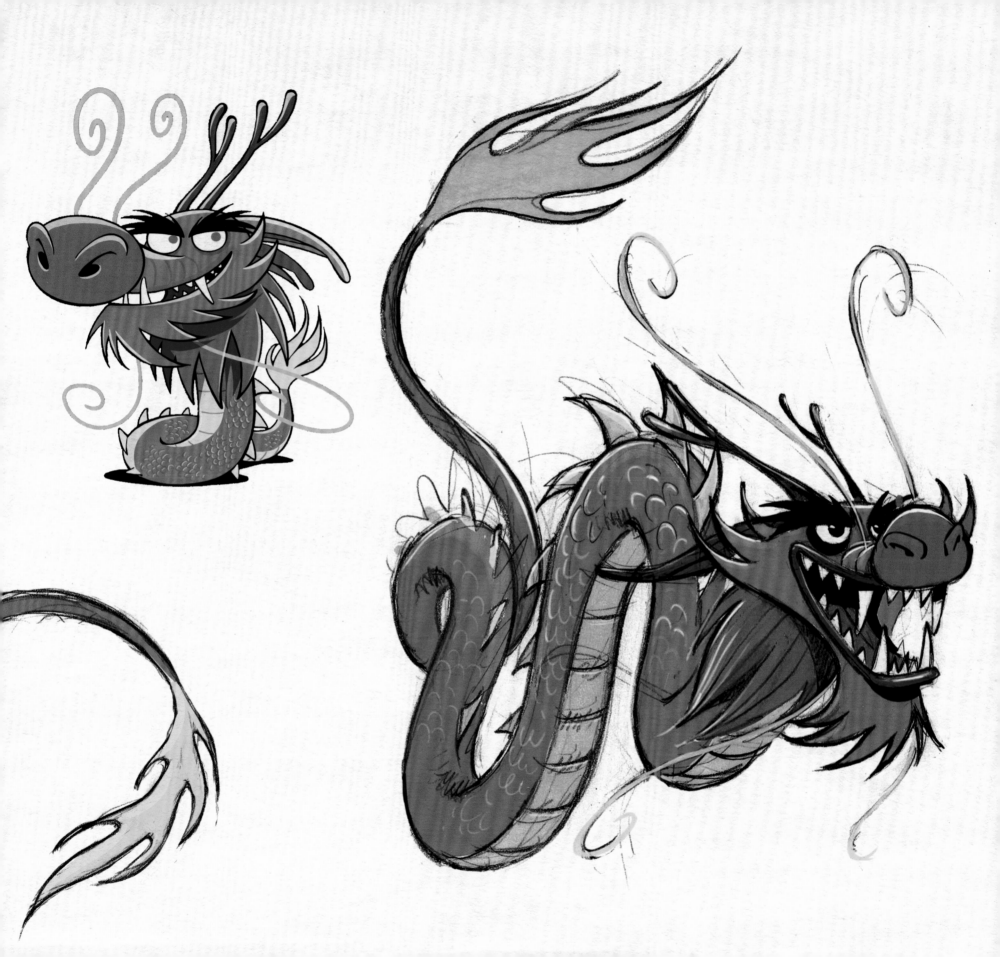

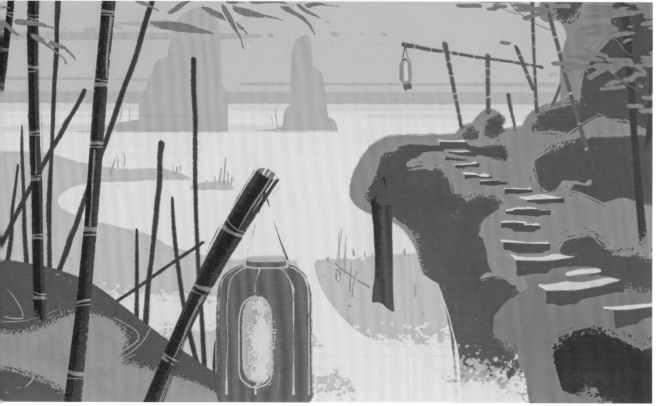

likewise, in Asia, people are becoming more familiar with Halloween. Things are becoming more global, but they are also becoming local."

A second Chinese-themed Seasons update, Year of the Dragon, followed Mooncakes and firmly reiterated Rovio's belief that *Angry Birds* can be a delivery system for local culture. "There is so much you can accomplish when you embrace these local customs and bring them to the world," says Vesterbacka. "There are stories in China, India, and Japan, as well as here in Finland, that we can make more accessible via *Angry Birds*."

Beyond localizing game content for the region, Rovio has opened retail outlets as well as theme parks in China. All of this has served to give *Angry Birds* an authentic presence in the region. "If you look at China, we are the most pirated brand by far," says Vesterbacka, "so we want to guarantee our Chinese fans authentic and high-quality experiences."

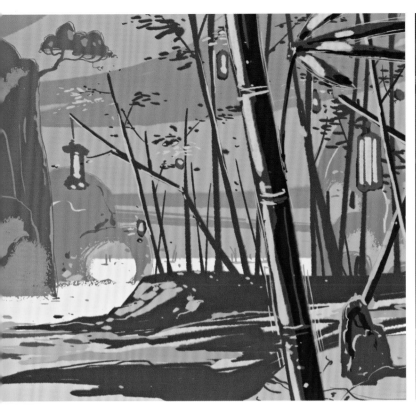

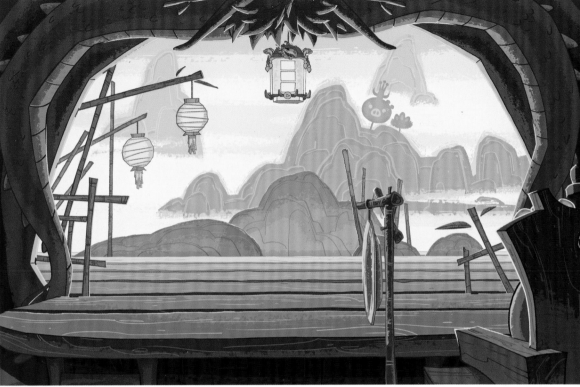

That drive for authenticity also applies to the rest of the world, where *Angry Birds* piracy is also rife. "It's both a challenge and an opportunity," says Mikael Hed. "It's a challenge because we are very particular about the quality of our merchandise and concerned about ethical production. We want our offerings to be an overall delight. Then again, it's an opportunity because pirated products indicate local demand. We investigate those markets and replace pirated products with safe, quality ones."

This rapid yet ethically minded expansion has confirmed *Angry Birds*' status as a universal phenomenon that is not just confined to games. "We want to provide a retail experience," says Vesterbacka. "We are on all the various devices and can interact with our fans. We can provide an online/offline experience."

Not just content with creating millions of new fans in China, Rovio has bravely tested the country's markets with unique, never-before-seen services.

Partnering with McDonald's, Rovio launched a new feature called *Angry Birds Magic* that utilizes cutting-edge technology. "*Angry Birds Magic* allows interaction between our games and the real world," Vesterbacka explains. "It lets us create locations where fans can download features for the game that they could not obtain anywhere else.

"McDonald's has 1,500 restaurants in China and we made them all *Magic* places where our fans could access digital content based on their physical location. It was the biggest campaign that McDonald's had ever undertaken. We turned their Golden Arches into slingshots for the birds and linked it all to the *Bad Piggies* game, revising the mythology so we had the pigs stealing burgers! We wanted to ensure that our fans don't feel like we've just added the *Angry Birds* brand onto something for no apparent reason. Wherever we go in the world, our ultimate goal is to delight our fans in everything we do."

**OPPOSITE AND ABOVE** *Year of the Dragon animation concept and production art • Jean-Michel Boesch*
**BELOW** *Year of the Dragon animation sketch • Miguel Moreno*
**FOLLOWING PAGES** *(left page) Moon Festival artwork • Antti Kemppainen; (right page) Year of the Dragon animation artwork • Tuomas Gustaffson*

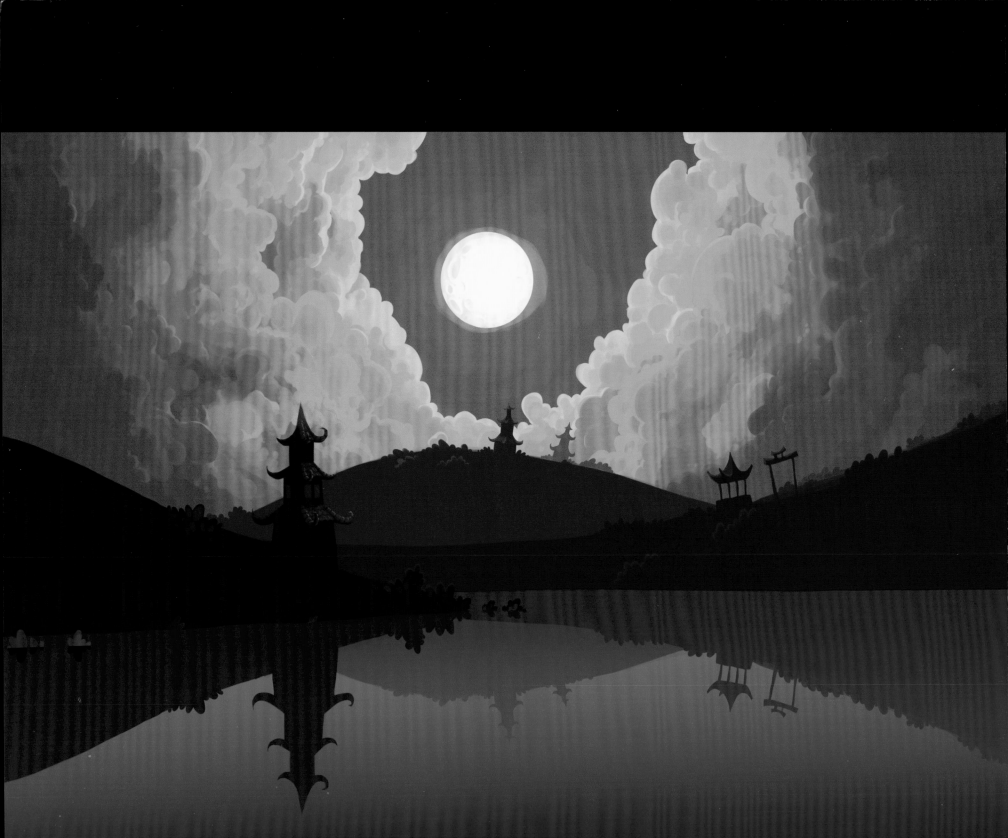

# THE FUTURE OF

**ANGRY BIRDS**

**THE RISE OF *ANGRY BIRDS*** from a single mobile game to a world-renowned entertainment universe and pop culture phenomenon has been nothing less than meteoric, achieved in merely three years. In December 2012, on the third anniversary of the release of the first game, Rovio Entertainment announced that *Angry Birds* will be catapulting onto the big screen, in the form of an animated 3D movie, due for release in 2016.

For its debut filmmaking venture, Rovio has joined forces with Hollywood producers David Maisel (*Iron Man, Captain America*) and John Cohen (*Despicable Me*), who will produce the film alongside Mikael Hed. Thanks to the staggering success of *Angry Birds*, the company will be financing the project entirely in-house, essentially making Rovio a film studio.

For Cohen, the opportunity to work with Rovio and *Angry Birds* was not one to be missed. "To say that I was a huge fan of the *Angry Birds* games would be an understatement," he says.

**PREVIOUS PAGES AND ABOVE**
*Original artwork for this
book* • Jean-Michel Boesch

**ABOVE** Bing Angry Birds *television advertisement concept art* • Sami Timonen

"I've been addicted since I first played the game a few years ago! I had originally contacted David back in June of 2011, as soon as I heard that he was going to be working with Rovio. He introduced me to Mikael, and we very quickly jumped in and began to explore all the cool ideas that Mikael and his team had already created."

As a result of all this brainstorming, the movie itself promises to be an epic canvas on which the universe of *Angry Birds* will be explored. Plus, it's guaranteed to cater to fans' considerable curiosity about the beloved property. "Something that I think is very exciting about *Angry Birds* is that every fan who plays the game already has a personal connection with the characters," says Cohen. "As a result, they have a great curiosity about who these birds are, what world they come from, and what their personalities are outside of the action in the games. These will all be fun discoveries for *Angry Birds* fans when they see the film."

Of course, both Cohen and Maisel are keenly aware of the important relationship between Rovio and the fans. "The biggest challenge for me is knowing how high the fans' expectations are," Cohen affirms, "and wanting them to love the movie as much as I do. As a huge fan of the game, I am always trying to put myself in the fans' shoes and think about what they would want to see and experience in the movie. I think they're going to be very happy with the final result."

Cohen is adamant that the movie version of *Angry Birds* will be produced in precisely the same way that the games, animations, books, and comics have been: "First and foremost, we are making this movie with the fans in mind. We not only want to make sure that they are satisfied and love this film, but that they are also introduced to surprising and exciting new things that they never knew about the *Angry Birds* universe. I can tell you now that this is going to be a very, very funny movie with a lot of terrific characters and incredible action."

No one at Rovio is underestimating the challenges that a movie—the biggest and most complex *Angry Birds* production yet created—will present. However, the project is being wholeheartedly embraced with the sense of boundless ambition that has become Rovio's signature. As Peter Vesterbacka notes, "It's important that we are not afraid of doing new things and taking on big challenges, which a movie that will cost tens of millions of dollars most certainly is. It's the biggest project Rovio has ever undertaken. As always, we will shake things up. Our goal is for it to be an amazing movie and the most successful of its kind, ever."

For Vesterbacka this is not just a single project but the start of many larger and more ambitious ventures. "We've been building to this, step by step, all as part of an effort to delight our fans," he says. "When you look at Rovio, we are a learning organization. We don't claim to know everything, but we know we can learn most things pretty fast. That's the attitude we are taking with the movie."

For Hed, the movie is a significant step for *Angry Birds*, but one that entirely keeps with Rovio's forward-looking vision for the property: "We want to make sure that the next steps in *Angry Birds*' evolution are ways in which we offer fresh and interesting ways of looking at the property while retaining the familiar magic of the brand. We know that our fans love the characters and their world and it's up to us to keep entertaining them in a variety of ways."

Although the games will always be a key focus for Rovio, and the de facto center of the *Angry Birds* universe, Mikael Hed sees Rovio first and foremost as an entertainment company, not just a game developer. "In his time, Walt Disney turned Mickey Mouse into a worldwide brand through traditional media," he says. "*Angry Birds* is an entertainment franchise as well, but its main media are connected devices. This new media is enabling faster growth than what Disney saw 70 years ago."

With *Angry Birds*, Rovio has three main aims: to ensure as many fans as possible get the chance to enjoy *Angry Birds*; to make sure the fans remain surprised and delighted by the *Angry Birds* universe; and, finally, to provide them with an ever-expanding array of storytelling experiences. "We don't know everything but we can learn anything from the industry," says Hed. "We are also learning from our fans. We listen to them and their wishes and combine the best elements of all that we learn in our products."

Ultimately, the games, the animations, the books, the comics, the merchandise, the amusement parks, the movies, and all the ventures to come will be diverse doors to an energetic and fun-packed universe, and, for Hed, this is the future of *Angry Birds*. "We want to do it all so well that people can be introduced to *Angry Birds* from any angle," he says. "I imagine that what will happen eventually is that people may not remember where it all started, only that they each have their own distinct entrance into our world . . ."

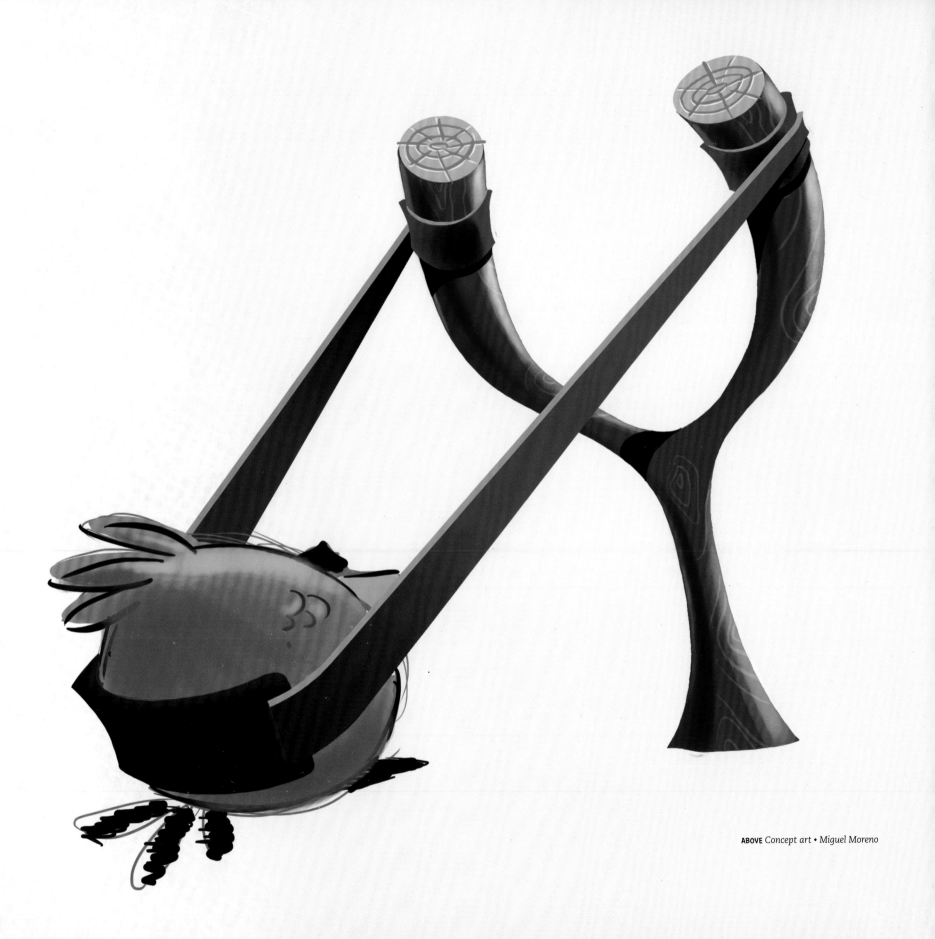

ABOVE *Concept art* ◆ Miguel Moreno

# ACKNOWLEDGMENTS

THIS PROJECT WAS AN INTERESTING challenge given that it was outside my usual areas of Film and Comics—although it touched upon them both—but it was truly fascinating to get a close-up glimpse of a genuine pop culture phenomenon spectacularly in the ascendant. I'd like to thank my editor and fellow Brit Chris Prince at Insight Editions, along with co-publisher Michael Madden, for the opportunity to work on this, my third project for Insight. Always a pleasure.

During my visit to Rovio's Espoo HQ, I was made incredibly welcome by everyone I met. In particular, huge thanks to Juha Kallio, who kept to time an incredibly packed interview schedule and ensured that I received the fullest view of Rovio during my stay. Similarly, I extend great gratitude to Jan Schulte-Tigges and Laura Nevanlinna of Rovio's Books and Learning Department.

Back home, I'd like to thank my colleague at the University of Hertfordshire, Dr. Alison Gazzard, for her knowledge of video games history. Last, but by no means least: my love and thanks to Lucy and our beloved cats Cosmo and Jess for habitually providing the classic antidote to deadline-addled days: tea and ceaseless affection. As always, this is for them—and for my nephew Roman, who was born as I finished this.

—DANNY GRAYDON

# COLOPHON

PUBLISHER Raoul Goff

CO-PUBLISHER Michael Madden

EDITOR Chris Prince

EDITOR FOR ROVIO Juha Kallio

ART DIRECTOR Chrissy Kwasnik

ART DIRECTOR FOR ROVIO Jan Schulte-Tigges

DESIGNER Jenelle Wagner

ACQUIRING EDITOR Steve Jones

PRODUCTION MANAGER Anna Wan

*Insight Editions would like to thank Juha Kallio, Jan Schulte-Tigges, Laura Nevanlinna, Sanna Lukander, Rovio's Books Team, and everyone else at Rovio who gave their time in the making of this book.*

*We would also like to thank Binh Au, Elaine Ou, and Jon Glick.*

*Meet the Flock caricatures • Miguel Moreno*
ENDPAPERS, PAGE 1 & 162 *Poster artwork • Terhi Haikonen*
PAGE 13 *Stickers • Terhi Haikonen*
PAGE 30 *Sketchbook • Carine Becker and Jean-Michel Boesch*
PAGE 40 *Postcards • Aleksi Räisänen*
PAGE 56 & 116 *Folding boxes • Rovio and Insight Editions*
PAGE 93 *Space poster • Olga Budanova and Toni Kysenius; Comic page • Paul Tobin, Ron Randall, and Ben Bates*
PAGE 110 *Postcards • Sam Spratt*
PAGE 132 *Bookmark • Miguel Moreno*
PAGE 132 *Doorknob hanger • Tuomas Gustafsson*
POSTER INSIDE ENDPAPER ENVELOPE *Poster artwork • Tuomas Korpi, Piñata*

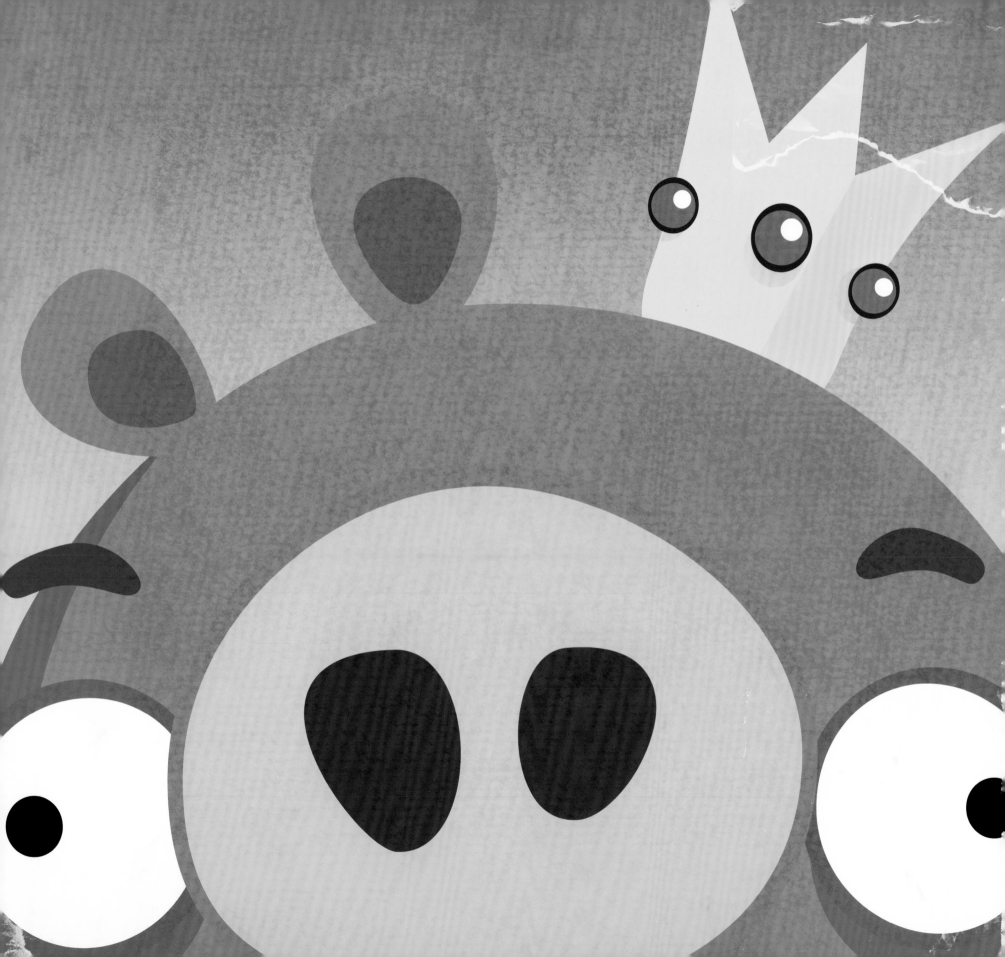

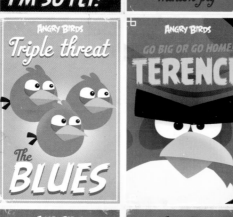